Frankenstein

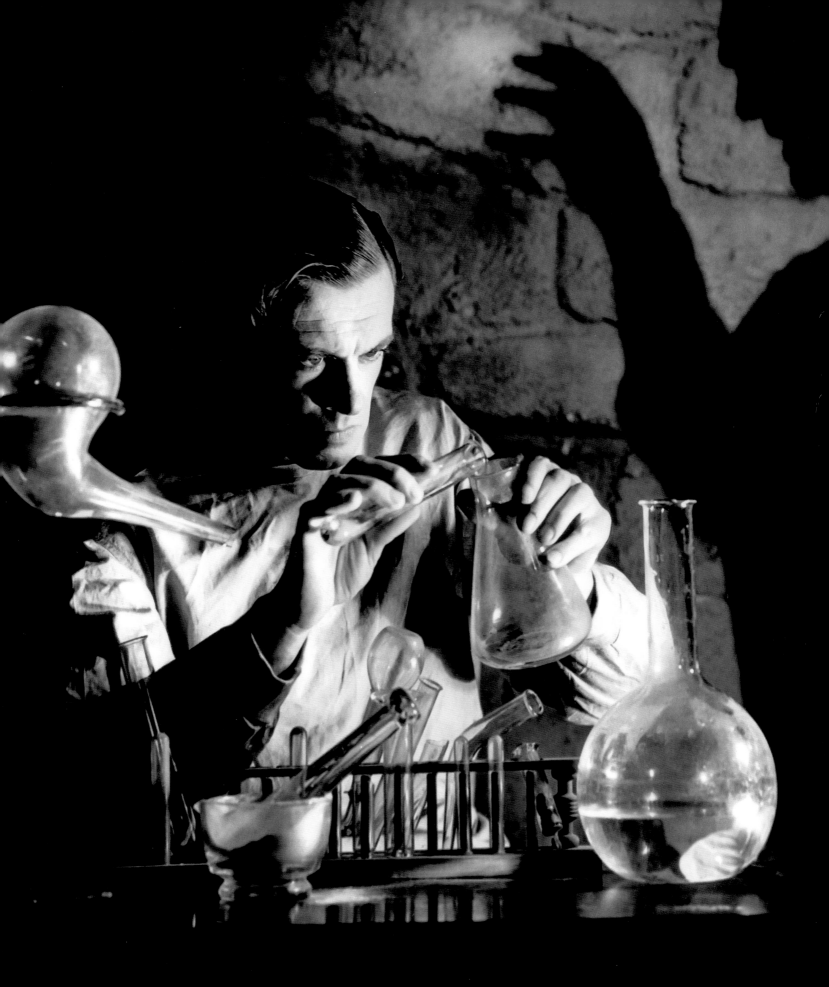

Frankenstein

The First Two Hundred Years

SIR CHRISTOPHER FRAYLING

REEL ART PRESS

The chemical or physical inventor is always Prometheus. There is no great invention, from fire to flying, which has not been hailed as an insult to some god. But if every physical and chemical invention is a blasphemy, every biological invention is a perversion. There is hardly one which, on first being brought to the notice of an observer from any nation which has not previously heard of their existence, would not appear to him as indecent and unnatural . . . I fancy that the sentimental interest attaching to Prometheus has unduly distracted our attention from the far more interesting figure of Daedalus . . . the first modern man . . . the first to demonstrate that the scientific worker is not concerned with gods.

J.B.S. Haldane: *Daedalus; or, Science and the Future* (Cambridge lecture, February 1923)

By the waters of Leman I sat down and wept.

T.S. Eliot: *The Waste Land* (1922)

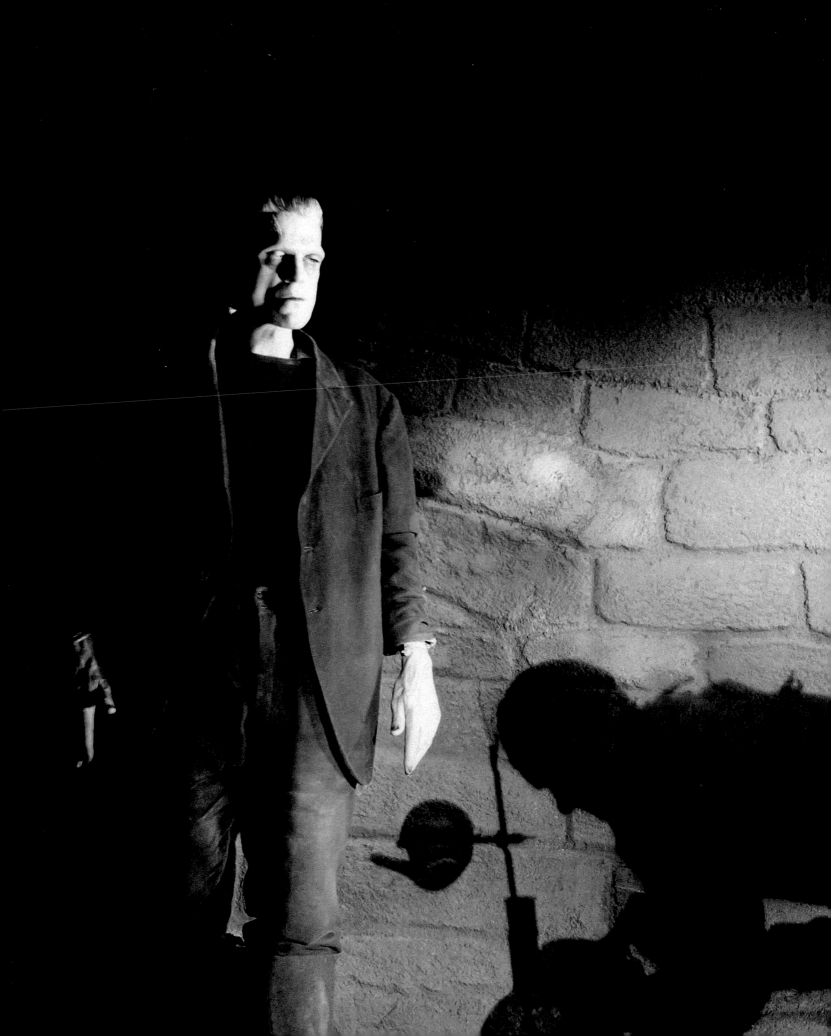

FRANKENSTEIN

Contents

The Story **11**

I.
'a wet, ungenial summer' **13**

II.
'Perhaps a corpse would be re-animated' **20**

III.
'We will each write a ghost story' **30**

IV.
'infusing life into an inanimate body' **60**

V.
'I bid my hideous progeny go forth and prosper' **76**

VI.
Frankenstein—a visual celebration **115**

VII.
Acknowledgements, Bibliography & Credits **204**

Frankenstein, or The Modern Prometheus

The Story

CAPTAIN ROBERT WALTON, an English explorer in the Arctic, takes the exhausted Genevan scientist Victor Frankenstein on board his ice-bound ship, and listens to his sad life story. Frankenstein, it transpires, has discovered the secret of giving life to dead tissue while researching medieval and modern chemistry at the University of Ingolstadt. After carefully assembling the various parts of a male human body—found in graveyards, dissecting rooms and slaughterhouses—he makes an eight-foot creature and gives him the spark of life; but the sight of the creature's 'watery eyes' causes Frankenstein to flee in a deep depression. The scientist tries hard to shut the blasphemous deed out of his mind, but the violent death of his little brother William (and subsequent, wrongful, execution of the family servant Justine Moritz for the murder) convinces him that the 'filthy daemon' is at large. They eventually meet on the Mer de Glace, in the Alps, and his creature tells of his rejection by all the people he has encountered, of his education in language, literature and emotion—by observing an impoverished family in a country cottage, and discovering a portmanteau full of books—and of his need for a female partner.

Victor Frankenstein at first agrees to create one for him, on condition the creature 'quits Europe forever'; and travels with his close friend Henry Clerval via the Rhine and Rotterdam to the remote north of Scotland in order to perform the operation. But he has second thoughts and aborts his female creature, causing the 'daemon' to threaten 'I will be with you on your wedding night' and to strangle Clerval (a crime for which Frankenstein himself is almost convicted). Despite the threat, Victor Frankenstein goes ahead and marries his cousin and childhood sweetheart Elizabeth Lavenza, and that night the creature murders her in the bridal bed. The scientist chases his creature across Europe and the Black Sea to the Frozen Ocean and the Arctic, where he dies of exhaustion after finishing his story with the words 'I have myself been blasted in these hopes, yet another may succeed.' The creature comes aboard, pays his last respects to his creator and floats on an ice-raft into the darkness. Captain Walton decides to abandon his explorations of 'the secret of the magnet', and of a navigable northwest passage—following pressure from his crew—and return home to England.

Detail from Swedish poster for **Frankenstein—The Man Who Made a Monster** (1931).

I.

'A wet, ungenial summer'

A FEW YEARS AGO, I was asked on a BBC radio programme 'If you could have been around on a single day in the historical past—which day would it have been?' I was Rector of the Royal College of Art at the time, so the producer had prompted me with some well-known art-related suggestions. Would it, perhaps, be the day when Michelangelo at last completed his fresco painting of the ceiling of the Sistine Chapel, in the Vatican, in 1512? Or the celebrated day in 1842 when the painter J.M.W. Turner lashed himself to the mast of a ship, pitching in a storm off Harwich, to prepare his masterpiece *Snow Storm—Steam-Boat off a Harbour's Mouth*, now in the Tate: did this actually happen—art historians were not sure, though Turner himself claimed that it did. You could, said the producer, actually find out for sure—you could time-travel to *be* there. Or the day in December 1888, when Vincent van Gogh lopped off his ear—or part of his ear maybe—in a moment of madness, in Arles. There was still much debate about what actually happened. Art history had no shortage of key days—colourful anecdotes—which had entered the popular imagination, distilling in strange ways the perception of both the artists and their art. Would I choose one of these days?

'No,' I replied. 'Not a day—I'd much prefer an evening and a night.' The night of June 17th/18th 1816 to be precise, when the eighteen-year-old Mary Godwin (later to become Mary Shelley) told the 'creation' scene from her *Frankenstein* as part of a family ghost-story session in a plush holiday villa overlooking the eastern shore of Lake Geneva, two miles outside the city—and when Lord Byron, the host

of the evening, began the first vampire story in modern literature. Byron was twenty-eight years old at the time, though he had recently, wearily, entered his age as one hundred in the guest register of the Hôtel d'Angleterre at Sécheron on the opposite shore of the Lake. The other contributors to the storytelling session or sessions were the poet Percy Shelley, aged twenty-four, although he looked older; Dr John William Polidori, Byron's travelling physician—and secret paid diarist—aged twenty; and Mary's volatile stepsister Clara Mary Jane Clairmont, who had since autumn 1814 decided to call herself first Clare, then Claire (derived from her first name), also aged eighteen, eight months younger than Mary. Percy and Mary's illegitimate infant son William—aged nearly four months—was being looked after in a nearby house, a smaller one about eight minutes' walk from the villa, at the Lake's edge, by a blonde rosy-cheeked Genevese nanny called Louise Duvillard known as Elise, who was twenty-one. Elise, too, was the mother of an illegitimate child, a daughter called Aimée who did not live with her.

From contemporary witnesses, the cast of main characters looked like this:

MARY GODWIN was small, plainly dressed, with notably pale skin and a high forehead, a wavy cloud of light-brown hair ('of sunny and burnished brightness', wrote Claire), brilliant hazel eyes which often gave attentive sideways glances (she was called 'the nymph of the sidelong looks'), sedate bearing, and she was formidably well-read, not just for her age, mainly from her father's extensive

Reputed to be Mary Godwin at age eighteen, copied from a miniature painted in Geneva, summer 1816.

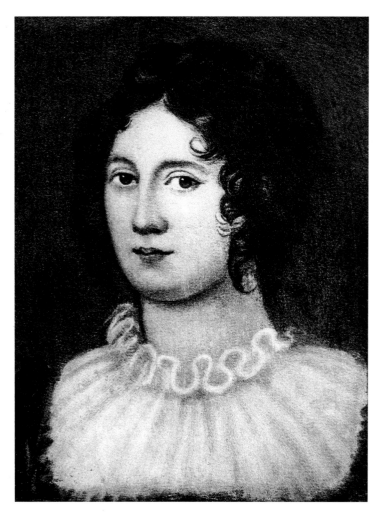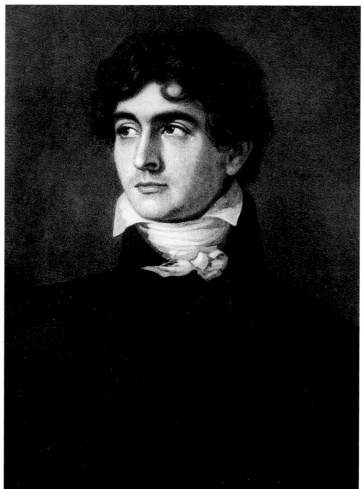

library. She was quick on the uptake, serious, impressionable and occasionally depressive, or 'melancholic' as it was then called. Her mother Mary Wollstonecraft had died at the age of thirty-eight, from complications of puerperal fever, eleven days after her birth, and she had learned to read by spelling out the letters on her mother's gravestone in St Pancras cemetery. From an early age, she had been proudly shown off to visitors as a potential Mary Wollstonecraft. She had deep affection for her father William Godwin, who had stopped communicating with her since the end of July 1814 because he did not approve of her liaison and elopement with Shelley. She was sixteen years old when she eloped. Godwin had written of her, at an early age: 'She is singularly bold, somewhat imperious, and active of mind. Her desire of knowledge is great, and her perseverance in everything she undertakes almost invincible.' Mary Godwin tended to bury herself in hard work, and routine, when faced with difficult challenges.

PERCY SHELLEY, according to the *Table Talk* of essayist William Hazlitt, '. . . has fire in his eye, a fever in his blood, a maggot in his brain, a hectic flutter in his speech, which mark out the philosophic fanatic'. He was noted for his brown curls, red face, shrill voice, sensual mouth, very prominent blue eyes, and thin, gangling, priest-like figure. In summer 1816, as a *writer* he was known (if at all) for a couple of badly received poems—though admired by a small circle of radical intellectuals. The son of a well-to-do Sussex baronet, Claire Clairmont later recalled of him: 'The beholder saw he was beautiful, but could not discover in what it consisted'.

Although GEORGE GORDON, SIXTH BARON BYRON was often called a 'pretty boy' or 'curled darling'—five foot eight inches, alabaster skin, dark curly hair, blue eyes fringed with dark lashes, famously white teeth revealed by a seductive smile—he had constantly to use diets and purgatives to control his fluctuating weight. In summer 1816, he had managed to reduce his bulk to ten stone. He was, in fact, one of the first celebrities to share his diet with the reading public. He also wore an iron leg-brace, since the calf muscles on his left leg had failed to develop properly, and his foot turned inwards. By summer 1816, he was a bestselling celebrity author—*Childe Harold's Pilgrimage*, *The Corsair*—with a reputation for sexual adventures. Lord Byron tended to mask his deeper feelings—in public—with arrogance and

ABOVE: (left) Claire Clairmont in 1819, the only known portrait, by Amelia Curran; (right) Dr. John Polidori in 1816 by F.G. Gainsford.
OPPOSITE: Romantic print of windswept Lord Byron, with boat and servant, based on a painting by George Sanders (1808).

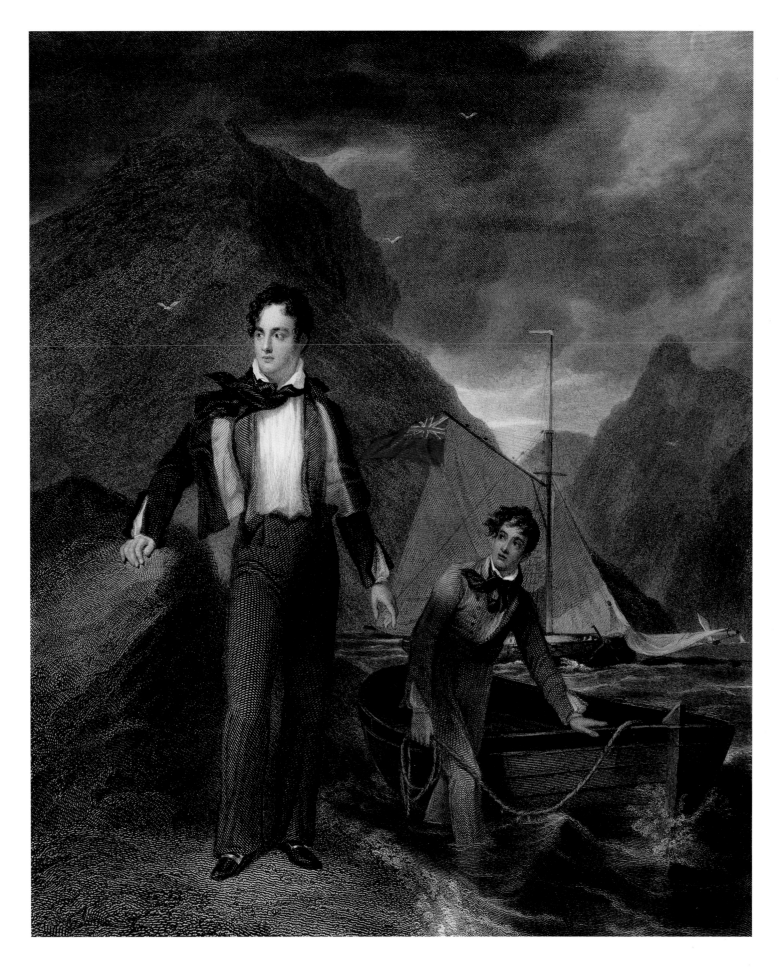

good lines. He was devastated by the recent break-up of his marriage to Annabella Milbanke.

DR JOHN WILLIAM POLIDORI was described by Harriet Martineau as a clever 'handsome, harum-scarum young man' and by Thomas Medwin—a Shelley cousin and later biographer—as 'a tall [six foot], handsome man with a marked Italian cast of countenance, which bore the impress of profound melancholy . . . more retiring than forward in society'. Byron thought him 'irresistible'—to start with, anyway—and Polidori enjoyed being mistaken for his employer on more than one occasion. Although a brilliant young doctor, he yearned to be taken seriously as a writer.

CLAIRE CLAIRMONT had—to judge by the only surviving portrait of her, made in 1819—dark curly hair framing a small plump face, dark eyes, a high colour and sullen expression, and a gypsy look. She was impulsive and volatile, and had a fine singing voice. Byron called her 'that odd-headed girl'. It was her mixture of persistence and deference that had led to a brief liaison with Byron—who accepted her 'by way of novelty' and who would in September 1816 confess to his half-sister:

—don't scold—but what could I do?—a foolish girl—in spite of all I could say or do—would come after me—or rather went before me—for I found her here [in Geneva] . . . I am not in love—but I could not exactly play the Stoic with a woman—who had scrambled eight hundred miles to unphilosophize me . . .

Claire was easily scared, like a child, and interestingly vulnerable. Later in life, she would much regret her involvement in the experimental goings-on in the Villa, and in old age wrote 'I was young and vain and poor'. Mary Godwin thought that the 'Clairmont style' was wild and out of control.

The ghost-story session of June 17th/18th was like a family bet, in a playful spirit, a chance to improve on some run-of-the-mill tales they had been reading—from a holiday book, bought in Geneva—a time to enjoy together the tempestuous loveliness of terror, the aesthetic thrill of the 'sublime' as it was known. To enjoy the special pleasure of frightening each other, and exploring heightened mental states. Percy Shelley was especially fond of doing this—often at the expense of the nervy and teasible Claire, who on an earlier occasion had thought the furniture and bedclothes were moving about of their own accord: or was she just seeking attention? Mary put such hallucinations down as 'Jane's horrors'.

Mary Godwin certainly succeeded in being 'aweful' that evening, as did Lord Byron before he became bored with the whole business, which was soon. It was the night before the first anniversary of the Battle of Waterloo—June 18th 1816—but, despite Byron's well-known and longstanding passion for most things Napoleonic, and despite his recent pilgrimage to the battlefield, they were not talking about Waterloo that night. Far from it.

The weather was terrible in June 1816: it has become known as 'the year without a summer' or 'the blood-red summer', the coldest ever recorded before or since. The fields and rivers surrounding the Lake were flooded, the rivers had burst their banks, the local harvest was ruined, snow lay until late May, parts of the city of Geneva were under water, the Genevese were still stoking their fires in June, the fowls all went to roost at noon—and there were some spectacular electrical storms to be seen over the Lake. This was frustrating for Byron and Shelley, who wanted to sail and row in the keelboat they had jointly purchased as often as they could, but it was also inspiring. Byron wrote in his bleak, futuristic poem *Darkness* dated July 1816 (which Claire happily transcribed for him):

I had a dream, which was not all a dream.
The bright sun was extinguish'd, and the stars
Did wander darkling in the eternal space,
Rayless, and pathless, and the icy earth
Swung blind and blackening in the moonless air;
Morn came and went—and came, and brought no day . . .

Mary Shelley later called the months of June and July 1816 a 'wet, ungenial summer'. On the first day of June, she had written in a letter, a rather formal letter which she had evidently revised for publication, from the lakeside house with little harbour the Shelleys had begun to rent:

Unfortunately we do not now enjoy those brilliant skies that hailed us on our first arrival to this country [on May 13th]. An almost perpetual rain confines us principally to the house; but when the sun bursts forth it is with a splendour and heat unknown in England. The thunderstorms that visit us are grander and more terrific than I have ever seen before. We watch them as they approach from the opposite side of the lake, observing the lightning play among the clouds in various parts of the heavens, and dart in jagged figures upon the piny heights of Jura, dark with the shadow of the overhanging cloud while perhaps the sun is shining cheerily upwards. One night we enjoyed a finer storm than I had ever before beheld. The lake was lit up—the pines on Jura made visible, and all the scene illuminated for an instant, when a pitchy blackness succeeded, and the thunder came in frightful bursts over our heads amid the darkness.

Her vivid description was to find its way into *Frankenstein*, when the young scientist Victor returns home in a storm to Geneva from his university at Ingolstadt. And the lightning encouraged the poets to talk about electricity. And the spark of creativity.

Lord Byron, in the Third Canto of his poetic/heroic narrative *Childe Harold's Pilgrimage*—which he started writing early in May 1816 as he crossed Europe—also described, in characteristic style, one of these thunderstorms which happened on June 13th ('at midnight . . . none more beautiful'), and which he had watched alone while standing on the iron balcony surrounding the rented villa. That gave him a ringside view; he also enjoyed sailing out into the middle of the Lake, at night, dressed only in his shirt, to experience the extreme

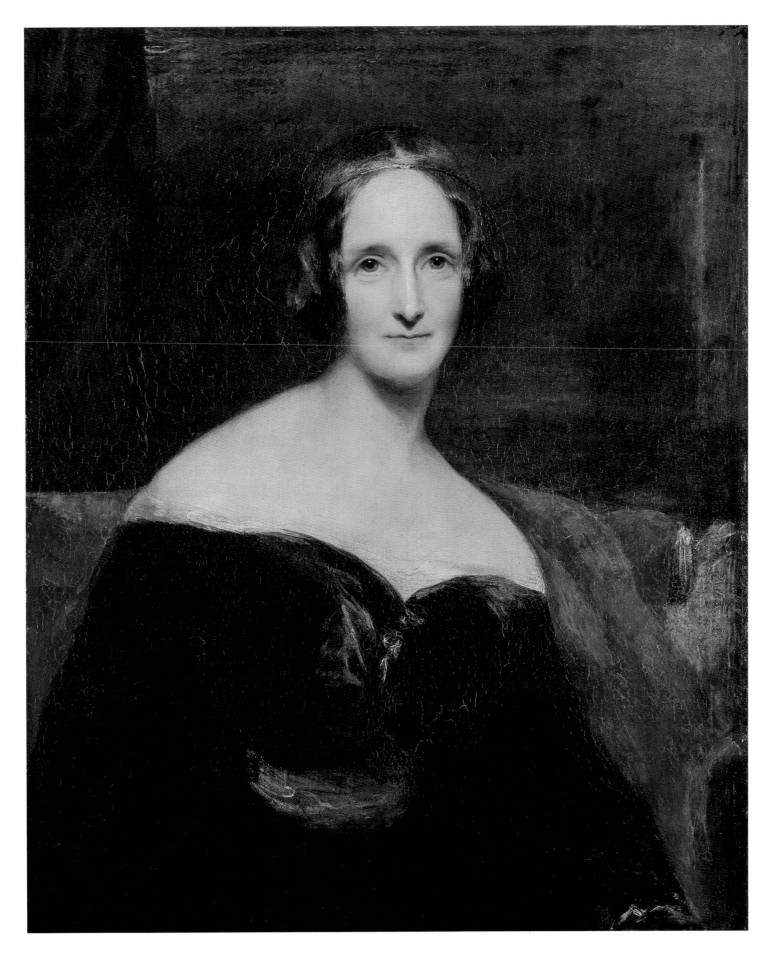

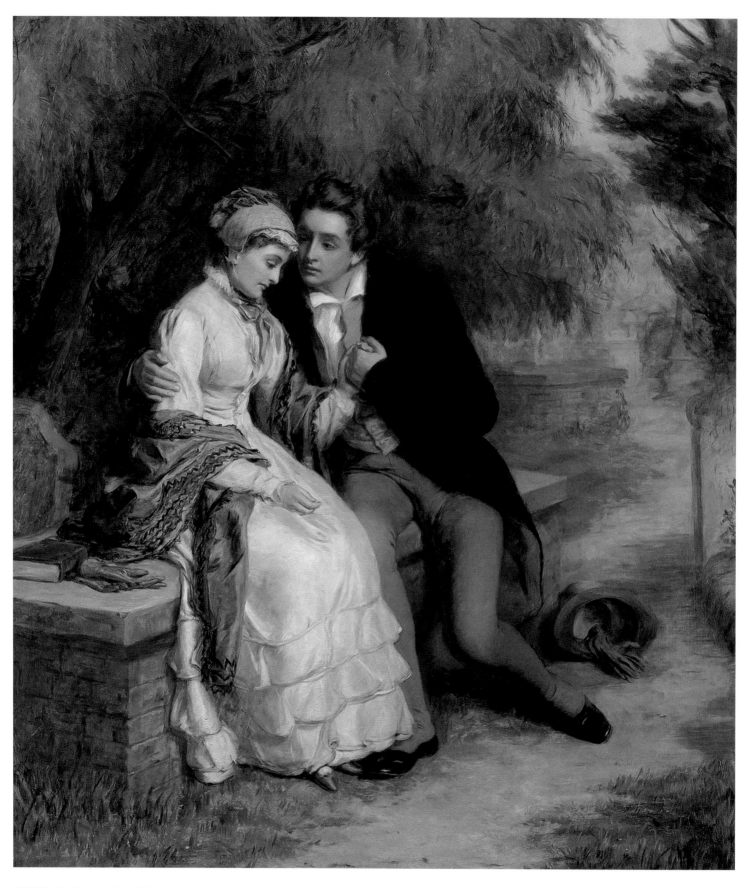

ABOVE: **The Lovers' Seat: Shelley and Mary Godwin in Old St. Pancras Churchyard,** *idealised painting by W.P. Frith (1877): Frith confessed to being a 'worshipper' of Shelley. OPPOSITE: (left) Lord Byron in 1814, portrait of a melancholy, pouting celebrity author at work, by Thomas Phillips; (right) Percy Shelley in 1819—the most famous, and much adapted, portrait by Amelia Curran.*

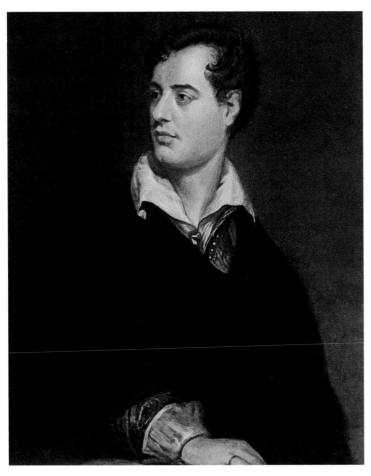

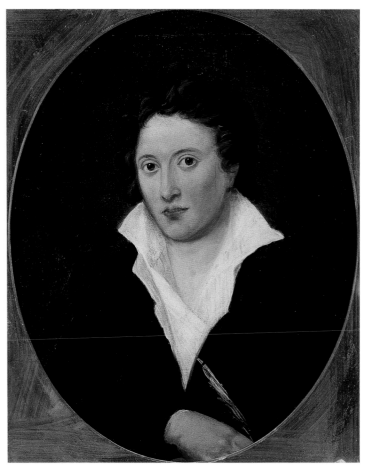

weather full-on. On one occasion, a rescue mission was prepared from the shore, until he shouted from the boat that he did *not* wish to be saved:

<div align="center">

XCII

The sky is changed!—and such a change! Oh night
And storm, and darkness, ye are wondrous strong,
Yet lovely in your strength, as is the light
Of a dark eye in woman! Far along,
From peak to peak, the rattling crags among
Leaps the live thunder! Not from one lone cloud,
But every mountain now hath found a tongue,
And Jura answers, through her misty shroud,
Back to the joyous Alps, who call to her aloud!

</div>

This storm and stress, he added in XCVIII, and the confinement it necessitated, could help them all to:

<div align="center">

. . . find room
And food for meditation, nor pass by
Much, that may give us pause, if ponder'd fittingly.

</div>

It now seems that the extreme weather was all to do with a volcanic event which had taken place on the other side of the world—the eruption of Mount Tambora, on the island of Sumbawa in what is now Indonesia, an eruption which produced more atmospheric dust than had ever been recorded before and which led several writers in Western Europe to question the existence of a benign providence.

The sublime was one thing; this was manifestly destructive. *The Times* newspaper, when commenting on the weather of summer 1816, referred to 'God's wrath', and the two poets in Geneva used the opportunity to react against sentimental, misty-eyed views of the landscape with their more exact and detailed descriptions of this volcanic veil over the earth. There were heated discussions—between the poets on board the sailing-boat *La Voile* and back at the Villa—about 'the manner and cast of thinking of Mr Wordsworth' and *Tintern Abbey* in particular; Shelley in favour of his rhapsodies, Byron not so sure.

So in mid-June, they were cooped up indoors. 'The season was cold and rainy,' wrote Percy Shelley in early September 1817, 'and in the evenings we crowded around a blazing wood fire.' Like many British tourists abroad, they groused about the weather. The walled city of Geneva closed its gates at 10 p.m. sharp; there was no possibility of nightlife there. As Mary Godwin noted of the city's walls: 'no bribery (as in France) can open them'. Dr Polidori enjoyed socialising and dining with local worthies, even though he sometimes admitted to feeling out of place when he was in their company—he went out on June 12th and June 13th ('walked home in thunder and lightning: lost my way . . . slept at the Balance'). But Lord Byron, after an initial flurry of social activity, preferred to stay in. He resented it when Dr Polidori invited some of his Genevan dinner-hosts back to the Villa without permission.

II.

'Perhaps a corpse would be re-animated'

THERE was much talk about science, or natural philosophy as it was known, as the electric storms raged outside. Percy Shelley had been fascinated by chemistry ever since his student days at Oxford in 1810–11, where he had even tried on one occasion to re-animate a dead cat. His undergraduate friend Thomas Jefferson Hogg was to recall visiting Shelley's chaotic rooms: 'An electrical machine, an air-pump, the galvanic trough, the solar microscope, and large glass jars and receivers'—which the young Percy proceeded to demonstrate while discoursing in double-quick time on 'the marvellous powers of electricity, of thunder and lightning, describing an electrical kite he had made at home . . .' Not to mention the piles of books strewn everywhere: philosophy, magic, poetry, German horror novels.

Dr Polidori had graduated in medicine from the University of Edinburgh at the very early age of nineteen (the average at the time was twenty-five) with a thesis in Latin on *Dreams and Sleepwalking* which had been highly commended by his examiners: while at Edinburgh, he had encountered the latest theories of galvanism by Dr Charles Henry Wilkinson, who had published *Elements of Galvanism* in 1804. Mary Godwin grew up in a household where, when she was in her early teens, eminent chemists and physicians were routinely invited to dine with her father William. She had met Humphry Davy, for instance, and had attended his charismatic lectures at the Royal Institution in 1812 at the age of fourteen. She had been taken by her father, as a child, to see the very first successful parachute landing in England when André-Jacques Garnerin jumped off a balloon and reached the ground just behind what was to become St Pancras railway station. And the pioneering work of the Garnerin brothers must have stayed with her, for over ten years later, on December 14th 1814, she noted in her *Journal*, which was shared with Percy:

> . . . go to Garnerin's lecture—on Electricity—the gasses—and
> the Phantasmagoria—when return at half past nine Shelley
> goes to sleep.
> *Thursday 29th*
> . . . in the evening S and Clary [Claire] go to Garnerin's lecture
> . . . S and C return a little before tea—there was no lecture
> tonight.

The Phantasmagoria was a mixture of magic lantern slides, optical illusions, and—as a climax—spectacular displays of electricity. Garnerin's public performances would sometimes include, as a *pièce de résistance*, making an electric current flow through members of the audience as they held hands.

On June 15th 1816, according to Dr Polidori's *Diary*, 'Shelley and

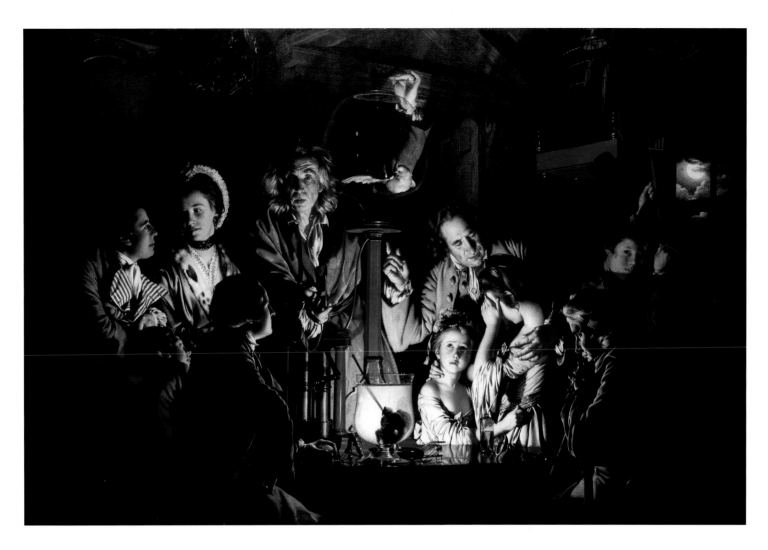

I [Polidori] had a conversation about principles—whether man was thought merely an instrument'. Much later, in mid-October 1831, Mary Shelley was to recall—perhaps of that same conversation, perhaps of one which took place on the following night, June 16th:

Many and long were the conversations between Lord Byron and Shelley, to which I was a devout but nearly silent listener. During one of these, various philosophical doctrines were discussed, and among others the nature of the principle of life, and whether there was any probability of its ever being discovered and communicated . . .

She did tend, in her reminiscences, to sideline and patronise Dr Polidori, who by then was no longer around to reply. She also tended to sanctify her late husband Percy Shelley. It is more than likely that Polidori took an important part in the conversation or conversations. They were doubtless about a debate known as the 'vitalism' controversy which was rocking the Royal College of Surgeons at the time—through rival series of public lectures about the chemistry of life. This debate was in essence between the spiritual on the one hand and the biological or physiological on the other; it was about the very origins and nature of life. Where did the 'vital spark' of life actually originate from—from God or from biology or rather from parents? What of the soul? And what happened to the soul after death? It was a heated Richard Dawkins-versus-intelligent-design-style debate, which had gone public in 1816, and the champion of the biological argument, the radical consultant surgeon and medical author William Lawrence, had been Percy Shelley's own doctor since a health scare in summer 1815—and had attended Mary Godwin, at her father's request, since May 1812. It was Lawrence who introduced the word 'biologist' to the English language. His opponent in the debate was the more staid John Abernethy FRS, the Professor of Anatomy and Surgery at the College, who had been Lawrence's mentor and tutor. Abernethy's view, according to a contemporary witness, was that: 'Life, in general, is *some* principle of activity added by the will of Omnipotence to organised structure—and that, in man, who is endowed with an intelligent faculty in addition to this vital principle possessed by other organized beings, to life and structure an immaterial *soul* is superadded.' So 'the will of Omnipotence' and the

Joseph Wright of Derby's 1768 painting, **An Experiment on a Bird in the Air Pump**: *note the expressions on the children's faces, consoled by their father, as the bird is deprived of air. The young Victor Frankenstein's 'utmost wonder was engaged by some experiments on an air pump'.*

'immaterial soul' were what animated the organised structure of the human body. Lawrence's reply, paraphrased, was that:

> . . . *the principle of life, whether sentient or intelligent, is in all organized beings the same: that, whether we look to man, the highest of the animal creation, with all his faculties of invention, memory, imagination, or to an oyster . . . the vital properties are all derived from their organic structure, and that the difference of this bodily structure constitutes the only difference in their faculties and powers.*

> . . . *Mr Lawrence considers that man . . . is nothing more than an orang-utang or an ape with 'more ample cerebral hemispheres' . . . [He] strives with all his powers to prove that men have no souls!*

Summarising this debate in his anonymous *Preface* to his wife's *Frankenstein*, written (as by the author) a year later, Percy Shelley was to recall:

> *The event on which this fiction is founded has been supposed, by Dr Darwin, and some of the physiological writers of Germany, as not of impossible occurrence . . . The event on which the interest of the story depends is exempt from the disadvantages of a mere tale of spectres and enchantment . . . I have thus endeavoured to preserve the truth of the elementary principles of human nature, while I have not scrupled to innovate upon their combinations . . . The circumstance on which my story rests was suggested in casual conversation. It was commenced, partly as a source of amusement, and partly as an expedient for exercising any untried resources of mind.*

In short, because *Frankenstein* was based on a real scientific debate—and explored the possibilities from this starting-point—it was of a different genre to 'mere' tales of the supernatural: a new kind of literary fiction, one which fused serious philosophical musings—'moral tendencies' within the characters—with an exciting story.

Lawrence's controversial thesis had been launched in the second of his two lectures *An Introduction to Comparative Anatomy and Physiology* given at the Royal College of Surgeons in London, on 21st and 25th March 1816, and published in book form in June 1816. He had recently been appointed the *second* Professor at the Royal College, and in time-honoured fashion, the apprentice immediately sought to provoke and challenge the sorcerer. Lawrence's thesis was an explicit reply to two Anatomical lectures given by John Abernethy. Both sides of the (by then) three-year argument within the established field of chemical physiology were summarised in the Tory *Quarterly Review* in July 1819—in terms which were very similar to Shelley's *Preface*, although the conclusions were of course radically different. Lawrence had published an even more radical version of his ideas in 1819. He had transcribed many of them—claimed the reviewer George D'Oyly—from 'the free-thinking physiologists of Germany' under the influence of J.F. Blumenbach of Göttingen, a dyed-in-the-wool materialist; further, Lawrence had approached the discipline of comparative anatomy 'through the medium of foreign, for the most part German, writers and professors'; and he owed more than he admitted to 'Dr. Darwin—who carried the hypothesis still further'. It was Blumenbach who had coined the catchy phrase: 'man is the most perfect of domesticated animals'. Lawrence had, the review article continued, overreached the boundaries of his own specialist discipline, and recklessly strayed into theological matters by denying the existence of 'the soul', by 'comparing brute animals and man', by confusing intelligence and creativity with mere vitality, and by arguing that the story of Adam and Eve in the Garden of Eden had an 'allegorical figurative character' and was not to be taken literally: if we were *not* descended from Adam, and if we had no soul, then we also lacked original sin and the need to be saved . . . unthinkable. Above all, he had corrupted the minds of impressionable young medical students in the lecture theatre, 'many of whom are obliged to enter on the peculiar studies of their profession with little or no general education, and are, consequently, not likely to have any principles of morality and religion steadily fixed in their minds'. Even the sceptical Voltaire had had the good sense to 'check his company before repeating blasphemous impieties before the servants, lest—said he—they should cut all our throats'. By delivering these lectures under the sanction of the Royal College of Surgeons, and by challenging his esteemed former patron, Lawrence had 'seriously injured himself in the opinion of the more respectable part of his profession'. He had even made reference to in-breeding and incest, among other unsayables, which had implications for the royal family . . . Dr Polidori would certainly have known about Lawrence's Introductory Lectures—he may even have attended them—as would the Godwin circle. Percy Shelley, with his enthusiasm for iconoclastic ideas, and his atheism, would also have been intrigued. The *Quarterly Review* article gives a clear idea of the terms in which the debate quickly entered the public domain. Actually, Lawrence had *not* denied the existence of the soul, but had argued it must surely be part of the body.

In Mary Shelley's novel, Victor Frankenstein studies at Ingolstadt in Germany (founded 1472), where his mind is enflamed by a course of lectures by a radical scientist, and where he manages to create a sentient being without the aid of any 'divine spark'. Other memories of Germany may also have been unlocked by those conversations about 'principles—whether man was thought merely an instrument'. Mary had travelled down the Rhine two years before, August–September 1814, in the cheapest possible form of transport, a slow-moving public boat, when returning from her impetuous elopement with Percy Shelley to France and Switzerland. Jane Clairmont had tagged along with them, mainly—she thought—because she could speak French and they couldn't. They had all run away, just one month after Percy and Mary fell in love. Their money had run out, and they would have much preferred to observe the romantic excitements of the river from the relative comfort of a private coach. They were depressed about going back to the distracting complexities of life in London—Shelley's wife Harriet, Mary's father William who had refused to speak or communicate with her ever since her decision to elope, Shelley's stick-in-the-mud aristocratic family in rural Sussex, the tactless and troublemaking second Mrs Godwin, Mary Jane

'Clairmont', who had spread the story that Godwin had sold the two girls to Shelley for £1500, gossip and scandal and bad reviews in the Tory press—and they did not much like the monstrous, vulgar company they were keeping on that public boat either . . . Their state of mind coloured everything they saw. They were feeling scared and secretive. Mary was later to pride herself on the fact that she was:

. . . nearly the first English person, who many years ago made a wild venturous voyage, since called hackneyed—when in an open flat-bottomed sort of barge we were borne down the rapid stream . . . and what uncouth animals were with us, forming a fearful contrast between their drunken brutalities and the scene of enchantment around.

The latter was a disgruntled observation she had made at the time, in her *Journal*, too: only in late August 1814 she added: 'Twere easier for god to make entirely new men than attempt to purify such monsters as these . . . loathsome creepers.' God with a small g. The heat, the food, the midges and the behaviour of the 'uncleansable animals' who accompanied them—especially two inebriated students from Strassburg University—seem seriously to have got on her nerves. Evidently, 'the Rhine experience' was spoiled by *people*. 'Our only wish was to absolutely annihilate such uncleansable animals.'

Percy and Mary described the *scenery*, though, as if it had come straight out of the paintings of Caspar David Friedrich—all ruined towers, plunging ravines and river sunsets. So did Jane Clairmont, when she wrote 'Ruined castles are here very numerous and many most romantically situated . . . I think we passed no less than twenty castles . . .'

As Mary Shelley was to recollect the experience through twilight-tinted spectacles:

Each tower-crowned hill—each picturesque ruin—each shadowy ravine and beetling precipice—was passed and gazed upon with eager curiosity and delight. The very names are the titles of volumes of romance; all the spirits of Old Germany haunt the place . . .

One of these names was an unusual one: Frankenstein. On the last leg of their journey which took them from Mannheim to Mainz (September 2nd–3rd), they looked in at the town of Gernsheim. And from there—looking east and upwards towards the northern foothills of Magnetberg—they could see the outer tower and bridge tower of Castle Frankenstein. Mary and Percy went for a 'walk for three hours' around the region, by themselves rather than with Mary Jane. They could not possibly have reached the Castle from the mooring in that time (I've tried it), but they could certainly have gazed from a distance upon its ruined walls and fortifications—constructed in their original form in the 1250s—with their 'usual eager curiosity and delight'. And they could well have heard about some of the local folk tales. The castle was not a grand medieval construction: it had domesticated turrets, a wood-and-brick structure with half-timbering, and it resembled a fortified *schloss* rather than a fully-blown Gothic castle. But it had a terrific name, meaning 'castle or rock of the Franks', and a legend associated with it—the legend of the alchemist

and necromancer Johann Konrad Dippel, who was born a refugee in the castle in 1673 (and thus signed himself 'Frankensteiner'). Dippel, it was said, had even experimented with a life-giving mixture of blood and bone, distilled from animal and human bodies stolen from graveyards and slaughterhouses. In the forest behind the castle, there was reputed to be a 'fountain of youth', and the rocks were naturally magnetic: compasses pointed towards them. Neither Mary Godwin nor Percy Shelley mentions the castle or its legendary resident. But they could well have seen it, and Mary at least could equally well have recollected the name. In her forties, she wrote that she would dearly like to spend a summer back in the region—with its memories of the first days of young love: and 'to hear *still more* of its legends'. Still more than the legend of Castle Frankenstein?

It was earlier on the same trip, while sitting by the shore of Lake Lucerne, that Mary Godwin had been introduced by Percy Shelley to a history by the Abbé Barruel of the French Revolutionary movement Jacobinism, 'the monster called Jacobin', which—the book argued—originated in a secret conspiracy hatched at Ingolstadt in Upper Bavaria, on the Danube: Ingolstadt as the crucible of dangerous, radical Enlightenment ideas as well as physiological research. This was a fashionable, post-Revolutionary conspiracy theory. The old Anatomy Building of the University of Ingolstadt still stands, now a museum of medicine.

Percy Shelley coupled 'Dr. Darwin'—with his ideas about the artificial generation of life—and 'some of the physiological writers of Germany'. Mary Shelley, in *her* Introduction written some fifteen years later, also remembered that the poet-botanist-physician Erasmus Darwin was one of the scientific figures discussed in those 'conversations', the only named one:

They talked of the experiments of Dr. Darwin, (I speak not of what the Doctor really did, or said that he did, but, as more to my purpose, of what was then spoken of as having been done by him,) who preserved a piece of vermicelli in a glass case, till by some extraordinary means it began to move with voluntary motion. Not thus, after all, would life be given . . .

Darwin had speculated about the (almost) evolutionary journey 'from microscopic specks in primeval seas to its present culmination in man', a theory which would be developed some sixty years later by his grandson Charles. And he had invented—to put over some of his proto-evolutionary theories—what he called a 'factitious spider' which walked around on a metal salver, by means of rotating magnets hidden beneath, and an artificial bird with flapping wings propelled by a bottle of compressed air, as forms of artificial life. Mary Shelley's strange reference to a 'piece of vermicelli in a glass case', though—which sounds like the window display of an Italian restaurant—seems to have been based on a confused reading of a footnote in Erasmus Darwin's *The Temple of Nature* (published 1802). In this footnote, there was a mention of vorticellae, or wheel animals/protozoans, which lived in gutters but were thought spontaneously to regenerate themselves in dry conditions; and a mention in the same note of 'a paste composed

of flour and water', in which tiny dead eels could apparently revive, even in a glass phial, 'with some degree of vitality'—another example of spontaneous generation. Flour and water—and vorticellae—became in Mary Shelley's version 'vermicelli'. Whether the error was hers—or the poets' who were discussing the experiment—is not known. The idea of re-animated pasta is about the only aspect of *Frankenstein* which has not yet been adapted into a film. Mary Godwin had read most of Erasmus Darwin's poetical works about the sex-life of plants, with their fascinating footnotes: and Darwin had dined with Mary Wollstonecraft.

Where Dr Darwin's spider was concerned, some of the more extreme thinkers of the French Enlightenment had written of human beings as merely soft machines, or meat puppets—in works such as the 'materialist' La Mettrie's *L'homme machine* (1747)—'thrown down by chance at a given point on the earth's surface' by God-the-clockmaker. And this had led to explorations of whether the behaviour of living beings could be simulated by artificial means, which in the mid-eighteenth century meant mechanical devices. One of the most celebrated of these was Jacques de Vaucanson's gilded copper digesting duck (1738), which caused a sensation by quacking, flapping its wings, drinking, extending its neck to be fed, digesting grain and apparently excreting the results from within its artificial digestive system. Actually, the duck was excreting a mixture of breadcrumbs and green dye, hidden in a secret compartment, which apparently passed muster as duck-poo. Even Voltaire was taken in, styling Vaucanson 'a rival to Prometheus'. Among the most advanced of these automata were three from the workshop of Neuchâtel clockmaker, mechanic and theology graduate Pierre Jaquet-Droz and his son Henri-Louis. The first of these to be made—called 'The Scribe' (1769)—represented a small child, sitting on a Louis XV-style stool: his right hand held a goose-quill pen, which he dipped into an inkwell and carefully wrote *Les automates Jaquet Droz à neuchatel* or *Jaquet Droz mon Inventeur* while his glass eyes followed the tracing of each letter. The Scribe's *pièce de résistance*, which raised most of the big issues in the 'man as machine' debate, was the phrase *Je pense donc Je suis*. 'I think, therefore I am'.

The second, made in 1774, was 'The Draughtsman', another small child who drew a pencil portrait of Louis XV or alternatively a cartoon of a dog called 'Mon Toutou' while holding down the paper with his right hand and blowing away the excess lead powder with his breath.

The third, which was considerably larger, was 'The Musician'—a teenage girl in a brocade dress which/who played a selection of Henri-Louis' compositions on a pipe organ in the shape of a wooden harpsichord. Unlike less complex robots, she really *did* touch the keys to produce the notes and, at the end of each piece, gave what seems like a self-satisfied sidelong glance at the audience with her glass eyes. She was powered by a clockwork mechanism and bellows in her chest.

All three automata—in full working order—are now in the Musée d'Art et d'Histoire de la Ville de Neuchâtel.

Percy Shelley and Mary Godwin may have seen them when they visited 'Neufchatel' on August 19th–21st 1814, although if they did they made no mention of the fact in their *Journal*. Or they may have read about these 'mechanical puppets' whose performances were widely reviewed in the press. German Romantic writers such as E.T.A. Hoffman were, in 1815–16, just beginning to exploit the imaginative possibilities of automata—as outward projections of inner states of mind, as obsessions. For example, Hoffman's *The Sandman*, written in 1815 and published a year later, told the story of Dr Coppelius, Professor Spalanzani and the divine Olympia—who 'played the piano with great accomplishment', 'performed a bravura aria in an almost piercingly clear, bell-like voice' and danced like an angel. The hero's fellow students, however, notice something rather odd about her:

She might be called beautiful if her eyes were not so completely lifeless, I would even say sightless. She walks with a curiously measured gait; every movement seems as if controlled by clockwork. When she plays and sings it is with the unpleasant soulless regularity of a machine and she dances in the same way . . . it seems to us that she is only acting like a living creature.

It is the eyes which give her away—just as it is the 'watery eyes' of Frankenstein's creature which seem so very horrid to the young scientist, contrasting with bodily features which he has selected as proportional and beautiful. Dead behind the eyes . . . or so he thinks.

Mary Godwin also had classical literature/myth in her mind. One of the books she read as she was preparing *Frankenstein* was Madame de Genlis's *Nouveaux contes moraux, et nouvelles historiques* (1802), which included a dramatic version of Pygmalion and Galatea: a beautiful sculpture is animated into life—and, pure and untainted as she is, discovers what a nasty place the world can sometimes be. And then there was *Prometheus Bound* by Aeschylus ('Prometheus of Eschylus—Greek') which she read in the original in 1816, and 'Ovid's Metamorphosis in Latin' (Book One), with its classic account of the Prometheus myth, which she had read the previous autumn. The very name 'Prometheus' meant 'to think ahead', to speculate, to *design*. That summer in Geneva, she no doubt heard the two poets discussing the Prometheus myth or myths, as they debated their relevance to the modern world. The myth took two main forms: the Greek version, which has the young Titan, Uranus's grandson, stealing fire from the gods and being punished for it; and the Latin version, which has him 'metamorphosing' clay from the plain of Boestia into man: creating first a man and then a woman, just like Victor Frankenstein. The poets were drawn to the Greek version, Mary to the Latin. Percy Shelley in fact translated the Aeschylus for Byron, as he prepared his own *Prometheus*. Mary had recently read Edmund Spenser's *The Faerie Queene*, which included in Book 2, Canto X:

> *Prometheus did create*
> *A man, of many parts*
> *from beasts derived.*

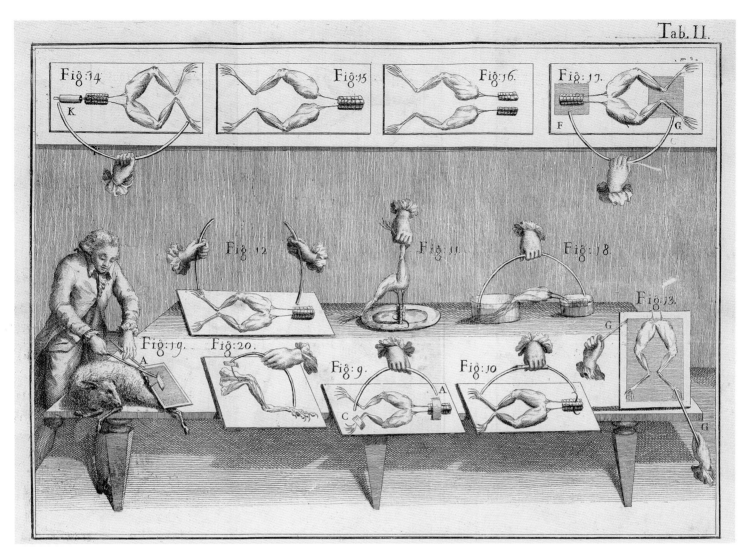

Tab. II.

But the creature of Mary Godwin's imagination was no sculpture or automaton. He was an organism pieced together from 'materials' found in graveyards, charnel-houses, slaughterhouses and dissecting rooms—a piece of biological rather than mechanical engineering. There are animal as well as human elements in his structure—which is how he becomes a little larger than life, 'about eight feet in height, and proportionably large', and why he is so agile leaping over Alpine rocks. The experiments involve not just human body-parts, but the torture of living animals as well. And, most disturbingly as we'll see, the resulting creature has the full range of human feelings and emotions. After her reference to Dr Darwin and his vermicelli, in her *Introduction* of 1831 Mary Shelley added:

Perhaps a corpse would be re-animated; galvanism had given token of such things: perhaps the component parts of a creature might be manufactured, brought together, and endued with vital warmth.

The German physiologist Johann Wilhelm Ritter, then at Jena University in Prussia, had said almost the same thing at the turn of the century: 'Galvanic phenomena seem to bridge the gap between living and non-living matter'. He was involved in galvanic experiments on animals, by wiring up a giant voltaic battery to dead creatures. When such experiments were outlawed by the Prussian government, he moved to the Bavarian Academy of Sciences in Munich, 1804. When he made *his* assertion about 'Galvanic phenomena', there was much debate in the scientific community about the relative claims of 'animal electricity' and 'contact theory'. 'Animal electricity' emerged as an idea in 1791 when Ritter's Italian counterpart Luigi Galvani published the results of a series of experiments involving dissected frogs' legs, under the title *Commentary on the Effect of Electricity on Muscular Motion*, experiments which had apparently begun when Galvani electrified a frog by mistake some ten years before. Since the muscles and nerves of the legs, when displayed on a metal table, began to twitch and contract and jump if they were prodded with a rod made of a different metal, Galvani jumped to the conclusion that *the legs* were the source of electricity rather than the rod. The metal rod simply 'released' the animal electricity, a form of 'vital force' produced by the animal's brain and transmitted to its nerves and

Luigi Galvani's experiments with dissected frogs' legs, extended to a sheep (from his Effect of Electricity on Muscular Motion, *1791).*

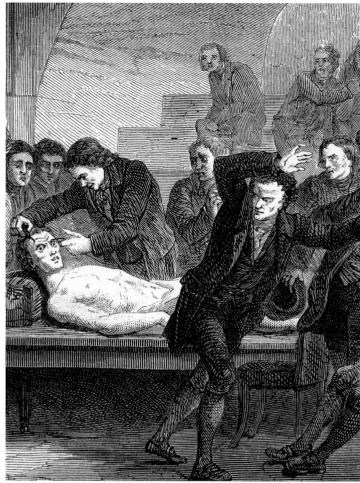

muscles. This was not the same as atmospheric or machine electricity.

Two years later, Alessandro Volta repudiated Galvani's conclusions by claiming that the source of electricity resided, after all, in the metal rather than the animal—so it was just an example of electricity or 'contact'—and that in the case of the two-metal experiment the change happened through the contact of two different metals, one plus and one minus. In 1796–97, building on this claim, Volta developed the Voltaic (or 'Galvanic') pile made up of copper and zinc discs separated by damp cardboard—the first electric battery. The Galvanists and the more down-to-earth Voltaists battled it out in print for several years—and the word 'galvanism' continued to be used for *all* forms of experiment involving electricity and organic matter, thanks to Volta's generosity of spirit—but in practice, Volta was to win the day. Spectacular public demonstrations, in 'theatres' of various descriptions, were key contributors to debate and understanding, and they were a popular form of entertainment as well.

Giovanni Aldini, Galvani's nephew and champion, in early 1803 went further by wiring a huge Voltaic pile (240 metal plates) to the mouth and ear of one Thomas Forster, a murderer who had been hanged at Newgate for killing his wife just one hour before. Aldini, who was Professor of Experimental Philosophy at Bologna University, had already revealed in 1802 that he could make a decapitated mastiff grind its jaws. But this experiment went several steps further, both physically and ethically. The result was reported by the *Annual Register* (February 1803):

> *On the first application of the process to the face, the jaw of the deceased criminal began to quiver, and the adjoining muscles were horribly contorted, and one eye actually opened. In the subsequent course of the experiment, the right hand was raised and clenched, and the legs and thighs were set in motion, and it appeared to all the by-standers that the wretched man was on the point of being restored to life . . .*

An attempt to replicate the experiment led to one of the gawping bystanders, who was standing a bit too close, being hit in the eye by the deceased murderer's abruptly raised arm. All in all, this public demonstration in front of a group of 'professional gentlemen' at Mr Wilson's Anatomical Theatre almost gave 'an appearance of re-animation'; it was even *possible* that 'vitality might have been restored, if many circumstances had not rendered it impossible'. Two of

ABOVE: (left) Nineteenth century reference book illustration of Luigi Galvani demonstrating the motion of muscles and 'animal electricity';
(right) Illustration of Giovanni Aldini's electrical experiment with a recently hanged murderer in 1803: 'one eye actually opened'.

William Godwin's medical friends had been the referees on behalf of the Royal Society of Alessandro Volta's scientific paper on the principles of the voltaic pile. One of them, the surgeon Anthony Carlisle, had excitedly told Godwin about Aldini's 1803 experiment when Mary Godwin was six years old. Carlisle had closely attended Mary's mother, Mary Wollstonecraft, when she was dying of puerperal fever after giving birth to her, in September 1797, and had later advised the family whenever Mary suffered childhood illnesses, which was quite often. Forster's 'one eye' which 'actually opened'—a highly memorable image—could well have led thirteen years later to Victor Frankenstein writing: 'I saw the dull yellow eye of the creature open; it breathed hard, and a convulsive motion agitated its limbs.' *This* experiment, remember, was conducted by a young scientist who had 'dabbled among the unhallowed damps of the grave, or tortured the living animal to animate the lifeless clay'. Mary Godwin and Percy Shelley were particularly upset by cruelty to animals. Percy was a devout vegetarian, Byron an occasional one. In the real world, such experiments on corpses had to be confined by law to recently executed criminals. But what if—Mary Shelley asked in her 1831 *Introduction*— what if they were to be extended beyond this, to 'the component parts of a creature'? Perhaps a corpse would be re-animated . . . In her novel of 1816–18 she made no explicit mention of galvanism. Just 'I collected the instruments of life around me that I might infuse a spark of being into the lifeless thing . . .', and during the incident when Victor's father explains the origin of thunder and lightning she uses the word 'Electricity'. Only in the 1831 popular edition did she actually refer to galvanism. In her *Introduction*, she wrote 'Perhaps a corpse would be re-animated; galvanism had given token of such things . . .', and she added:

I saw—with shut eyes, but acute mental vision,—I saw . . . the hideous phantasm of a man stretched out, and then, on the working of some powerful engine, show signs of life . . .'

And in the 1831 text, describing the impact on the young Victor of seeing an old oak tree blasted by 'a most violent and terrible thunder-storm [which] advanced from behind the mountains of the Jura', Mary Shelley omitted the father's explanation of 'Electricity' and substituted:

Before this I was not unacquainted with the more obvious laws of electricity. On this occasion a man of great research in natural philosophy was with us, and, excited by this catastrophe, he entered on the explanation of a theory which he had formed on the subject of electricity and galvanism, which was at once new and astonishing to me . . .

She had noticed an inconsistency, when she re-read her first edition in 1823: 'our family', Victor recalls, 'was not scientifical'. So how did Victor's father know about electricity? The 'man of great research in natural philosophy' was invented instead. And the poetic reference to 'the instruments of life' in the 1818 edition became a more literal explanation in 1831, involving galvanism and a powerful engine.

Victor Frankenstein is inspired to pursue his research—which he believes, at first, will benefit society—by Professor Waldman, a charismatic lecturer in chemistry at Ingolstadt. He had, Victor recalls, 'an aspect expressive of the greatest benevolence . . . and his voice the sweetest I had ever heard'. Mary Godwin mentions reading 'Introduction to Davy's chemistry'—almost certainly *A Discourse, Introductory to A Course of Lectures on Chemistry* (1802) by Sir Humphry Davy—when she was writing, or expanding, her chapters on Frankenstein's scientific curriculum at the university. She had been in the audience at one of Davy's celebrated public demonstrations at the Royal Institution in 1812, and Davy was, as we've seen, a friend of her father's. The *Discourse* was the only specialised scientific text to appear on her reading list during this period of preparing *Frankenstein*. Humphry Davy had, in fact, stayed in the *campagne* Fauconnet, the Fauconnet country house, on the shore of Lake Geneva near Montalègre, in 1814—right next door to where Percy and Mary were to rent their small house in summer 1816. He had enjoyed fishing from one of the windows, while everyone thought he was studying natural philosophy. While there, Davy had also experimented 'on the solar spectrum' at the house of Marc-Auguste Pictet. Pictet, a stalwart of the Genevan Natural History Society, was to spend time with Lord Byron and Dr Polidori in June 1816: he was one of the hosts Polidori invited to dine with him at the Villa 'without any authority from the noble owner' and got into trouble for it. So it is not at all surprising that Prof. Waldman's visionary rhetoric, in his introduction to a course in modern chemistry, should be very similar to the tone of Davy's published *Discourse*:

The ancient teachers of this science [said he] promised impossibilities, and performed nothing. The modern masters promise very little; they know that metals cannot be transmuted, and that the elixir of life is a chimera. But these philosophers, whose hands seem only made to dabble in dirt, and their eyes to pore over the microscope or crucible, have indeed performed miracles. They penetrate into the recesses of Nature, and show how she works in her hiding-places. They ascend into the heavens; they have discovered how the blood circulates, and the nature of the air we breathe. They have acquired new and almost unlimited powers; they can command the thunders of heaven, mimic the earthquake, and even mock the invisible world with its own shadows. I departed highly pleased with the professor and his lecture . . . it decided my future destiny.

And from the *Discourse*:

[The alchemists'] views of things have passed away, and a new science has gradually arisen. The dim and uncertain twilight of discovery, which gave to objects false or indefinite appearances, has been succeeded by the steady light of truth, which has shown the external world in its distinct forms, and in its true relations to human powers. The composition of the atmosphere, and the properties of the gases, have been ascertained; the phenomena of electricity have been developed; the lightnings have been taken from the clouds; and, lastly, a new influence has been discovered, which has enabled man to produce from combinations of dead matter effects which were formerly occasioned only by animal organs.

Sir Humphry Davy—at that stage in his teaching career—was even excited by the potential of galvanic chemistry. And he, too,

rhapsodised about the benefits to society of the latest developments in chemical physiology. Victor Frankenstein picks up from Waldman/ Davy not just the vision and the excitement but a carefully considered research programme consisting of 'distinct' stages: the understanding of basic principles, 'the improvement of some chemical instruments', the framing of an hypothesis, the gathering of materials, the discovery, the hesitation 'a long time concerning the manner in which I should employ it', the preparation 'for a multitude of reverses':

My operations [he says] might be incessantly baffled, and at last my work be imperfect: yet, when I considered the improvement which every day takes place in science and mechanics, I was encouraged to hope my present attempts would at least lay the foundations of future success. Nor could I consider the magnitude and complexity of my plan as any argument of its impracticability.

Victor's education is like the whole history of Western science, up to 1816, in microcosm: he begins with 'the search of the philosopher's stone and the elixir of life', using medieval masters such as Albertus Magnus and Paracelsus as his magi; he becomes fascinated—at around the age of fifteen—by 'the wonderful effects of steam' and his 'utmost wonder was engaged by some experiments on an air-pump, which I saw employed by a gentleman whom we were in the habit of visiting'; after he has seen the lightning-bolt turn the old oak tree into a blasted stump, he moves on to more observational science and the study of nature. His Professor of natural philosophy, M. Krempe, urges him to abandon 'exploded systems', to be less intellectually ambitious and to study 'modern natural philosophy' instead. Then he listens to M. Waldman. Like Mary Godwin listening to Humphry Davy in 1812, or those impressionable young medical students listening to William Lawrence in March 1816.

Victor is enthralled by Waldman's lecture because, although he has gone through a succession of scientific revolutions in his own quest for knowledge, and understands the importance of careful experimentation and taking things step by step, he is still asking the big questions of 'the ancient teachers' and still wants power and glory. He promises much and hopes to perform much. He is the last of the alchemists as well as being the first of the modern scientists.

In *his* youth, Humphry Davy had written a hymn of praise to the modern chemist—in verse—which he had published in Robert Southey's *Annual Anthology* (1799–1800). It was called *Sons of Genius*:

> To scan the laws of Nature, to explore
> The tranquil reign of mild Philosophy;
> Or on Newtonian wings sublime to soar
> Through the bright regions of the starry sky . . .
> Like you proud rocks amidst the sea of time,
> Superior, scorning all the billows' rage,
> The living Sons of Genius stand sublime,
> Th'immortal children of another age.

Mary Godwin probably had Davy in mind, as she dreamed of her scientist-hero. But from the very beginning, she was concerned that the 'living Sons of Genius' would, in all their excitement about 'the bright regions of the starry sky', forget their humility, their sense of responsibility and their social conscience: the Sons should be challenged by the daughters. According to Thomas Medwin's *Conversations of Lord Byron at Pisa* (1824), Byron was to say of Mary's 'Pygmalion story, the modern Prometheus' about 'the making of a man' that 'a lady who read it afterwards asked Sir Humphry Davy, to his great astonishment, if he could do it'.

So the conversation in Geneva about 'principles—whether man was thought merely an instrument' and/or 'the nature of the principle of life'—on June 15th/16th 1816—would have tapped into some of the key topical debates in early nineteenth-century science, and related them to creativity and the writing of poetry: these debates included the 'vitalist' controversy, electricity and magnetism, vivisection, proto-evolutionism, man-as-machine—and probably amputation as well. In the wake of the Napoleonic Wars, there were disabled ex-soldiers and sailors to be seen in towns and villages all across the south of England and France. Two years earlier, Percy Shelley had noted 'filth, misery and famine' on the journey from Paris, everywhere he looked. Frankenstein's creation was a form of amputation in reverse.

On June 17th, the combination of science and ghost stories reached its climax. Mary Godwin began her story with the words 'It was a dreary night of November'. The earliest version we have goes like this:

It was on a dreary night of November, that I beheld my man completed; [and] with an anxiety that almost amounted to agony, I collected instruments of life around me, [and endeavoured to] that I might infuse a spark of being into the lifeless thing that lay at my feet. It was already one in the morning, the rain pattered dismally against the window panes, and my candle was nearly burnt out, when by the glimmer of the half extinguished light I saw the dull yellow eye of the creature open—It breathed hard, and a convulsive motion agitated its limbs.

Two of the great genres of modern popular literature—science fiction and the vampire story—were born that night. As I said to that BBC radio producer a few years ago, I'd have loved to be a fly on the wall, eavesdropping on that astonishing ghost-story session which has become as well-known as the works it inspired: even, more well-known. Its legacy is to be seen all over the world—on small and large screens, in print and online, on stage and on hoardings, in graphic novels, comics and even on cereal packets. The real creation myth of modern times—the era of genetic engineering, three-parent babies, nanotechnology, artificial intelligence, robotics and singularity, human/animal interfaces and secularism—is no longer Adam and Eve in the Garden of Eden (as William Lawrence predicted in 1816). The real creation myth is *Frankenstein*.

The Jaquet-Droz 'Musician' and 'Scribe' automata, in Neuchâtel: she is powered by a clockwork mechanism, and bellows in her chest. He is writing 'Je pense, donc je suis'.

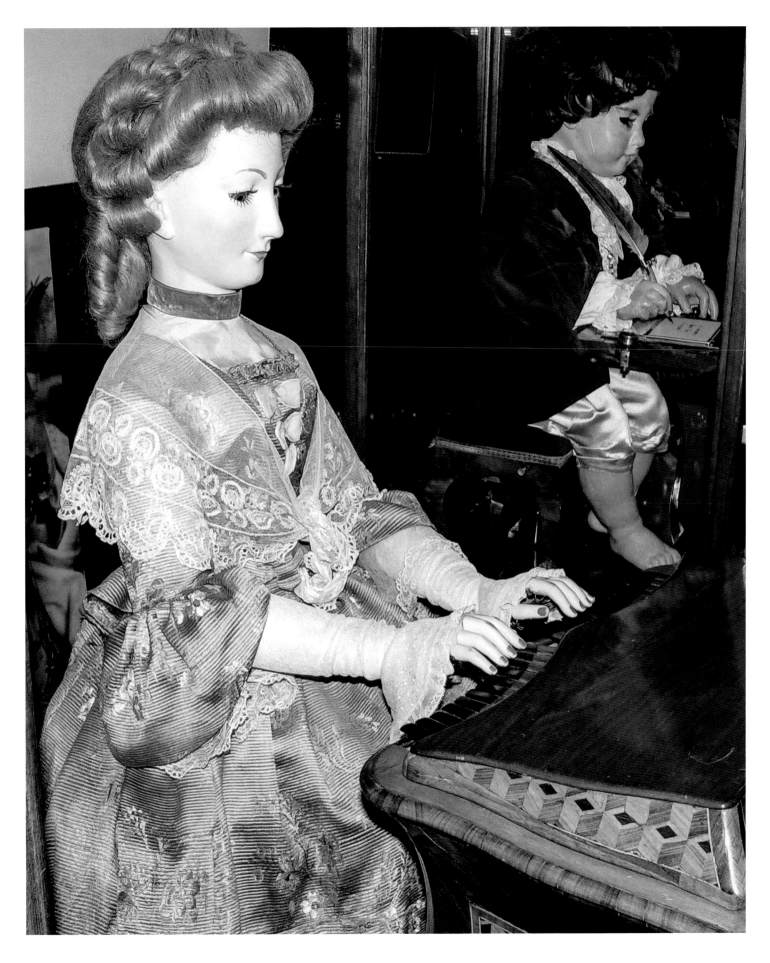

III.

'We will each write a ghost story'

FROM THE EVIDENCE of the published texts of *Frankenstein* (1818 and 1831 editions), although Mary Shelley was attentive—and sensitive—to contemporary scientific debates, she did not feel at all comfortable writing about them except in broad, general terms. There is actually remarkably little in the way of scientific *detail* in the novel, given the circumstances of its genesis, and given Percy Shelley's—and her father's—predilections. Victor Frankenstein—deliberately—never explains the final stage of his research.

. . . this discovery was so great and overwhelming, that all the steps by which I had been progressively led to it were obliterated, and I beheld only the result . . . I see . . . that you expect to be informed of the secret with which I am acquainted; that cannot be: listen patiently until the end of my story, and you will easily perceive why I am reserved upon that subject.

As Mary's most recent biographer Miranda Seymour has wisely cautioned:

. . . [Mary Shelley's] role as 'the wicked stepmother' of genetic science . . . threatens to lead her larger but underinformed audience into new misconceptions both of the author and the intentions behind her most celebrated work. Fascinating though it is to explore the novel's evident connections to both Mary and her husband's knowledge of galvanism and of contemporary discussions of vitalism . . . this is

not where her own interest lay. The making of the Creature, so enthralling to film directors, concerned Mary Shelley less than the idea of parental alienation from a manufactured child, a laboratory product. The story at the heart of Frankenstein *is of a monstrously selfish scientific experiment, monstrous because Victor, having made a living, loving son for himself . . . rejects it. Love is the message at the heart of Mary's novel.*

. . . 'larger but underinformed' is somewhat patronising—but the point is well made. And though it would be equally wrong to read *Frankenstein* too readily as an autobiographical novel—Seymour observes that it 'can easily be turned into a biographer's sandpit', a self-fulfilling resource—the personal themes which run through the text are clearly key to fully understanding it: among them, Mary Godwin's relationship—emotional and intellectual—with her own parents and their writings; her anxieties as a parent having lost her first baby, a daughter, in February 1815; her reservations about some of Percy Shelley's and Lord Byron's overreaching; her distress at being shunned by her beloved father; her personal development as a self-possessed thinker with strong views of her own; the great expectations placed upon her as the daughter of two eminent intellectuals. *Frankenstein* has been described as the first-ever novel written by a

woman contemporaneously with her experience of childbirth.

Richard Holmes has recently written: 'Mary's entire literary career was inspired by her mother's example', and *Frankenstein* perhaps most of all. The celebrated conclusions of Mary Wollstonecraft's *A Vindication of the Rights of Woman* (1791) could almost be a summary of the relationship between scientist and creature: 'a great proportion of the misery that wanders, in hideous forms, around the world, is allowed to rise from the negligence of parents'; and 'from the tyranny of man' the greater number of follies proceed. The earliest reviews of *Frankenstein*, taking their cues from the book's *Dedication*, noted that the novel was clearly the work of a devoted Godwinian: the 'overreaching' theme, and the pursuit, echoed William Godwin's novel *Caleb Williams*; the responsibility-of-the-scientist theme echoed *St. Leon*, the story of an alchemist searching for the secret of life; the Swiss setting of 'the glorious founders of liberty' echoed *Fleetwood*. Mary Godwin was very careful, when drafting *Frankenstein*, about the chronology of her story: it has been calculated that it begins on December 11th 1796 (though she wrote '17—'), the month she was conceived by Mary Wollstonecraft, and ends on September 12th 1797, thirteen days after her birth and just after her mother's death. Or maybe she was conceived on 'a dreary night of November'.

On May 13th 1816, Percy Shelley, eighteen-year-old Mary Wollstonecraft Godwin, their little son William and Mary's stepsister Claire Clairmont checked into Messieurs Jean-Jacques and Antoine Jérémie Dejean's fashionable Hôtel d'Angleterre in Sécheron on the north side of the Lake, a mile outside the city of Geneva. They were tired out. Mary had been sea-sick and coach-sick, for most of the ten-day journey from London, much of it along the main tourist route via Paris, Troyes, Dijon, Poligny and the Jura.

The Hôtel d'Angleterre, a large three-storey stone building set back from the lakeside, with a park leading to the road from Geneva to Lausanne, was a stop-over favoured by the well-heeled British starting on their grand tours. It was the first coaching inn on the way out of the austere walled city, and it had a little harbour. The Shelley party took a set of rooms with Lake view, 'at the top of the house', as husband, wife and married sister. Mary had described the last leg of

*Lord Byron writing, on the balcony of the Villa Diodati, and being inspired by the weather: this lithograph of c.1820 included lines from **Childe Harold** beneath.*

the journey as seen through the window of a closed carriage:

. . . never was a scene more awefully desolate. The trees in these regions are incredibly large, and stand in scattered clumps over the white wilderness; the vast expanse of snow was chequered only by these gigantic pines, and the poles that marked our road: no river or rock-encircled lawn relieved the eye, by adding the picturesque to the sublime. The natural silence of that uninhabited desert contrasted strangely with the voices of the men who conducted us, who, with animated tones and gestures, called to one another in a patois composed of French and Italian, creating disturbance, where but for them, there was none.

But then, on settling in at the hotel in Sécheron, 'to what a different scene are we now arrived!' Mary wrote on May 17th:

From the windows of our hotel we see the lovely lake, blue as the heavens which it reflects, and sparkling with golden beams. The opposite shore is sloping and covered with vines, which however do not so early in the season add to the beauty of the prospect. Gentlemen's seats are scattered over these banks, behind which rise the various ridges of black mountains, and towering far above, in the midst of its snowy Alps, the majestic Mont Blanc, highest and queen of all. Such is the view reflected by the lake . . . We do not enter into society here, yet our time passes swiftly and delightfully.

We read Latin and Italian during the heats of noon, and when the sun declines we walk in the garden of the hotel, looking at the rabbits, relieving fallen cockchafers, and watching the motions of a myriad of lizards, who inhabit a southern wall of

The Villa Diodati, overlooking Lake Geneva (actually it is much higher up the hillside), with Byron meditating in the garden: the original caption of 1832 was 'Diodati—the residence of Lord Byron'.

the garden . . . coming to this delightful spot during this divine weather, I feel as happy as a new-fledged bird, and hardly care what twig I fly to, so that I may try my new-found wings.

Mary Godwin was fond of lakes and mountains: the happiest time in her childhood had, she said, been spent on 'several long visits' between 1812 and 1814 to Broughton Ferry just outside Dundee—exploring from that 'blank and dreary' base some of the more picturesque parts of Scotland. It was there that she gained the confidence to 'commune with the creatures of my fancy'. There is a local legend at Broughton Ferry that the young Mary may first have conceived *Frankenstein* in that setting—or at least the framing story of the ex-whaler turned-explorer Robert Walton being trapped in the ice, on his way to discover the secret of the magnet, and a navigable northwest passage, at the North Pole.

In the evenings at Sécheron, at about six o'clock, the party of three would go for a sail on the Lake, in a small hired boat:

The waves of this lake never afflict me with that sickness that deprives me of all enjoyment in a sea voyage.

William, who had been feeling poorly before they left England on May 2nd, was now feeling much better.

Mary's idyllic description of these relaxing evenings spent drifting on the Lake—which 'inspires me with unusual hilarity'—was to become Victor Frankenstein's, on the evening of his marriage, the lull before the storm.

Thirteen days after they had checked in, late at night on May 25th—later than he'd hoped—Lord Byron arrived in style in his huge, mud-spattered military blue carriage modelled on Napoleon's captured at Genappe, but with some extras:

. . . besides a lit de repos, *it contained a library, a plate-chest, and every apparatus for dining in it. It was not, however, considered sufficiently capacious for his baggage and suite; and he purchased a calèche in Brussels for his servants.*

His retinue of servants included his valet William Fletcher; his 'handsome page' Robert Rushton (there were rumours); his Swiss guide and courier Berger; and a postilion on the main coach who was wearing 'large jack boots—and a tight jacket that did not fit him'. The craftsman who had made the Napoleonic replica was still waiting to be paid his £500. His handiwork, especially the springs and wheels, had 'not done their duty': they had broken down several times on the journey from Ostend, which was why Lord Byron was arriving late. The prospect of settling the bill was receding fast. Half an hour after Byron had signed the register at the Hotel ('age—100'), Claire Clairmont dashed off a characteristically heart-on-sleeve note:

I am sorry you are grown so old, indeed I suspected you were 200, from the slowness of your journey . . . Well, heaven send you sweet sleep—I am so happy.

Byron did not reply. He never did encourage her by replying to her notes and letters. After such a taxing journey, he was not tempted by her craving for love, her persistent demands for sex and her resistible mixture of persistence and possessiveness. M. Dejean insisted that the British Milord fill in the hotel register properly, with more accurate

details of his age and destination. Before he left the shores of England, Byron had under pressure given Claire Clairmont his address as 'Milord Byron, Poste-Restante, à Genève', which was one reason why she had managed to persuade Percy Shelley and Mary Godwin to go to Geneva, a rather conventional choice, rather than Italy which Percy had originally preferred. For in April 1816, Claire briefly—in an impetuous move which, she later wrote, gave her ten minutes of perfect pleasure and a lifetime of pain—had become Byron's lover. And she was pregnant, although it did not show yet. Unknown to his noble employer, Dr Polidori had been offered 500 guineas by the publisher John Murray to produce a printable journal of their adventures, so he noted the Byron party's movements in some detail. He also had ambitions to be a poet as well as a medical man and diarist. But, as his *Journal* amply shows, he was not a very gifted writer. He did notice things, though: on May 27th, he wrote that Shelley 'keeps the two daughters of Godwin, who practise his theories; one L.B.'s'. Claire wasn't Godwin's daughter—but had evidently slept with Byron again by the 27th. After the two poets had met, on the shore of the Lake—Claire led Shelley to the quay—at first shyly, then with 'an overwhelming intimacy', Mary later recalled:

Every evening, during their residence under the same roof at Sécheron, they embarked accompanied by the ladies and Polidori, on the Lake; and to the feelings and fancies inspired by these excursions, which were not infrequently prolonged into the hours of moonlight, we are indebted for some of these enchanting stanzas [in Childe Harold, *Canto 3].*

When Polidori was introduced to 'Mary Wollstonecraft Godwin—called here Mrs. Shelley', he noted: 'No names announced, no ceremony—each speaks when he pleases'. According to Claire's later account, when Percy and Mary had first caught sight of Byron and Polidori in a boat, they thought 'Polidori Byron—and how handsome he was!' She evidently hoped that, by introducing Shelley to Byron, she might create a sense of obligation in him: she had told him, shortly after they left England, that it was *she* who persuaded Shelley to meet Byron in Geneva. If so, the ploy did not work. One of Mary's most cherished memories later in life was of Lord Byron's behaviour on one of their outings on the Lake:

'I will sing you an Albanian song,' cried Lord Byron, 'now, be sentimental and give me all your attention.' It was a strange, wild howl that he gave forth; but such as, he declared, was an exact imitation of the savage Albanian mode—laughing, all the while at our disappointment . . .

Together, on May 28th, they all made a pilgrimage to 'the Plainpalais' in the city of Geneva—actually to the drawbridged Pont Neuve just south of the city that led *towards* the fields of the Plainpalais:

Here a small obelisk [a small bust and memorial] is erected to the glory of Rousseau, and here (such is the mutability of human life) the magistrates, the successors of those who exiled him from his native country, were shot by the populace during that revolution which his writings mainly contributed to mature.

As Polidori wrote in his *Diary*:

Saw the bust of Jean Jacques [Rousseau] erected on the spot where the Genevan magistrates were shot. LB said it was probably built of some of the stones with which they pelted him.

Mary was very familiar with Rousseau's *Émile*, his thought-experiment on education originally published in 1762 and often republished since: she had read it with Percy while they were getting to know each other; her mother had written a spirited critique of the section on the education of young girls—she admired the rest of the book, if only it had considered 'females as human creatures rather than as women'—and her father William said that reading the book had changed his life. Mary had re-read *Émile* in 1816. Much of *Frankenstein*—the Genevan setting, Victor's childhood, his father a Syndic of Geneva, the young scientist's attempts to improve on nature, the creature's self-education, Frankenstein's abandonment of his motherless child, the creature's search for a mentor, even the first murder at the Plainpalais—can be read through the prism of *Émile*. In fact, Victor Frankenstein is himself a Citizen of Geneva—as Jean-Jacques Rousseau proudly announced himself to be on his title-pages: '*Citoyen de Genève*'—'from birth a Genevese'. Geneva was annexed by France in 1798, the year after the story takes place, and was only admitted to the Swiss Confederation in 1814. Before that, it was the Republic of Geneva. Victor Frankenstein is invariably described by commentators as Swiss, or French, or German—all of which are wrong. Like Rousseau, he was '*Citoyen de Genève*', and proud of it.

As Mary Shelley later wrote, Rousseau's *Émile* was about 'how children ought to be treated like younger men, not as slaves or automata', which is also a fair summary of *Frankenstein*. It was a theme which Percy was to distil into the aphorism 'Treat a person ill, and he will become wicked'. Lord Byron felt a closer affinity with Rousseau's novel *La Nouvelle Héloïse*. He introduced Percy to it, and towards the end of June 1816, after his eight-day excursion with Shelley around Lac Léman, could accurately write 'I have traversed all Rousseau's ground [the lakeside locations of the novel]—with the *Héloïse* before me, and am struck to a degree with the tone and accuracy of his descriptions': Meillerie, Clarens, Vevai, the mountains of the Valais. He also observed with some relief: 'Thank God, Polidori is not here'. Percy Shelley wrote that 'in some respects' *La Nouvelle Héloïse* was 'absurd', but that nevertheless Rousseau was 'indeed in my mind the greatest man the world has produced since Milton'. In *Childe Harold*, Byron mentioned 'the self-torturing sophist, wild Rousseau', which was less than effusive unless it was intended as a compliment. In between descriptions of the country around Lake Geneva, *La Nouvelle Héloïse* contains long sections on education—a summary of *Émile* in effect—and on political theory: on the formation of 'man and citizen'. When Claire Clairmont changed her name to 'Claire', in November 1814, it was probably because the character of Claire in *La Nouvelle Héloïse* was the vivacious, dark-haired friend and *confidante* of the lovers Julie and Saint-Preux.

In late May, at the Hôtel in Sécheron, the two poets had drawn closer to each other after a tentative start. Polidori noted that Shelley enjoyed telling Byron a highly-coloured version of his life story, full of dramatic incident, and that 'LB' seemed amused by this. He also noted—with surprise—that the Shelleys rather enjoyed talking about the macabre. There was much good-natured bamming and humming (bamboozling and humbugging), which would continue in a competitive way throughout June. The poets were proving good for each other's spirits. Byron, reminiscing about the Geneva summer, was to write:

[Shelley] is a very good—very clever—but very singular man—he was a great comfort to me here by his intelligence and good nature.

Thomas Moore, in his collaged biography of Byron, was to add:

The conversation of Mr. Shelley [at Sécheron], from the extent of his poetic reading, and the strange, mystic speculations into which his system of philosophy led him, was of a nature strongly to arrest and interest the attention of Lord Byron.

But it was becoming increasingly urgent to leave the expensive, and exposed, hotel. Gossip was beginning to circulate among the other residents, several of them British: as Byron recalled 'There was no story so absurd that they did not invent at my cost. I believe they looked on me as a man-monster'. He started recceing suitable locations on the opposite shore of the Lake within a day of his late-night arrival. But as it turned out the Shelley party—including Claire—was the first to make a move. For, by June 1st, Mary was writing from 'Campagne Chapuis—near Cologny', explaining that they—now with Elise—had moved to the eastern shore of the Lake—'we have exchanged the view of Mont Blanc and her snowy *aiguilles* for the dark frowning Jura'—to the smaller of two secluded properties owned by M. Jacob (or Jacques) Chappuis. The full address was 'Maison Chappuis, Montalègre' (it wasn't the size of a country house) and it was near the village of Cologny. This modest, stone-built, two-storey four-bedroomed 'cottage' set among vineyards gave access to a small private harbour belonging to Chappuis. It was, apparently, expensive for what it was. This was the letter in which the change in the weather to 'an almost perpetual rain' was described by Mary.

The Maison Chappuis was demolished in 1883, and all that remains of the surroundings is the stable next door (converted into a small house)—which can be seen from today's main road—a cellar with an ornamental iron door, and a stone stairway in the garden. A photograph of the original exists. Another of Mary's fond memories from that time was of Lord Byron rowing back to the hotel at Sécheron over the darkened waters, late at night, after a visit from the hotel side:

. . . the wind, from far across, bore us his voice singing your Tyrolese Song of Liberty, which I then first heard, and which is to me inextricably linked with his remembrance.

This was probably on June 2nd, when according to Polidori's *Diary*, Byron dined with Shelley, and they all discussed madness and Irish Revolutionaries. This was also the day when Polidori was asked to vaccinate little William Shelley, for which he received a gold chain and seal 'as a fee': he was impressed by the Shelleys' up-to-date

attitude towards science. For the rest of her life, Mary later wrote, 'I do not think that any person's voice has the same power of awakening melancholy in me as [Byron's].' Clearly, at some level Byron was beginning to work his charming spell on her. Byron himself wrote later that summer, to his beloved half-sister, of 'that Tyrolean air and song which you love—Augusta—because I love it—and I love because you love it . . . so wild and original and at the same time of great sweetness'.

Mary also remembered him lazily trailing his sword-cane in the water beside the boat, as it drifted. Later in June, he would accidentally drop it into the water and lose it: it 'tumbled into the lake'. Byron's and Shelley's new sailing-boat *La Voile* arrived on June 8th, and was promptly moored in the harbour at Montalègre. It cost 25 *louis*, had four oars and sails, and was apparently 'at that time the only keeled boat on the lake', rigged to withstand at least some of the sudden squalls. They all tried it out on the 8th:

. . . into the new boat . . . and talked, till the ladies' brains whizzed with giddiness, about idealism . . . Back; rain; puffs of wind, Mistake.

This 'pretty open boat' was English in construction, and 'was brought lately from Bordeaux'.

Two days later, Lord Byron, Dr Polidori and retinue moved into the 'Villa Diodati', also known sometimes as the 'Villa Belle Rive', 'the house beyond Cologny that belonged to Diodati', up on the high bank: Victor Frankenstein's family home is called Bel Rive. They had been haggling over the price, and the six-month lease, since May 26th, with support from Charles Hentsch, Byron's trusted young banker and agent in Geneva. The papers were finally signed on June 6th. The cost was still on the steep side, as was characteristic with Swiss and Genevan landlords in prime locations over the summer season of late May to October—at 125 *louis*.

Edouard Diodati's initial asking price had been 'five-and-twenty *louis* a month', so they had at least secured a reduction of twenty-five *louis*. They visited the villa several times between June 6th and moving in four days later. Byron described the property, towards the end of June:

I have taken a very pretty villa in a vineyard—with the Alps behind—and

Promenade sur le Léman, *with Chillon in the background. Lithograph by Achille Devéria (c.1832): unusually, this includes both the Byron and Shelley parties.*

Nº d'ordre	Date de la permission	Renouvellement	Noms	Prénoms	Profession	Patrie	Domicile à Genève	Observations
571	11 juillet		Shelley	Percy B.		Angleterre	rue: Montalègre maison: Chapuis	Parti le 17 août
614	13 juillet	Parti	Pollidor	docteur	Anglais	Angleterre	rue: Cologny maison: Diodati	
615	13 juillet	Parti	Byron	Lord	Anglais	Angleterre	rue: Cologny maison: Diodati	

Mount Jura and the Lake before—it is called Diodati—from the name of the Proprietor—who is a descendant of the critical and illustrissimi Diodati . . .

The choice of residence, and the fact that Byron went to view it immediately after he arrived at Sécheron, suggest that he knew about the Villa or the Diodatis in advance. This is not surprising. William Godwin had recently written—in *The Lives of Edward and John Philips, Nephews and Pupils of Milton* (1815)—of John Milton's stay in Geneva with an ancestor of Edouard in 1639: 'At Geneva, he contracted a friendship with the learned Dr. Deodati'; '. . . and so by the Lake Leman to Geneva; where he staid for some time and had daily converse with the most learned Giovanni Deodati; theology professor in that city'. This established a link between Milton, Diodati and Geneva which convinced Byron and Shelley that Milton had stayed at the Villa. He hadn't—another Diodati, Gabriel, had supervised the Villa's construction in 1710, some seventy years later. But the association may well have drawn Byron to the 'Villa Diodati'. In fact, John Milton had stayed at a house in Geneva's old town. The Gothic novelist and art connoisseur William Beckford had stayed for eight months at the Villa d'Espine in Cologny, just up the slope from the Villa Diodati, in 1783—when he was putting the finishing touches to his orientalist fantasy *Vathek* (published in French, 1786), and had earlier resided in Geneva for eighteen months from 1777: it was from Geneva that Beckford made his celebrated visit to Voltaire at Ferney, on the border with France. Humphry Davy, as we've seen, had also lived in Cologny in 1814, nearer the Maison Chappuis. So

the Villa certainly had just the right form: Milton, Gothic fantasy, science. It was not occupied when Byron leased it. Edouard Diodati and relatives lived in a smaller house near the village of Cologny, while they rented out the main house to visitors and especially British visitors 'per season or annum as suits the lessee'.

There was a saying amongst British tourists at the time: 'point d'argent, point de Suisse' ('no money, no Swiss'). The asking price for the numerous *campagnes* surrounding Lac Léman in the season was notoriously high. But, according to a near-contemporary, the demands 'invariably' made by choosy tourists were even higher:

must not be in the town but near it in the country; must positively not only see the lake but have a good view of it from our very windows; must command a good view of Mont Blanc; should like to possess shady gravel-walks, for hot weather, and trellised vine-bowers, besides a good garden; a pleasant carriage approach to a faultless campagne; and the house must be commodious, low in rent, well-furnished, clean and all ready to step into.

The Villa Diodati met at least some of these demands. It was and is a substantial two-storey grey stone porticoed villa, surrounded on three sides—at first-floor level—by an elaborate shaded wrought-iron balcony. 'The view from this house is very fine', wrote Polidori, 'beautiful lake; at the bottom of the crescent is Geneva'. The view was of Lac Léman and the Jura. The Maison Chappuis, below at the lakeside, was reachable along a narrow track through trellised vine fields: the Shelleys gave their address (to a select few) that summer as 'Shelley/campagne/Diodati/at Cologny'. Downstairs at Diodati

Register of 'permis de séjour' (from the Geneva Archives of State) for the male visitors: actually, the Shelleys left on the 29th August.

was the main room, a 'picture gallery', and a hallway leading to the balcony. The entrance was via a small tree-lined courtyard: a grand exterior and a surprisingly intimate interior, not at all spooky.

One of the M. Dejeans, of the Hôtel d'Angleterre, celebrated Byron's arrival there by renting out a telescope, through which tourists could pry from a safe distance into the antics at the Villa. 'Certain robes and flounces' were observed 'on his Lordship's balcony', which turned out—disappointingly—to be bedsheets drying on the balcony. Did the petticoats belong to 'Mrs. Shelley' or to her 'actress' sister? Who was doing what to whom? Was there a 'league of incest?' One British tourist—Sylvester Douglas, Lord Glenbervie—picked up some juicy stories while dining at Sécheron later in the season:

Among more than sixty English travellers here, there is Lord Byron, who is cut by everybody. They tell a strange adventure of his, at Déjan's Inn. He is now living at a villa on the Savoy side of the lake with that woman, who it seems proves to be a Mrs Shelley, wife to the man who keeps the Mount Coffee-house.

This gives an idea of the kind of gossip which was circulating among the large colony of British tourists on the other side of the Lake. The final sentence gets every single detail wrong. Byron was *not*, of course, living with 'a Mrs Shelley', who, in any case, was still Mary Godwin at the time. The man who had once kept the very respectable Mount Coffee-house in Grosvenor Square was John Westbrook, father of Harriet Westbrook, who was Shelley's first (and only, in 1816) wife. So Lord Glenbervie had succeeded in confusing Mary Godwin with both Claire Clairmont *and* Harriet Westbrook, Percy Shelley with Harriet's father, and Shelley with Lord Byron. Never mind; there was obviously *something* tasty going on in the Villa; probably group sex and/or 'a league of incest'. It was even hinted down the road—perhaps with a Calvinistic shudder—that Lord Byron was haunting the walled city at the dead of night to have his wicked way with Genevese virgins.

Mary Godwin was certainly attracted to Lord Byron's charm in a 'timid' way as she was to put it. And Percy Shelley *may* have slept with Claire Clairmont in London before she began besieging Lord Byron with *billets doux* when he was on the committee of the Drury Lane Theatre. One of the reasons the Shelley party had gone to Geneva was that Claire had used her close connections with them, and with the Godwins, to help sustain Byron's interest in her. Or had Percy Shelley used Claire to gain him an entrée to Byron?

In England I shall see you no more [she wrote melodramatically to Byron]. Blessed and quick be the time when I shall watch its receeding [sic] shores: think of me in Switzerland; the land of my ancestors.

. . . pray give me some explicit direction [she had written as early as April 22nd], for I shall be at Geneva soon and it will break my heart if I do not know where you are—

She seems to have thought 'Milord Byron, Poste-Restante, à Genève' might not be precise enough to be able to locate him, might even be an attempt to brush her off. In fact, it was as precise as Byron was able to be, before he left. Another attraction about Geneva, where Claire was concerned, was that she had been told by her mother—William Godwin's second wife—that some of their forebears came from Uri in Switzerland, the ancient stamping-ground of the Clairmonts, and that the Alps were 'my native mountains . . . which I love to consider my own country'. So she might even have 'relations in Geneva'. Rashly, Claire believed her. In fact, the aristocratic-sounding name of 'Clairmont' was an invention—Claire never knew who her legitimate father was—and the Swiss connection was a family myth.

On May 6th, from the rue de Richelieu in Paris, where they had stopped on the journey over, Claire had written yet another letter to Byron:

You bade me not come without protection: 'the whole tribe of the Otaheite philosophers are come'. Shelley . . . had nothing to detain him and yielded to my pressing solicitations; you will I suppose wish to see Mary who talks and looks at you with admiration; you will I dare say fall in love with her; she is very handsome and very amiable and you will no doubt be blest in your attachment; nothing can afford me such pleasure as to see you happy in any of your attachments. If it should be so I will redouble my efforts to please her . . . In five or six days I shall be at Geneva. I entreat you on receipt of this to write a little note to me directed as Madame Clairville, Poste Restante, saying where you are and how you are.

The coquettish reference to 'Otaheite philosophers' was to the pleasure-loving inhabitants of Tahiti, who were reputed to prefer free love to marriage: according to Erasmus Darwin, the females on the island formed 'one promiscuous marriage'. It seems that the quotation may have been from Byron himself, though his tone of voice is difficult to judge: most likely, he would have been shocked. Byron had certainly let Claire know that *under no circumstances* should she follow him to Switzerland alone: hence, 'You bade me not come without protection'. Claire's letters and notes were to become increasingly plaintive and increasingly possessive. Byron did not reply to any of them.

The prurient tourists may also have been thinking about the scandals surrounding Lord Byron's departure from England in April 1816, 'exiled from my country by a species of ostracism': very damaging rumours of incest with his half-sister Augusta, and of sodomy. Which were depressing him mightily—'I am in fair—though unequal—spirits'—though he seldom shared this in public.

Unfortunately, Mary Godwin's *Journal* for the summer months of 1816 up to July 21st has been lost or destroyed—her account of the events of June/early July would have been on the final pages of her second *Journal*, dating from May 1815–July 1816—but she did supply interesting information to Thomas Moore when he was compiling his *Life of Lord Byron* (1830) some twelve years later. This information was presented anonymously as by 'a person who was of these parties'. 'Mrs. Shelley' was mentioned in the third person. Events are rearranged, compressed and dramatised—a key stage towards Mary Shelley's much better-known *Introduction* to the 1831 edition of *Frankenstein*: she was proud of her contribution to the *Life of Byron*, but in 1828 still worried that her secret identity might be

FANTASMAGORIANA,

OU

RECUEIL

D'HISTOIRES D'APPARITIONS DE SPECTRES,

REVENANS, FANTÔMES, etc.;

Traduit de l'allemand, par un Amateur.

Falsis terroribus implet.
HORAT.

TOME PREMIER.

PARIS,

Chez F. SCHOELL, rue des Fossés-Montmartre, n°. 14.

1812.

discovered. Shelley and Byron were by then dead, as was Polidori, and Claire wanted to distance herself as much as possible from memories of Lord Byron. Mary's testimony of 1828 reads like the authorised version. It makes the first week at the Villa Diodati seem almost dull. Much tea is drunk:

At Diodati, his [Lord Byron's] life was passed in the same regular round of habits and occupations into which, when left to himself, he always naturally fell; a late breakfast, then a visit to the Shelleys' cottage and an excursion on the lake; at five, dinner (when he usually preferred being alone) and then, if the weather permitted, an excursion again. He and Shelley had joined in purchasing a boat—for which they gave twenty-five louis,—a small sailing vessel . . . When the weather did not allow of their excursions after dinner—an occurrence not unfrequent during this very wet summer,—the inmates of the cottage passed their evenings at Diodati, and, when the rain rendered it inconvenient for them to return home, remained there to sleep. 'We often,' says one . . . 'sat up in conversation till the morning light. There was never any lack of subjects, and, grave or gay, we were always interested.'*

** His system of diet here was regulated by an abstinence almost incredible. A thin slice of bread, with tea, at breakfast—a light, vegetable dinner, with a bottle or two of Selzer water, tinged with vin de Grave and in the evening, a cup of green tea, without milk or sugar, formed the whole of his sustenance. The pangs of hunger he appeased by privately chewing tobacco or smoking cigars.*

'We were always interested'. Unless, that is, Polidori joined in. Mary's reminiscences present the doctor as a vainglorious and hot-headed fool—jealous of the growing intimacy between his noble patron and Percy Shelley. It does seem, from Byron's letters and Polidori's *Diary* at the time, that the rows with Lord Byron, some of them petty or petulant, did become more frequent after the poets had met and when Byron and Shelley began to spend time together. Before then, on first arrival at Sécheron, Byron wrote of his physician and companion:

Polidori has been ill—but is much better—a little experience will make him a very good traveller—if his health can stand it.

By June 23rd, less than a month later, he was writing about 'that child and childish Pollydolly' and teasing him in front of the others. Byron would limp down the path to Montalègre, partly to spend time with Shelley, partly to get away from 'Dr. Dori'. Mary Shelley, in 1828, was even more scathing. He had become one of the fools she did not suffer gladly:

When Polidori was of their party (which, till he found attractions elsewhere, was generally the case), their more elevated subjects of conversation were almost always put to flight by the strange sallies of this eccentric young man, whose vanity made him a constant butt for Lord Byron's sarcasm and merriment . . . his ambition for distinction far outweighed both his powers and opportunities of attaining it.

Polidori was also presented as a source of 'much expense'—hiring carriages at one *louis* a day, to ferry him to and from parties in and around Geneva—while Byron 'retired for my part entirely from society, with the exception of one English family' (meaning the Shelley party?). In late June and July, he would, however, spend time with Madame de Staël at her château Coppet, on the northern shore of the Lake, across from Diodati. Claire Clairmont was not mentioned at all by Mary Shelley, except for one glancing reference to 'Mr. and Mrs. Shelley, and a female relative of the latter'. At the time, according to both Polidori and Byron, she was much in evidence: usually chaperoned by Percy or Mary, or else busy preparing copies of Byron's poems and especially *Childe Harold*. She had offered to act as his secretary, in an attempt to be close to him: and she continued to try and extend casual sex with Byron into a proper relationship. Claire seemed to be getting increasingly on Mary's nerves—maybe because Mary suspected an earlier liaison with Percy. The novelty of her impetuous antics had long ago worn off, and they had always been competitive. Byron, for his part, made every effort to ignore Claire—and to ensure that she was seldom alone with him in public except as a copyist; in private, there was still occasional sex. He later wrote to his banker-friend Douglas Kinnaird, the man who had recruited him to the Drury Lane committee, in an astonishingly contemptuous tone:

I never loved nor pretended to love her, but a man is a man, and if a girl of eighteen comes prancing to you at all hours there is but one way—the suite of all this is that she was with child *. . . Whether this impregnation took place before I left England or since I do not know; the [carnal] connection had commenced previously to my setting out . . . the next question is, is the brat* mine*? I have reason to think so, for I know as much as one can know such a thing—that she had* not *lived with S. [Shelley] during the time of our acquaintance—and that she had a good deal of that same with me . . . this comes of 'putting it about' . . . and thus people come into the world.*

What exactly did Byron mean to convey when he wrote 'she had *not lived* with S. during the time of our acquaintance'?

Claire must have realised she was pregnant in the first weeks of June. Shelley was the first to hear about it, and so on June 24th he altered his Will to include a more substantial bequest to Claire: £12,000, half for her unborn child. He told Byron at the end of June, when they were on their *promenade sur le lac*. Mary, at that stage, was not to be informed. On August 2nd, Percy and Claire went to see Byron at Diodati for an intimate discussion about the child's upbringing. 'I do not,' wrote Mary, 'for Lord Byron did not seem to wish it.' Did Shelley arrange such a generous portion for Claire's child, because he suspected or knew that Byron would not be making any financial provision?

Polidori's *Diary* covering the first week at the Villa Diodati confirms that he did indeed manage to find 'attractions elsewhere'; a lot of partying. As Byron was later to write: '. . . having seen very little of [the world], Polidori was naturally more desirous of seeing more society than suited my present habits or my past experience.' So he made a point of presenting his young physician to those 'gentlemen of Geneva' for whom he (Byron) had letters of introduction.

Title-page of the book of 'German ghost stories', which inspired the storytelling evenings of June 17th/18th 1816 in the Villa Diodati.

June 11.—Wrote home . . . Went to Shelley's; dined; Shelley in the evening with us.

June 12.—Rode to town. Subscribed to a circulating library, and went in the evening to Madame Odier [one of several visits: Dr Odier was a fellow graduate of Edinburgh University]. Found no one. Miss O, to make time pass, played the Ranz des Vaches—plaintive and warlike. People arrived . . . Began dancing: waltzes, cotillons, French country-dances and English ones: first time I shook my feet to French measure. Ladies all waltzed except the English: they looked on frowning. Introduced to Mrs. Slaney: invited me for next night. You ask without introduction; the girls refuse those they dislike. Till 12. Went and slept at the Balance.

June 13.—Rode home, and to town again. Went to Mrs. Slaney: a ball. Danced and played at chess. Walked home in thunder and lightning: lost my way . . . [This was the storm evoked by Byron in Childe Harold.*]*

June 14.—Rode home—rode almost all day. Dined with [Dr] Rossi, who came to us . . . Shelley etc. fell in [sic] in the evening.

June 15.—Up late; began my letters. Went to Shelley's. After dinner, jumping a wall my foot slipped and I strained my left ankle. Shelley etc. came in the evening; talked of my play etc., which all agreed was worth nothing. Afterwards, Shelley and I had a conversation about principles . . .

June 16.—Laid up. Shelley came and dined and slept here, with Mrs. S[helley] and Miss Clare Clairmont [up to now in his Diary, *Polidori had always referred to Claire as 'Miss Godwin'; he continued to call Mary Godwin 'Mrs. S.']. Wrote another letter.*

This accident was mentioned by Byron, in letters of June 23th and 27th, and by Mary Shelley in her testimony to Thomas Moore. It explains why Dr Polidori stayed in, for most of the time, at Diodati for the crucial evenings and nights of 16th–18th June. Byron explained in a letter, curtly, that Dr Polidori was confined to Diodati 'in hospital with a sprained ancle [sic], which he acquired in tumbling from a wall—he can't jump'. And 'I left the Doctor at Diodati—he sprained his ankle'. Mary gave a fuller account:

Another time, when the lady just mentioned was, after a shower of rain, walking up the hill to Diodati, Lord Byron, who saw her from his balcony where he was standing with Polidori, said to the latter, 'Now, you who wish to be gallant ought to jump down this small height, and offer your arm.' Polidori chose the easiest part of the declivity and leaped;—but, the ground being wet, his foot slipped and he sprained his ankle. Lord Byron instantly helped to carry him in, and after he was laid on the sofa, went upstairs himself to fetch a pillow for him. 'Well, I did not believe you had so much feeling,' was Polidori's ungracious remark which, it may be supposed, not a little clouded the noble poet's brow . . .

This incident seems particularly poignant if, as Miranda Seymour suggests, Dr Polidori 'fell a little in love with Mary'. He had selected himself her tutor in Italian and his *Diary* later in June is full of references such as 'Walked to Mrs. Shelley', 'Went down to Mrs. S[helley] for the evening', 'Saw Mrs. Shelley: dined', 'All day to Mrs. S[helley's]', 'Came away at 11 after confabbing'. The publisher John Murray had commissioned an eye-witness journal of Lord Byron's colourful adventures on the continent: but most of Polidori's entries were about 'Mrs. S.'. If Polidori *was* a little in love with her, Mary Shelley may have been knowingly mischievous when she told Thomas Moore in 1828 about another incident which took place just after Byron and Shelley had returned from their Rousseau pilgrimage. 'The young physician' had told Byron, in confidence, that he had 'fallen in love':

On the evening of this tender confession, they both appeared at Shelley's cottage—Lord Byron, in the highest and most boyish spirits, rubbing his hands as he walked about the room, and in that utter incapacity of retention which was one of his foibles, making jesting allusions to the secret he had just heard . . . Polidori [in extreme embarrassment] said, 'I never . . . met with a person so unfeeling.' This sally, though the poet had evidently brought it upon himself, annoyed him most deeply. 'Call me cold-hearted—me insensible!' he exclaimed, with manifest emotion.

On June 18th, the same evening as he began *his* ghost story after tea, Polidori noted ruefully: 'Mrs. S[helley] called me her brother (younger)'. Claire wrote to Byron, in an undated note evidently from around this time:

Pray if you can send M. Polidori either to write another dictionary or to the lady he loves. I hope this last may be his pillow and then he will go to sleep; for I cannot come at this hour of the night and be seen by him.

Was she perhaps suggesting that Polidori should spend the night at Montalègre? The 'dictionary' reference was a confusion with Polidori's father Gaetano, who *had* compiled a dictionary. Others made the same mistake that summer.

Perhaps to console the doctor for the sprained ankle and damaged pride, the poets 'talked of my play' on the evening of June 15th. This was probably his *Cajetan*. Mary elaborated that Polidori 'had set his heart upon shining as an author', and that the play-reading was 'not a little trying to gravity' with the poets stifling their laughter at some of the lines. At the end of the performance, Byron—according to Mary—delivered a kindly verdict (which Polidori does not mention):

I assure you, when I was in the Drury-lane committee, much worse things were offered to us.

In general, by the time she helped Thomas Moore with his biography, Polidori had become 'the other', the outsider, the court jester, the gauche foreigner—while the poets were on their way to becoming saints. Any tensions at the Villa were attributed to the hapless Doctor, while Claire was written out of the story altogether. He was so insignificant that he kept getting confused with his father.

That said, it is clear that Mary Godwin's tense relationship with Polidori—which she was to turn into comedy in her written memories in 1828 and 1831—played its part in the highly-charged events leading up to the night of 17th/18th June. So did her attitudes towards Shelley, Byron and Claire. As she was to write: 'incapacity and timidity always prevented my mingling in the nightly conversations of Diodati—they were, as it were, entirely tête-à-tête between Shelley and Byron'. And 'I was a devout but nearly silent listener'. It is clear from Polidori's *Diary* that when he dined in company, Byron much preferred to dine

This attempt to describe the effects of the Sublime & Wonderful is dedicated to M. G. Lewis Efq. M.P.

TALES of WONDER!

alone with Percy Shelley—'Dined with S', 'Thence to S', 'To S in a boat'. Which explains why when he wasn't dining and dancing in Geneva, Polidori spent a fair amount of time with Mary and Claire.

And she felt other stresses. She was the daughter of two of Shelley's favourite political thinkers. His talk of free love, and the tyranny of marriage, was partly inspired by William Godwin's early treatise on *Political Justice*—even though the mature and more socially respectable William Godwin had disowned Percy and Mary: Percy, because he had deserted his wife and two small children; Mary, because she had run off with a married man when she was still a schoolchild. As Mary Shelley later wrote, in 1831: 'My husband . . . was from the first, very anxious that I should prove myself worthy of my parentage, and enrol myself on the page of fame. He was for ever inciting me to obtain literary reputation'. And again: 'as the daughter of two persons of distinguished literary celebrity', Shelley 'desired

that I should write, not so much with the idea that I could produce any thing worthy of notice, but that he might himself judge how far I possessed the promise of better things hereafter.' No pressure, then. Percy and Mary constantly read, wrote and translated together—they liked discussing their day's reading last thing at night, on the sound Godwinian principle that 'to read one book without others beside you to which you may refer is mere child's work'; they talked about 'the cardinal article of [Shelley's] faith, that if men were but taught to treat their fellows with love, charity and equal rights, this earth would realize Paradise'; and they both did without sugar because it was produced by slaves on West Indian plantations. Some have interpreted Victor Frankenstein's creature as a public comment on the institution of slavery and the mutually corrupting influence of the master-slave relationship.

So when Mary Godwin found herself sometimes excluded from

James Gillray's 1802 hand-coloured etching and aquatint Tales of Wonder!, *showing three enthralled young ladies reading Gothic stories by M.G. Lewis, well after their bed-time, with Fuseli-style painting on the wall.*

the 'nightly conversations of Diodati', it must have come as a shock. It also meant she had to spend too much time with Claire and Polidori. And she distracted herself by studying. In her novel, the creature learns how to live from the three books he is reading: he learns about emotional intelligence, sensibility and human friendship from Goethe's *The Sorrows of Young Werther*; about human achievements and admirable heroes of past ages in a volume of Plutarch's *Lives* (or *Parallel Lives of Greek and Roman heroes*) and about himself as the new Adam from Milton's epic *Paradise Lost*, which 'excited far deeper emotions'. 'The possession of these treasures gave me extreme delight,' he says. 'I now continually studied and exercised my mind upon these histories . . .'

The events leading up to the night of June 17th/18th, when the tensions between these highly-strung individuals finally bore fruit, were to be described in five main sources. Mary Godwin's *Journal* has disappeared, and there are no Byron letters between May 27th and June 23rd: when he *does* write about Diodati, Byron scarcely mentions Percy Shelley and never once mentions Mary. He mentions Dr Polidori several times, and writes about Claire with open contempt.

The earliest published account of the immediate circumstances in which *Frankenstein* was first told comes from Percy Shelley's preface to the first (anonymous) edition of the novel, later dated by Mary Shelley September 1817. This was presented 'as if' by Mary, and took the place of a preface written by her on 14th May 1817, but was in actual fact subtly diminishing of her efforts (in comparison with those of her two better-known friends):

. . . this story was begun in the majestic region where the scene is principally laid, and in society which cannot cease to be regretted. I passed the summer of 1816 in the environs of Geneva. The season was cold and rainy, and in the evenings we crowded around a blazing wood fire, and occasionally amused ourselves with some German stories of ghosts, which happened to fall into our hands. These tales excited in us a playful desire of imitation. Two other friends (a tale from the pen of one of whom would be far more acceptable to the public than any thing I can ever hope to produce) and myself agreed to write each a story, founded on some supernatural occurrence. The weather, however, suddenly became serene; and my two friends left me on a journey among the Alps, and lost, in the magnificent scenes which they present, all memory of their ghostly visions. The following tale is the only one which has been completed.

Mary Shelley's earliest published account was contained, anonymously, in Volume Two of Thomas Moore's *Life of Lord Byron* (1830):

During a week of rain at this time, having amused themselves with reading German ghost-stories, they agreed, at last, to write something in imitation of them. 'You and I,' said Lord Byron to Mrs. Shelley, 'will publish ours together' [an astonishing offer to an eighteen-year-old who had never published anything before]. He then began his tale of the Vampire; and, having the whole arranged in his head, repeated to them the sketch of a story one evening,—but, from the narrative being in prose, made but little progress in filling up his outline. The most memorable result, indeed, of their story-telling compact, was Mrs. Shelley's wild and powerful*

romance of Frankenstein,—*one of those original conceptions that take hold of the public mind at once, and for ever.*

** From his remembrance of this sketch, Polidori afterwards vamped up his strange novel of the Vampire; which, under the impression of its being Lord Byron's, was received with much enthusiasm in France. It would, indeed, not a little deduct from our value of foreign fame, if what some French writers have asserted to be true, that the appearance of this extravagant novel among our neighbours first attracted their attention to the genius of Lord Byron.*

The reference to *The Vampyre*, and the footnote, were evidently intended as a belated reply to an 'Extract of a letter from Geneva' which had appeared in the *New Monthly Magazine* on April Fools' Day 1819, another source. This *Extract* was the first publication to *name* the visitors to the Villa Diodati that summer of 1816. It had, apparently, arrived on the editor's desk in autumn 1818, together with a manuscript copy of *The Vampyre*, from 'a friend travelling on the Continent'. Byron thought it must be the work of Dr Polidori, and admitted that *some* of it (the account of his social life) was accurate. As to the incident involving the poem *Christabel* (see later), Shelley 'certainly had the fit of phantasy which Polidori describes, though not exactly as he describes it'. Recently, it has been suggested that the *Extract* was either the work of a hack journalist called John Mitford; or of a canny and gossipy resident of Geneva—who had quizzed the servants at the Villa, asked around the city, found a talkative 'cottager' in Cologny and—the main source—had talked to or doorstepped the Countess Catherine Bruce (the 'Countess of Breuss' in Polidori's *Diary*), who lived in the Maison d'Abraham Gallatin near Geneva. Polidori had visited the Countess several times in June 1816, she probably heard her stories from him, though her chronology of events (such as the 'Christabel' night) does differ from his. Polidori was to disown the *Extract*, and to cross it out in his author's copy of *The Vampyre*. In the introduction to his novel *Ernestus Berchtold* (1819)— 'The tale here presented to the public is the one I began at Cologny, when *Frankenstein* was planned'—he included a note which explained the genesis of *The Vampyre* in Byron's contribution:

Upon this foundation I built the Vampyre, *at the request of a lady, who denied the possibility of such a ground-work forming the outline of a tale which should bear the slightest appearance of probability. In the course of three mornings, I produced that tale, and left it with her. From thence it appears to have fallen into the hands of some person, who sent it to the Editor in such a way, or to leave it so doubtful from his words, whether it was his lordship's or not . . .*

The *Extract* is introduced with a reference to Byron's bestselling epic poem:

You must have heard, or the Third Canto of Childe Harold *will have informed you, that Lord Byron resided many months [actually four and a half] in the neighbourhood.*

Although 'Canto the Third' of *Childe Harold* was written in May and June 1816, on the hoof—as a sort of poetic travelogue, capturing moments in Byron's exile—and although the poet was inspired by the extreme landscape and weather (the darken'd Jura, the storms,

the food for meditation, the pilgrimage to Rousseau-land), the ghost-story session was not mentioned in it. Lord Byron recalled being 'half mad during the time of its composition', but still regarded it as 'a fine indistinct piece of poetic desolation'. The relevant verses begin at LXVIII ('Lake Leman woos me with its crystal face') and end at CXVIII, the finale of the Canto ('The child of love,—though born in bitterness / And nurtured in convulsion'). The 'Chamouny' references in the *Extract* were to a series of incidents involving hotel registers and a visitors' book, towards the end of July 1816—well-known to gossipy British tourists who preferred to see the Alps as nature's temples of the Lord, sublime evidence of creationism. In the 'Destination' column of the Visitors' Book at the Hôtel de Londres, Chamonix, Shelley wrote 'L'Enfer' ('Hell'), and in the 'Occupation' column he added, in Greek, 'I am a lover of mankind, a philanthropist, a democrat and an atheist'. In the Hotel Register, Mary was 'Mad. MWG', Claire was 'Mad. JC'. In the mountain hut at Montanvers, their next stop, Shelley changed this—probably at Mary's request—to 'Madame son Épouse' and 'la soeur' ('Madame his wife' and 'the sister'). But he repeated the 'atheos' reference. This went down badly with his fellow Alpine tourists, one of whom—a Lutheran minister—wrote of 'the horrid avowal of *atheism* industriously subjoined'. He also wrote, about the Villa Diodati, of:

. . . the house where Lord Byron lives, in sullen and disgraceful seclusion. Besides his servants, his only companions are two wicked women. He sees no company . . . no person of respectability would visit him.

So, Byron's decision not to socialise in Geneva was being taken as evidence against him. This gives an idea of the moral—and indeed political—context in which the *Extract* would have been received, in 1819. Dr Polidori was not with the Shelleys when the Visitors' Book was signed.

I have gathered from their accounts some excellent traits of his lordship's character, which I will relate to you at some future opportunity. I must, however, free him from one imputation attached to him—of having in his house two sisters as the partakers of his revels. This is, like many other charges which have been brought against his lordship, entirely destitute of truth. His only companion was the physician I have already mentioned. The report originated from the following circumstance: Mr Percy Bysshe Shelly, a gentleman well known for extravagance of doctrine, and for his daring in their profession, even to sign himself with the title of Αθεος in the Album at Chamouny, having taken a house below, in which he resided with Miss M.W. Godwin and Miss Clermont, (the daughters of the celebrated Mr Godwin) they were frequently visitors at Diodati, and were often seen upon the lake with his Lordship, which gave rise to the report, the truth of which is here positively denied.

Among other things which the lady, from whom I procured these anecdotes, related to me, she mentioned the outline of a ghost story by Lord Byron. It appears that one evening, Lord B., Mr P.B. Shelly, the two ladies and the gentleman before alluded to, after having perused a German work, which was entitled Phantasmagoriana, *began relating ghost stories; when his lordship having recited the beginning of* Christabel, *then unpublished, the whole took so strong*

a hold of Mr Shelly's mind, that he suddenly started up and ran out of the room. The physician and Lord Byron followed, and discovered him leaning against a mantle-piece, with cold drops of perspiration trickling down his face. After having given him something to refresh him, upon enquiring into the cause of his alarm, they found that his wild imagination having pictured to him the bosom of one of the ladies with eyes (which was reported of a lady in the neighbourhood where he lived) he was obliged to leave the room in order to destroy the impression. It was afterwards proposed, in the course of conversation, that each of the company present should write a tale depending upon some supernatural agency, which was undertaken by Lord B., the physician, and Miss M.W. Godwin. My friend, the lady above referred to, had in her possession the outline of each of these stories; I obtained them as a great favour, and herewith forward them to you, as I was assured you would feel as much curiosity as myself, to peruse the ébauches *of so great a genius, and those immediately under his influence.*

We have in our possession the* Tale of Dr. ——, *as well as the outline of that of Miss Godwin. The latter has already appeared under the title of* Frankenstein, or The Modern Prometheus; *the former, however, upon consulting with its author, we may, probably, hereafter give to our readers.—Ed.

So, the editor of the *New Monthly Magazine* received from *someone* the *Extract*, plus 'the outline of each of these stories': that is, Miss Godwin's outline—presumably a transcription of the story she told on June 17th/18th, which was to become the novel *Frankenstein*—and Polidori's *The Vampyre*. Sadly, the former has been lost: it would have been the very earliest version of *Frankenstein*, and would have helped to solve various mysteries about her process of drafting. William Godwin was furious about the publication of this *Extract*, which he felt contained passages 'full of the grossest and most unmanly reflections' on himself and his daughter Mary—and on 6th April 1819, five days after publication, tried to arrange with the publisher Colburn for the offending passages to be removed from future editions.

A fuller and much better-known account comes from Mary Shelley's retrospective *Introduction* to the 1831 popular edition—written some fourteen years after Shelley's, on October 15th 1831, and fifteen years after the events it purported to describe. It was published separately on October 22nd 1831 in the *Court Journal*, edited by the same man—Henry Colburn—as had published the *Extract* in 1819. It is a great pity he did not publish the outline version at the same time. *Frankenstein* was issued nine days later:

In the summer of 1816, we visited Switzerland, and became the neighbours of Lord Byron. At first we spent our pleasant hours on the lake, or wandering on its shores; and Lord Byron, who was writing the third canto of Childe Harold, *was the only one among us who put his thoughts upon paper . . .*

But it proved a wet, ungenial summer, and incessant rain often confined us for days to the house. Some volumes of ghost stories, translated from the German into French, fell into our hands. There was the History of the Inconstant Lover, *who, when he thought to clasp the bride to whom he had pledged his vows, found himself in the arms of the pale ghost of her whom he had deserted. There was the tale of the sinful founder of his race whose miserable doom it was to bestow the kiss of death on all the younger sons of his fated house, just when they reached the*

age of promise . . . I have not seen these stories since then; but their incidents are as fresh in my mind as if I had read them yesterday.

'We will each write a ghost story', said Lord Byron, and his proposition was acceded to. There were four of us. The noble author began a tale, a fragment of which he printed at the end of his poem of Mazeppa. Shelley, more apt to embody ideas and sentiments in the radiance of brilliant imagery, and in the music of the most melodious verse that adorns our language, than to invent the machinery of a story, commenced one founded on the experiences of his early life. Poor Polidori had some terrible idea about a skull-headed lady, who was so punished for peeping through a keyhole—what to see I forget—something very shocking and wrong of course . . . The illustrious poets also, annoyed by the platitude of prose, speedily

relinquished their uncongenial task.

I busied myself to think of a story—a story to rival those which had excited me to this task. One which would speak to the mysterious fears of our nature, and awaken thrilling horror—one to make the reader dread to look round, to curdle the blood, and quicken the beatings of the heart. If I did not accomplish these things, my ghost story would be unworthy of its name. I thought and pondered—vainly. I felt that blank incapacity of invention which is the greatest misery of authorship, when dull Nothing replies to our anxious invocations. Have you thought of a story? I was asked each morning, and each morning I was forced to reply with a mortifying negative.

Many and long were the conversations between Lord Byron and Shelley to which

The myth of June 1816, Hollywood-style: Mary Shelley (Elsa Lanchester), Lord Byron (Gavin Gordon), Percy Shelley (Douglas Walton) and a maid (Una O'Connor), in the vast drawing-room of the Villa Diodati (from the prologue to **The Bride of Frankenstein**, 1935).

I was a devout but nearly silent listener. During one of these, various philosophical doctrines were discussed, and among others the nature of the principle of life, and whether there was any probability of its ever being discovered and communicated. They talked of the experiments of Dr Darwin (I speak not of what the Doctor really did, or said that he did, but, as more to my purpose, of what was then spoken of as having been done by him), who preserved a piece of vermicelli in a glass case, till by some extraordinary means it began to move with voluntary motion. Not thus, after all, would life be given. Perhaps a corpse would be re-animated; galvanism had given token of such things: perhaps the component parts of a creature might be manufactured, brought together, and endued with vital warmth.

Night waned upon this talk, and even the witching hour had gone by, before we retired to rest. When I placed my head on my pillow, I did not sleep . . . On the morrow I announced that I had thought of a story. *I began that day with the words,* It was on a dreary night of November, *making only a transcript of the grim terrors of my waking dream.*

At first I thought of but a few pages—of a short tale; but Shelley urged me to develop the idea at greater length. I certainly did not owe the suggestion of one incident, nor scarcely of one train of feeling, to my husband, and yet but for his incitement, it would never have taken the form in which it was presented to the world. From this declaration I must except the preface. As far as I can recollect, it was entirely written by him.

And now, once again, I bid my hideous progeny go forth and prosper. I have an affection for it, for it was the offspring of happy days . . .

This cliffhanger, written in 1831 to promote the popular edition of *Frankenstein*, owed much to Coleridge's celebrated account of another waking dream, the one which resulted in *Kubla Khan* (first published 1816). It also implied parallels between the creation of the novel and the fictional scientist's creation of the daemon. The short tale ('but a few pages') was presumably similar to the *New Monthly Magazine*'s outline. The 'volume of ghost stories' which fell into their hands was a two-volume collection of fantasies *Fantasmagoriana, ou Recueil d'Histoires d'Apparitions, de Spectres, Revenans, Fantômes etc.* (1812), translated into French from the original five-volume German version *Der Gespensterbuch* by Jean-Baptiste Benoit Eyriès. A copy of the book had been purchased in Geneva, probably by Byron, as some holiday reading, and Lord Byron read it aloud while they sat around the ornate fireplace at the Villa Diodati, with its blazing wood fire. It, in Mary's account, was a dark and stormy night (a phrase which, by the way, opened the novel *Paul Clifford* by Edward Bulwer-Lytton in 1830, and launched it into the English language). There was an English translation of *Fantasmagoriana* available under the title *Tales of the Dead* (London, 1813) but presumably this was not to be had in Geneva. Taking his cue from the second story in the *Fantasmagoriana*, he evidently suggested in a playful spirit that they should each have a go at writing a tale of terror, to improve on the tacky collection he was reading out. Percy Shelley called this 'the playful desire of imitation'. 'Everyone is to relate a story of ghost, or something of a similar nature,' said a character in the story *Les Portraits de Famille*, 'it is agreed amongst us that no one shall search for any explanation, even

though it bears the stamp of truth, as explanations would take away all pleasure from ghost stories.' So the stories would not be like those respectable Gothic novels—school of Mrs Ann Radcliffe—which explained everything away in the last chapter.

Although Mary Shelley recalls that the stories in the *Fantasmagoriana* were 'as fresh in my mind as if I had read them yesterday', understandably after so many years her summaries of them are approximate. And she forgets that another of them was actually about the re-animation of a corpse's head. But it is interesting that she remembered the stories about a) a man who is pursued by the pale ghost of his deserted wife and b) a family whose younger sons are doomed to be killed by a giant spectre who creeps into their bedroom at night and gives them a deathly kiss on the forehead: shades, maybe, of Percy Shelley and Harriet Westbrook; and of her personal experience of losing a baby girl.

Dr Polidori's *Diary*—the only account written at the time—tells a different story, which is also at variance with the compressed order of events presented in the *Extract* of 1819:

June 16.—laid up. Shelley came, and dined and slept here [at Diodati], with Mrs. S and Miss Clare Clairmont. Wrote another letter.

June 17.—Went into the town; dined with Shelley etc. here. Went after dinner to a ball at Madame Odier's, where I was introduced to Princess Something and Countess Potocka [Potocki], Poles, and had with them a long confab. Attempted to dance, but felt such horrid pain was forced to stop. The ghost stories are begun by all but me.

June 18.—My leg much worse. Shelley and party here. Mrs. S called me her brother (younger) [Mary was in fact eighteen, Polidori twenty]. Began my ghost-story after tea. Twelve o'clock, really began to talk ghostly. LB repeated some verses of Coleridge's Christabel, *of the witch's breast; when silence ensued, and Shelley, suddenly shrieking and putting his hands to his head, ran out of the room with a candle. Threw water in his face, and after gave him ether. He was looking at Mrs. S, and suddenly thought of a woman he had heard of who had eyes instead of nipples, which, taking hold of his mind, horrified him.—He married; and, a friend of his liking his wife, he tried all he could to induce her to love him in turn. He is surrounded by friends who feed upon him, and draw upon him as their banker. Once, having hired a house, a man wanted to make him pay more, and came trying to bully him, and at last challenged him. Shelley refused, and was knocked down; coolly said that would not gain him his object, and was knocked down again. [Dr] Slaney called.*

June 19.—Leg worse; began my ghost-story. Mr. S etc. forth here. [Charles Victor von] Bonstetten and Rossi called . . . Bed at 3 as usual.

June 20.—My leg kept me at home. Shelley etc. here.

June 21.—Same.

June 22.—LB and Shelley went to Vevai; Mrs. S and Miss Clare Clairmont to town. Went to Rossi's—had tried his patience. Called on Odier; Miss reading Byron.

Polidori would surely have mentioned it if Mary Godwin really *was* the last to tell her story, and if she really *had* dramatically announced to the company one morning that she had at last *thought of a story.* Instead, he writes that on the night of June 17th 'The ghost stories

are begun by all but me.' Percy Shelley, too, makes no mention of Mary's dream, or her struggle to contribute. So Mary Godwin may well have been the *first* to tell her story, not the last. Unless by 'begun' Polidori means preparation rather than telling. Mary recalls of the ghost-story session, 'there were four of us': in fact, there were five people present that night in the long room/picture gallery at Diodati. And they all contributed. As with her testimony to Thomas Moore, she omits Claire Clairmont from her reminiscences. 'Poor Polidori had some terrible idea about a skull-headed lady . . .': in fact, the story the doctor told was to become his novel *Ernestus Berchtold*, about the love affair between a Swiss patriot and a lady who turns out to be his sister and which, in the published version, he referred to as 'the one I began at Cologny, when *Frankenstein* was planned'. Maybe this was thought by Mary Shelley to be too near the knuckle, given that Lord Byron was sitting in the room at the time. The 1831 edition of *Frankenstein* transforms Victor's beloved Elizabeth Lavenza from first cousin to childhood friend. The 'terrible idea about a skull-headed lady', her punishment for peeping through a keyhole and seeing something she shouldn't, may well have been the story told by *Claire*. It sounds characteristically risqué and romantic—maybe delivered with a dash of humour—and in a strange way conventional as well. Very Claire. Mary Shelley continues with her account of 'the conversations between Lord Byron and Shelley': these almost certainly involved Dr Polidori too, as we've seen. A conversation about 'the nature of the principles of life', for example, took place on June 15th, and was between *Polidori* and Shelley. She presents the ghost-story session as a game, a distraction from the more significant business of writing 'the most melodious verse that adorns our language'. In 1831, she was writing after the near-sanctification of Percy Shelley, and the apotheosis of Lord Byron. Percy Shelley, too, wrote of 'a playful desire of imitation', and stressed how the poets soon grew tired of the game, to go on their journey 'among the Alps'. It seems that the atmosphere was much more tense than this. Polidori was feeling irritable and in pain, annoyed to be excluded from the charmed circle of the poets. Claire may well have just told Shelley, in confidence, that she was pregnant. Mary was anxious about her son William, and about Percy's sometimes careless attitude towards the feelings of others; she was also uneasy about the amount of time Claire was spending with him—and suspected that Claire might be proving better, more cheerful, company than her. Byron was devastated by the breakdown of his marriage, and his exile, but determined not to show it. The weather was getting on everyone's nerves. They were cooped up in the Villa Diodati. When Mary Shelley described the physical surroundings of her dream, 'the very surroundings of the room, the dark *parquet*, the closed shutters, with the moonlight struggling through, and the sense I had that the glassy lake and the high white Alps were beyond', she was describing a room in the Villa rather than the Maison Chappuis. Actually, it wasn't the Alps that were beyond the lake, it was the Jura. And when Percy Shelley wrote

in *his* Preface (as by Mary) that 'my two friends left me on a journey among the Alps', he also was misremembering: Byron and Shelley never journeyed together to the Alps. It was Mary, Percy and Claire who set out towards Chamonix on Sunday July 21st—a month later. Byron was so fed up with Claire by then that he did not even bother to say goodbye.

Meanwhile, tourists from the Sécheron shore were continuing to gawp at them. As Shelley was to recall in a letter some five years later:

The natives of Geneva and the English people who were living there did not hesitate to affirm that we were leading the life of the most unbridled libertinism. They said that we had found a pact to outrage all that is regarded as most sacred in human society. Allow me . . . to spare you the details. I will only tell you that atheism, incest, and many other things—sometimes ridiculous and sometimes terrible—were imputed to us. The English papers did not delay to spread the scandal, and the people believed it. . . . The inhabitants on the banks of the lake opposite Lord Byron's house used telescopes to spy on his movements. One English lady fainted with horror (or pretended to!) on seeing him enter a drawing room. . . . You cannot . . . conceive the excessive violence with which a certain class of the English detest those whose conduct and opinions are not precisely modelled on their own. The systems of those ideas forms a superstition, which constantly demands and constantly finds fresh victims. Strong as theological hatred may be, it always yields to social hatred.

To make matters worse, according to the Genevan police records, the visitors to the Villa Diodati had become well-known to the local constabulary—who were not renowned for their sense of humour. Byron had reported that his sailing-boat's anchor and some fixtures and fittings had been stolen from the little harbour near the Maison Chappuis, and then took the law into his own hands by noisily threatening some completely innocent local residents. Polidori had roughed up a local apothecary—breaking his spectacles and throwing his hat into the gutter—because he had supplied him (or rather Lord Byron) with some substandard drugs: this resulted in a warrant for the Doctor's arrest. But the most interesting case was a bungled breaking-and-entering attempt at the Villa Diodati itself: which, according to the *rapports de police*, resulted in a lieutenant suggesting that the neighbouring cabarets should be placed under observation to see if any '*étrangers et gens suspects*' were loitering with intent.

All of which came to a head on the night of June 18th, a night which Mary Shelley does not mention. Nor does Percy Shelley. This may have been the occasion when Percy—'more apt to embody ideas and sentiments in the radiance of brilliant imagery'—told or continued *his* story 'founded on the experiences of his early life', one he apparently never wrote down, although some have suggested that his story may have been the fragmentary *A shovel of his ashes*. If this *was* the occasion, it was—as Richard Holmes has observed—'an explosive performance'. The *Extract* appended to Polidori's *The Vampyre* places this incident *before* Byron suggested that they each write a ghost story—and implies that it gave them the idea—when in fact it was probably the night after. The trouble started at midnight when Lord

Byron recited by heart some verses from Coleridge's poem *Christabel*, a poem he much admired. He must already have known the piece well. When *Christabel* was published by John Murray at the end of July 1816, it was accompanied by a promotional quote from Byron: 'that wild and singularly original and beautiful poem'. He scolded Murray, from Diodati, for disagreeing with him about its merits: 'I won't have you sneer at *Christabel*—it is a fine wild poem'. He had met Coleridge on April 10th 1816, shortly before leaving England, and had encouraged him to finish the poem and find a publisher for it: he had also persuaded Coleridge to recite *Kubla Khan*. Where Mary Godwin was concerned, perhaps Byron's rendition reminded her—an indelible memory—of Coleridge reciting *The Rime of the Ancient Mariner* to the grown-ups of the Godwin household in 1806 one evening when she was nine years old, in his West Country accent, while she hid in terror behind the parlour sofa well past her bedtime. In *Frankenstein*, she would have the explorer Robert Walton write of 'the land of mist and snow'—from the *Rime*—and, in the creation chapter, would have Victor Frankenstein quote the lines:

> *Like one who, on a lonely road,*
> *Doth walk in fear and dread*
> *And, having once turn'd round, walks on,*
> *And turns no more his head:*
> *Because he knows a frightful fiend*
> *Doth close behind him tread.*

Complete with Mary's footnote: 'Coleridge's *Ancient Mariner*'. Both quotations were anachronistic, since the novel was supposedly set in 1796–1797, but *The Rime* cast a long shadow over the whole of *Frankenstein*. It is likely that Mary included this quotation, from memory, in the ghost story she told.

The verses from *Christabel* which caused the trouble were 'of the witch's breast'. In the poem, a dreamy lesbian fantasy, the witch is disguised as a fragrant princess, but is really a lamia—who seeks to drain the vitality of the young heroine Christabel. The witch inveigles herself into Christabel's bedroom, casts a spell on her and then undresses. The poem also makes reference to the abandonment of a child (the seductive Geraldine says she was abandoned an hour after her birth) and to the witch's piercing eyes.

The lines from Coleridge's *Christabel* that had pushed Shelley over the edge and sent him shrieking from the room were these:

> *Beneath the lamp the lady bowed,*
> *And slowly rolled her eyes around;*
> *Then drawing in her breath, aloud*
> *Like one that shuddered, she unbound*
> *The cincture from beneath her breast:*
> *Her silken robe and inner vest*
> *Dropped to her feet, and full in view,*
> *Behold! her bosom and half her side—*
> *Hideous, deformed, and pale of hue—*
> *O shield her! shield sweet Christabel!*

This horrifying image of disfigurement, confused with fantasies about his early life that were already on his mind, was the one that Shelley projected on to 'Mrs S'. The image of Mary as a harpy— 'hideous, deformed and pale of hue'—was too much for him. And all *this* was encompassed in Mary's bland reminiscence: 'Shelley . . . commenced [a story] founded on the experiences of his early life'. Neither she nor Shelley, for obvious reasons, admitted in print the many autobiographical elements in *Frankenstein*.

Percy Shelley ran out of the room, and Polidori—the doctor in the house—went after him, threw water on his face, gave him ether to calm him down and sat up with him. Throughout that summer, Polidori was on hand to administer laudanum to Shelley (prescribed for his nervous headaches) and Black Drop—another compound of opium and alcohol—to Byron. Shelley sometimes enjoyed frightening others, especially Claire, and talking 'terrors'—he'd been doing it ever since he'd spooked his little sisters—but this went deeper. Under the influence, he confessed to Polidori some of his darkest secrets— which the Doctor mostly understood. About Harriet Westbrook and 'a friend of his', perhaps Hogg, sharing everything along Godwinian lines. About William Godwin himself, who thought he had been promised a substantial allowance by Shelley, 'to contribute to the comforts of my closing days' and to write off his enormous debts, and who regularly wrote sharp letters about that promise even though he had broken off communication about anything else and would only talk through intermediaries. Perhaps also about Charles Clairmont, Claire's half-brother: he had been given financial support by Shelley, early in 1816, for a distillery project in Ireland which came to nothing. And about how he often felt persecuted by landlords—but would never resort to physical violence even if they did persecute him. Later that summer, Shelley would refuse to be challenged to a duel with Polidori. For some time, he had fantasised that his father and uncle were determined to lock him up in a lunatic asylum. After Shelley had unburdened himself, Dr Slaney, a doctor living locally, was called to take over. Lord Byron was bemused: 'I can't tell what seized him [Shelley]—for he don't want courage.'

The story Mary Godwin told—beginning with the words 'It was on a dreary night of November'—was eventually to become the opening of Volume 1 Chapter IV of the 1818 edition and Chapter V of the 1831 edition. That short story has not survived in manuscript, nor has the 'outline' transcribed by Polidori and left in Geneva. 'At first I thought but of a few pages', Mary was to recall. But when she decided to 'develope [sic] the idea at greater length', she was to produce the most influential novel of science-meets-fiction ever written.

Mary Godwin's manuscript draft of the 'creation' chapter of Frankenstein, *written in a notebook purchased in Geneva, and copied from the story she told on the night of 17th/18th 1816—the earliest surviving version, dating from that same summer.*

It was on a dreary night of November that I beheld ~~the frame of~~ my man compleated; ~~and~~ with an anxiety that almost amounted to agony, I collected ~~instruments~~ instruments of life around me ~~and endeavoured to~~ that I might infuse a spark of being into the lifeless thing that lay at my feet. It was already one in the morning, the rain pattered dismally against the window panes, & my candle was nearly burnt out, when by the glimmer of the half extinguished light I saw the dull yellow eye of the creature open — It breathed hard, and a convulsive motion agitated its limbs.

~~But how~~ How can I describe my emotion at this catastrophe; or how delineate the wretch whom with such infinite pains and care I had endeavoured to form. His limbs were in proportion and I had selected his features & as

beautiful.

~~handsome~~ ~~handsome~~ ~~Beautiful~~ ~~Handsome~~ Great God! His

yellow ~~dun~~ skin scarcely covered the work of

of a lustrous black, &

muscles and arteries beneath; his hair was flowing and his teeth of a pearly whiteness but these luxuriances only ~~formed~~ formed a more horrid contrast with his watry eyes that seemed almost of the same colour ~~as~~ the dun white sockets in which they were set.

his shrivelled complexion and strait black lips.

The different accidents of life are not so changeable as the feelings of human nature. I had worked hard for nearly two years for the sole purpose of infusing ╪ life into an inanimate body. for this I had deprived myself of rest and ~~health~~ health. I had desired it with an ardour that far exceeded moderation; but now that I had succeeded these dreams vanished and breathless horror and disgust filled my heart. Unable ^to endure the aspect of the ~~creature~~ being I had created, I rushed out of the room and ~~remained~~ continued a long time traversing my bed chamber unable to compose my mind to sleep. at lenght lassitude succeeded to the tumult I had before endured, and I threw myself on my bed in my clothes endeavouring to seek a ~~feew~~ few moments of forgetfulness. But it was in vain; I slept indeed but was disturbed by the wildest dreams. I saw Elizabeth, in the bloom of health walking in the streets of Ingolstadt; delighted & surprised I embraced her but as I imprinted the first kiss on her lips they became livid with the hue of death; her features appeared

to change and I thought that I held
the corpse of my dead mother in my arms;
a shroud enveloped her form & I saw
the grave worms crawling in the folds of
the flannel. I started ~~from my sleep~~ with horror, a
~~when I saw~~ cold dew covered my forehead
my teeth ~~th~~ chattered and every limb
became ~~was~~ convulsed, when, by the dim and
yellow light of the moon as it forced
its way through the window shutters, I
beheld the wretch — the miserable
monster whom I had created; he held
up the curtain, and his eyes, if eyes
they may be called, were fixed on me. His
jaws opened and he muttered some ~~words~~
inarticulate sounds while a grin wrinkled his cheeks. He
might have spoken but I did not
hear — one ~~had~~ hand was stretched out
to detain me, but I escaped and ~~ran~~
rushed down ~~stairs~~ I took refuge in
a court-yard belonging to the house
which I inhabited; where I remained
during the rest of the night walking up and
down in the greatest agitation; listen-
ing attentively, catching and fearing each
sound as if it were to announce the
arrival of the demoniacal corpse to
which I had so miserably given life.
oh! no mortal could support
the horror of that countenance. a
mummy again endued with animation ~~life~~ would not be

78

so hideous as he. I had gazed on him
while unfinished, and I thought he
was ugly then. But when those muscles
and joints were endued with motion
it became a thing such as even Dante
could never have conceived.

I passed the night wretchedly.
sometimes my pulses beat so quickly and
hardly that I felt the palpitation of
every artery; at others I nearly sunk
to the ground through languor and ex-
treme weakness. ~~Surely so wretched a~~
~~creature as I never before existed.~~
dreams that had been my food and
rest for so long a space were now
become a hell to me. and the
change was so rapid, the overthrow
so complete.

Morning — dismal and wet — at length
dawned, and discovered to my sleepless
and aching eyes the church of Ingol-
stadt its white steeple & clock which
pointed to the sixth hour. The porter
opened the gates of the court which had
that night been my asylum and I
issued into the streets, pacing them with
quick steps as if I sought to
avoid the wretch whom I feared every turn-
ing in the street would present to

and mingled
with this hor-
ror I felt the
bitterness of
disappoint
ment.

avoid

my views. I did not dare return
to the apartment which I inhabited but
felt impelled to hurry on although
wetted by the ~~drizzling~~ rain which poured
from a black and comfortless sky.

I continued walking in this manner
for some time endeavouring by bodily
exercise to ease the load that weighed
upon my mind I traversed the streets
without any clear conception of where
I was or what I was doing. my heart
palpitated ~~with~~ in the sickness of fear and I hurried
on with irregular steps. not daring
to look about me,

> "Like one who on a lonesome road
> "Doth walk in fear and dread
> "And having once turned round [Walks on
> "~~And~~ turns no more his head
> "Because he knows a frightful fiend
> "Doth close behind him ~~tread~~ tread." *

opposite Continueing this. I came at length
~~opposite~~ the Inn at which the dili
-gences and carriages usually stopped here
I paused I knew not why but remained
some minutes with my eyes fixed on
a coach that was coming towards me
from the other end of the street.
As it drew nearer I observed that it
was the Swiss diligence; it stopped
just where I was standing and on

* Coleridge's
"Ancient Mariner.

the doors being opened I perceived Henry
Clerval, who on ~~see~~ seeing me instantly
sprung out.

"My dear Frankenstein," exclaimed he
"How glad I am to see you; how
"fortunate that you should be here at
"the very moment of my alighting".

Nothing could equal my delight
on ~~see~~ seeing Clerval. His presence
brought back to my thoughts my fa
ther, Elizabeth and all those scenes
of home so dear to my recollection.
I grasped his hand, and in a moment
forgot my horror and misfortune
I felt, suddenly indy for the first time ~~for~~ during
many months, calm and serene
joy. I welcomed my friend therefore
in the most cordial manner &
We walked towards my colledge.
Clerval ~~ran on~~ ~~talked~~ continued our ~~mutual~~
talking for some time about my
friends and his own good fortune in
being allowed to come to Ingolstadt.

"You may believe," said he, "~~that~~
"it was not ~~without~~ considerable
"trouble that I persuaded my
"father that it was not absolutely
"necessary for a merchant to
"know nothing except bookkeeping

"and indeed I believe I left him
"incredulous to the last for his con
"stant answer to my applications 29
"was the same as the dutch school
"master in the vicar of Wakefield —
"~~I live very well yet I do not know~~
"~~Greek~~" I have ten thousand florins.
"But his affection for me at
"length overcame his dislike for
"learning, and he permitted me
"to take a voyage to the land of
"knowledge."

"and my father, brother & Eliza
beth" said I

"very well & very happy" replied
he "only a little uneasy that
"they hear from you so seldom &
"by the bye, I mean to lecture you
"a little upon their account
"myself — But my dear Frankenstein"
continued he stopping short & gazing
"full in my face "Did not I before
"remark how very ill you are — so thin
"and pale; you appear as if you had
"been watching for several nights.

"You have guessed right" replied
"I have lately been so engaged in
"~~several~~ one occupation that I did
"not allow myself sufficient rest as you

"a year with
"out greek — I
"eat heartily
"without greek q —

52
100
104
52
24
180

17

136

have

"see; but I hope, I sincerely hope all those "occupations are at an end—I am free "now I hope."

I trembled excessively: I could not bear to think of & far less to allude to the occurrences of the preceding night. ~~I continued to walk there~~ I walked therefore with a quick pace, and we soon arrived at my colledge. I then reflected—and the thought made me shiver that the creature whom I had left in my appartment might be still there—alive and walking about. I dreaded to see him but I dreaded still more that Henry should behold the monster. ~~I therefore~~ entreating him therefore to remain a few minutes at the bottom of the stairs, ~~while~~ I darted up towards my own room. My hand was already on the lock before I recovered myself, when I paused and a cold shivering came over me. I threw the door open as children are accustomed to do when they expect a spectre to stand in waiting for them on the other side. But nothing appeared. I stepped fearfully in; the appartment was empty, and my bedroom was also freed from its hideous guest. I could hardly ~~believe~~

believe that so great a good fortune
could have befallen me; but when
I became assured that my enemy had
indeed fled, I clapped my hands for
joy and ran down to Henry.

We ascended into my room & presently
the servant brought breakfast,
but I was unable to contain my-
self. It was not joy only that possess-
ed me; I felt my flesh tingle with
the excess of sensitiveness and my
pulse beat rapidly. I was unable to
remain for a single instant in
the same place — I jumped over
the chairs, clapped my hands & laughed
aloud. Clerval at first attributed
my unusual spirits to joy on his
arrival but when more attentively he observed
me, he saw a wildness in my eyes for
which he could not account and
my loud unrestrained heartless laugh-
ter frightened and astonished him.

"My dear Frankenstein," cried he "what
for God's sake is the matter do not
laugh so — How ill you are!
What is the cause of all this?

"Do not ask me" cried I, putting my
hands before my eyes, for I thought
I saw the spectre glide into the

room — He can tell! Oh save me save I me" — I imagined that the monster seized me. I struggled furiously & fell down in a fit.

Poor Clerval! what must have been his feelings. a joy meet meeting which he had anticipated with such joy so strangely turned to bitterness. But I did not witness his grief for I was helpless senseless and did not recover my senses for several a long, long time.

IV.
'infusing life into an inanimate body'

THE LATEST researches into the Abinger manuscripts in the Bodleian Library, Oxford—the earliest surviving manuscripts—suggest that the process of writing the novel involved four main phases. These were: the story Mary Godwin told on the night of June 17th 1816; the expansion of this performance into a 'short tale' in July and August 1816; the expansion of this 'short tale' into a draft novel, between 21st August 1816 and 17th April 1817—some of it copied from the earlier version (there are no crossings-out on significant portions of the manuscript); and a fair copy of the full-length novel, written between 18th April 1817 and 13th May, which was the one sent to the publishers and printers. The draft novel of 1816–17, which has largely survived in manuscript, is contained in two notebooks: the first was purchased in Geneva, and was used by Mary Godwin between July and 5th December 1816; the second was purchased in Bath, and was used between 6th December 1816 and 17th April 1817. The Geneva notebook in the Bodleian begins with young Victor Frankenstein's childhood playfellow, his cousin Elizabeth (originally called Myrtella) Lavenza, and his schoolboy friendship with Henry Clerval (originally called Carignan), sometimes spelled as Clairval. It seems most likely that the 'short tale' version centred on the creation chapter—as told in the Villa Diodati—with parts of some of the earlier chapters (maybe half the length of the finished novel) about Victor's family background and his scientific education at Ingolstadt, and, from subsequent chapters, the journey to Chamonix, parts of the creature's narrative, the murder of Victor's younger brother William and Justine Moritz's (originally Justine Martin's) wrongful execution, and a sketch of the creature's self-education—though not yet the chapters where he learns to read. It would have been substantial, though still a 'short tale': say, forty to fifty pages. A couple of years later, Percy Shelley was to write to Mary about '[such] fruits of my absence as were produced when [we were] at Geneva'—a clear reference to her expanding the tale she told on 17th/18th June while Shelley and Byron were boating on the Lake, 22nd–30th June. *Frankenstein* was first told in June 1816 when Mary Godwin was eighteen years old, completed as a novel in May 1817 when Mary was nineteen, and published on 1 January 1818 when she was twenty. It was a long haul.

In the Abinger manuscripts, the creation chapter—headed Chapter 7th—has hardly any crossings-out. Mary Godwin is clearly copying an earlier version from her short tale, and maybe even from the story she told. The only corrections of any significance are changing 'handsome' into 'beautiful' for Victor's selection of the creature's features, changing 'creature' into 'being' and 'words' into 'inarticulate sounds' and correcting a quotation from Chapter 20 of Oliver Goldsmith's *Vicar of Wakefield* from 'I live very well yet I do not know Greek' to 'a year without Greek—I eat heartily without greek'. Presumably, this quotation was originally written from memory—as was the 'fear and dread' quotation from *The Ancient Mariner* which Mary Godwin gets slightly wrong but this time did not amend: 'Like one who [rather than 'one that'] on a lonesome road . . .'. Interestingly, the passages describing Victor's early excitement about science are also evidently copied from an earlier version:

None but those who have experienced it can conceive of the enticements of science (especially). In other studies you go as far as others have gone before you and there is nothing more to (learn) know; but in a scientific pursuit (their) there is continual food for discovery and wonder . . .

As in Waldman's (originally Waldham's) lecture:

The ancient teachers of this science promised impossibilities and performed

nothing. The modern masters promise very little . . . But those philosophers whose (eyes) hands appear only made to dabble in dirt, and their eyes to pore over the microscope or crucible, have indeed performed miracles.

Victor's reaction to this lecture, and his fateful meeting with Waldman—on the other hand—gave Mary much more trouble; as did the electric storm and the blasted oak, with an insert added much later. There are long additions in the margin, and many corrections on the main text. The references to animal experiments—'[my attention was attracted by] the structure of the human frame: and indeed that of any animal endued with life'; 'now I was . . . forced to spend days and nights in vaults and charnel houses'; 'as I dabbled among the unhallowed damps of the grave, or tortured the living (animate) animal to animate (my) the lifeless clay'; 'the dissecting room and the slaughter house furnished many of my materials'—were there from the beginning. Frankenstein's confession was always intended to be addressed to *someone*—'I see by your eagerness . . . that you expect to be informed of the secret with which I am acquainted': but it is not clear in the draft version to whom. Mary Godwin's hesitations about names are also interesting. Elizabeth was called Myrtella—myrtle being a classical symbol of love, as Mary well knew. Clerval was sometimes Clairval, presumably a reference to Clairmont as in Charles or Claire. Safie was originally Maimouna (a name from Southey's poem *Thalaba*), then Amina, and finally Safie—perhaps an ironic reference to 'Sophie' in Rousseau's *Émile*, the girl who is not educated as thoroughly as her male friend. Mary Wollstonecraft had written a lot about Rousseau's Sophie. The child Louisa M turned into Louisa Biron, a nod towards Milord Byron, and the banker M. Hopland turned into M. Duvillard, a reference to Mary's nursemaid Elise. William, Victor's beautiful little brother, was also the name of Mary's baby son *and* the name of her father. Justine Moritz gained her surname from Carl Philipp Moritz, whose book *A German in England* in 1782 (1783, tr. 1795) was read by Mary early in 1816. Margaret Saville—Robert Walton's sister—has the same initials as Mary Shelley. The name Frankenstein probably refers to the Castle on the Rhine, but it has recently been suggested—without corroborating evidence so far—that it was also the name of the German consul in Geneva in 1816, one Baron Frankenstein, 'the nicest man she knew there'. If this *was* the case, it would fit with all the other names of real people in the novel. Jean de Palacio traces the name to literary sources—two *Tales* by M.G. Lewis which Mary Godwin was reading at the time: the tall and diabolical Frankenheim (from *Mistrust* in *Romantic Tales*, 1808) and Falkenstein (from *Osric the Lion* in *Tales of Wonder*, 1801). This would fit with her absorption of texts she was reading into her novel as she went along. But the Castle remains most likely source.

The 152 leaves of the two notebooks are almost entirely in Mary Godwin's/Mary Shelley's handwriting, with some corrections of punctuation, syntax and phraseology by Percy Shelley. The prose is simple, direct and sturdy. It seems that Percy read Mary's words as she wrote them down, and then read the notebooks again in April 1817. Only later, with the fair copy, would he make more significant amendments—sometimes adding rhetorical flourishes, more mannered modes of expression. He also clarified the narrative. Percy sometimes considered Mary's style to be too 'abrupt'. On one occasion, she wrote the word 'igmmatic', and he added in the margin 'enigmatic, o you pretty Pecksie'—Pecksie being a wise robin in a children's book; on other occasions he liked to call her 'Dormouse'; after reading *The Faerie Queene* she called him 'Elf' or 'Sweet Elf'. The Shelleys, as we've seen, often read and wrote together—they each had small portable writing desks—and they acted as editors or advisers on each other's work. She would give him chapters to read and edit—just as Victor Frankenstein corrects and edits Walton's transcription of his autobiography. '[Frankenstein] asked to see [my notes] and then himself corrected and augmented them . . . "Since you have preserved my narration," said he, "I would not that a mutilated one should go down to posterity."' Mary Godwin had never written a substantial piece of work for publication before, and Percy was a published author, albeit a little-known one whose poems had been rarely—and badly—reviewed. Writing and reading together brought Mary and Percy closer together—perhaps closer than ever before. As Miranda Seymour has justly concluded, 'Shelley shared in Mary's pleasure at the discovery of her talent'.

The notebooks represent—in addition to the central idea—the first novel about the education of a young scientist ever to be written. Novels about the education of the emotions, or sensibilities, were in vogue post-Goethe but this was something different. It was about the formation of a young scientist—and how he deludes himself. The notebooks also present a more positive view of scientific exploration—and of the creature—than either the 1818 or 1831 editions of *Frankenstein*. Mary Godwin was speculating about science and morality, and she was also writing about her own experience and the people around her. Her university, up to the age of sixteen, had been her father's extensive library—with her mother's benign portrait looking down at her from the wall—and the Godwin dinner table. Beside Mary Wollstonecraft's deathbed, William Godwin had undertaken to educate the infant Mary on sound principles: so there was a Governess, a tutor, a few months at school outside the home environment. Then, post-sixteen, there were the conversations with Shelley and his circle of radical friends. Over the next eleven months or so—between July 1816 and May 1817—Mary would have to work hard to turn the notebooks into a seventy-two-thousand-word novel, drafting and researching as she went along.

While Percy Shelley and Lord Byron were away from the Villa on their 'promenade sur le lac', Dr Polidori spent more time than usual walking down to the Maison Chappuis, in the daytime and in the evenings.

June 23.—. . . Walked to Mrs. Shelley . . . Went down to Mrs. S for the evening.

June 24.—Up at 12. Dined down with Mrs. S and Miss CC.

June 26.—. . . Saw Mrs. Shelley: dined. To Dr. Rossi's party of physicians: after at Mrs. S.

June 27.—Up at Mrs. Shelley's: dined . . . Rode two hours; went to Mrs. S; Miss C talked of a soliloquy.

June 28.—All day at Mrs. S.

June 29.—Up at 1; studied, down at Mrs. S.

June 30.—Same.

July 1.—Went in calèche to town with Mrs. S and C for a ride, and to mass (which we did not go to, being begun). Dined at 1 . . . Found Lord Byron and Shelley returned.

July 2.—Rain all day. In the evening to Mrs. S.

And then, at 8.30 a.m. on 21st July, Percy and Mary—with Claire—decided to escape the oppressive atmosphere of the Villa and take a week-long excursion to Chamonix. Byron did not join them, probably because Claire was with the party; but perhaps also because they wanted to get away from him for a time. Elise Duvillard stayed behind, to look after William. Claire seems to have been invited because she was so obviously distressed by Byron's rebuff and because he now knew about her pregnancy and had not taken the news well. Also, as before she spoke good French. They followed the swollen river Arve to Bonneville and Cluses, Mary and Claire on mules, Percy walking. The poet noted enthusiastically that the flooded scene was assuming 'a more savage and colossal character' by the minute. Mary reckoned that the 'mountainous and rocky path'—and particularly 'alpine bridge over the Arve' (where Shelley was inspired to write his poem *Mont Blanc*)—represented 'one of the loveliest scenes in the world'. She was less struck with the savagery:

. . . as we went along we heard a sound like the rolling of distant thunder and beheld an avalanche rush down a ravine of the rock—it stopped midway but in its course forced a torrent from its bed which now fell to the base of the mountain. We had passed the torrent here in the morning—the torrents had torn away the road and it was with difficulty we crossed—Clare went on her mule—S. walked and I was carried. Fatigued to death we arrived at seven o'clock [on July 22nd] at Chamounix.

ABOVE: J.M.W. Turner, **Mer de Glace** *(1812), etched and engraved by the artist for his* Liber Studiorum/Drawing Book.
OPPOSITE: Caspar David Friedrich, **The Polar Sea** *(1824). Note the wrecked ship, to the right.*

They checked into the recently rebuilt Hôtel de Londres (on the corner of today's Rue des Moulins near the Musée Alpin), the most substantial building in the village. It had been extended from three to five storeys in 1810, by the proprietor Victor Tairraz, to cope with demand—especially from British tourists, whose numbers were soon to increase in the aftermath of the Napoleonic wars. The Shelley party had fun with the Hotel Register and Visitors' Book, as we've seen—partly to provoke their stuffy compatriots. Mary and Percy also resumed writing their joint *Journal*. The first contemporary reference to *Frankenstein* was in the *Journal* entry for 24th July: 'write my story', Mary noted, after they had returned to the hotel in a heavy rainstorm. If the creation chapter had been strongly influenced by the environment and atmosphere of the Villa Diodati, the subsequent development of *Frankenstein* would be equally strongly shaped by her impressions of the wasteland of the Alps: the *Journal* kept by Mary and Percy in July 1816 would find its way, sometimes almost *verbatim*, into volume II, chapters 1 and 2 of the 1818 *Frankenstein*. The meeting of Victor and his hideous progeny was probably written in situ. It was part of the shorter, early version of *Frankenstein*.

On the morning of July 23rd, after breakfast, the girls mounted their mules to reach the source of the Arvéron, and to visit the desolate *Mer de Glace*, the sea of ice, in the shadow of Mont Blanc. The last part of the journey, on a very steep and treacherous path, was 'on foot over loose stones many of which were of an enormous size'. Shelley had been reading about the 'sublime but gloomy theory, that this earth which we inhabit will at some future period be changed into a mass of frost', which must have made the ascent towards an advancing glacier—and the absence of vegetation—seem particularly frightening: for this was, to them, *the* most dramatic example of global freezing. Other tourists tended to see such marvels as evidence of the existence of God. For Shelley, the encroaching glacier was evidence of the opposite. Mary wrote:

Nothing can be more desolate than the ascent of this mountain—the trees in many places have been torn away by avalanches and some half leaning over others, intermingled with stones present the appearance of vast and dreadful desolation . . . when we had mounted considerably we turned to look on the scene—a dense white mist covered the vale and tops of the scattered pines peeping above were the only objects that presented themselves. The rain continued in torrents—we were wetted to the skin so that when we had ascended more than half way we resolved to turn back . . . I write my story.

The following day, July 25th, they finally reached the Mer de Glace. Victor Frankenstein's ascent along precisely the same route compresses the two days into one. Mary turned back from her ascent to Montanvert because 'The rain continued in torrents', and resumed her writing of *Frankenstein* back at the hotel. When Victor makes the same ascent, 'the rain poured down in torrents, and thick mists hid the summits of the mountains': he, by contrast, leaves the rest of his family at the inn, and braves the elements to be alone in a desolate place. There, he meets the creature on the Mer de Glace. He also quotes two stanzas of Percy Shelley's poem *Mutability* from *Alastor* (1816), to express his reaction to the sublime, but ever-changing, landscape—another example of how Mary Godwin transposed descriptions of her personal experiences, or journal entries, into her novel, rather as Byron had done with *Childe Harold*, with minimal changes. Mary wrote in her *Journal*:

We get to the top at twelve and behold le Mer de Glace. This is the most desolate place in the world—iced mountains surround it—no sign of vegetation appears except on the place from which we view the scene—we went on the ice—It is traversed by irregular crevices whose sides of ice appear blue while the surface is of a dirty white—We dine on the mountain . . .

The vast Mer de Glace, the result of the confluence of three glaciers, resembled a freeze-dried blue sea at the end of the world. They dined in the wooden 'temple of nature', built in 1778 (and still there), overlooking the southern tip of the Sea, and had more fun with the Register of Guests. Mary seems to have decided there and then that this was a most suitable location for the climactic meeting between the scientist and his creation. Rejected by society, the creature seeks the most remote place imaginable—just as, at the end of the story, he makes for the land of mist and snow, the unexplored regions of the North Pole. The earliest version we have:

. . . I suddenly beheld (a human figure) the figure of a man [writes Victor Frankenstein], at some distance, advancing towards me with superhuman speed. He bounded over the crevices in the ice, (by) among which I had walked with caution; his stature also, as he approached, seemed to exceed that of man. I was troubled; a mist covered my eyes, and I felt (ready to faint) a faintness seize me. The cold breeze of the mountains quickly restored me. (But) I perceived, as (he) the shape came nearer (Oh) (sight tremendous and abhorred!) that it was the wretch whom I had created (and who had caused me such deep misery). I trembled with rage and horror . . .

At last, Victor is forced to confront the 'accomplishment of my toils'. In a hut next to Mer de Glace, the creature pours out his sad life story and demands that Victor, his single parent, 'create a female for me, with who I can live in the interchange of those sympathies necessary for my being . . . I demand it of you as a right which you must not refuse'. He wants to belong.

After their return to Montalègre, on July 27th, Mary Godwin's *Journal* entry says 'Write' or 'write' more and more often: eight entries up to August 9th. On August 12th, she specified 'Write my story'. Two days later the controversial Gothic novelist M.G. Lewis—he

of *The Monk* and *Tales of Wonder* fame—arrived at Diodati, with a retinue of Jamaican servants, and stayed with Byron for a few days. This visit was later to cause several confusions about Lewis's alleged inspiration of the ghost-story session, in an early biography of Byron. Lewis did indeed discuss the craft of writing ghost stories with Shelley, who questioned him about 'the mysteries of his trade'. He even told a few ghost stories, which Shelley summarised in the *Journal*. But that was nearly a month *after* the famous ghost-story session—and besides, there is no evidence that Mary Godwin actually met him at that time. She simply noted 'Lewis came to Diodati', and later specified—for the posthumous benefit of lazy biographers—'Lewis did not arrive in Geneva until some time after'. It is quite possible that Percy discussed Lewis and his craft with Mary. But *Frankenstein* was well under away by then.

She again put 'Write' or 'write' in her *Journal* for August 13th, 15th, 16th, 17th, 18th, 19th and 20th. On the following day, 'Shelley and I talk about my story', which may be the conversation which encouraged Mary to expand her short version of *Frankenstein*. She was careful to distinguish between 'story' and 'book' in her *Journal* entries. As she was to recall in her 1831 *Introduction*, 'At first I thought but of a few pages—of a short tale; but Shelley urged me to develop the idea at greater length . . .' Then, on August 23rd, 'My Dear Shelley and Mary' received from Charles Clairmont, Claire's half-brother, a rather self-pitying letter—sent from the Hautes-Pyrénées—in which he said he was trying hard to improve himself after the failure of his Irish ventures, 'to make me more respectable and more valuable', that he was short of money and unsure what to do about this, and that he was going to learn or improve his 'Continental languages'— French, Italian, Spanish and, perhaps, German: 'Ingolstadt does not seem sufficiently removed from the frontiers to create any difficulty'. This may well have inspired the development of the character of Henry Clerval in *Frankenstein*, of whom his schoolfriend Victor writes: 'Languages were his principal study; and he sought, by acquiring their elements, to open a field for self instruction on his return to Geneva'. Clerval does indeed travel to Ingolstadt by the Swiss diligence, where by chance he meets a distracted Victor the 'dismal and wet' morning after the creation.

On August 22nd, 24th and 25th, Mary Godwin noted that she was writing again, until early in the morning of Thursday August 29th she left Geneva—with Percy, little William, Claire and Elise Duvillard, a lot of luggage, and the manuscripts of Byron's *Childe Harold* and *The Prisoner of Chillon*. It was the day before her nineteenth birthday. They travelled to Le Havre, via Versailles, Fontainebleau and Rouen, and had chosen the cross-channel route to Portsmouth (rather than Dover) because Portsmouth was much closer to out-of-season Bath, where they intended to lodge—well away from London, the Godwins' prying eyes, and creditors. Claire's pregnancy could perhaps be kept secret in Bath, at least until after the child was born. Just before they left—maybe even as the carriage was being loaded—

Claire had penned a final, pleading letter to Lord Byron:

When you receive this I shall be many miles away don't be impatient then with me . . . There is nothing in the world I love or care about but yourself and though you may love others better there are none more faithfully and disinterestedly attached to you than myself . . . One thing I do entreat you to remember and beware of any excess in wine; my dearest dear friend pray take care of yourself . . . Sometimes I feel as if you were dead and I make no account of Mary and Shelley's friendship so much more do I love you. Think sometimes of me dearest will you . . .

If Mary Godwin had caught sight of this letter, her sympathy for Claire—and it was already in short supply by the end of the Geneva summer—would surely have reached breaking-point. It gives an idea of the strained relations between them. Instead, Mary always looked back on her time with Lord Byron at the Villa Diodati with melancholy pleasure. She remembered Shelley reading some stanzas of *Childe Harold* to her 'one evening after returning from Diodati. It was in our little room at Chappuis'. And a year later, after *Frankenstein* had just been submitted to the publisher John Murray, her re-reading of Canto the Third of *Childe Harold* caused the memories to come flooding back.

I think of our excursions on the lake. How we saw him [Lord Byron] when he came down to us and welcomed our arrival with a good humoured smile. How very vividly does each verse of his poem recall some scene of this kind to my memory.

Byron was more hard-nosed about that summer, and in particular about Claire. At that meeting on August 2nd, he had undertaken to look after the child's welfare—without the mother—up to the age of seven. The child would be handed over to him when it was a few months old. 'He promised faithfully never to give it until seven years of age into a stranger's care', Claire later wrote. 'I was to be called the Child's Aunt . . .' She would give birth in England 'without injuring anyone's reputation'. Whether Byron ever really intended to honour this agreement is a moot point. It had seemed workable at the time. He appended a casual postscript to one of his letters to his half-sister Augusta:

PS.—I forgot to tell you—that the Demoiselle—*who returned to England from Geneva—went there to produce a new baby B.—who is now to make his appearance.*

He assumed, of course, that the baby would be a 'he'.

The Shelley party arrived at Portsmouth on September 9th. Percy went straight to London to deliver the Byron manuscripts to Murray, raise some loans, dodge the bailiffs and sort out other business affairs. The women spent their first night back on English soil in Salisbury, and then on to Bath, where they found lodgings on September 11th. Percy and Mary—with William and Elise—would stay at 5, Abbey Churchyard next to the entrance to the Pump Room in the shadow of Bath Abbey, a house belonging to William Meyler, publisher of the *Bath Herald*. They would 'settle themselves' until more permanent arrangements could be made, perhaps around Marlow on the Thames near Percy's old school chum Thomas Love Peacock. Their rooms were above Meyler's circulating library and reading room, which was handy. During her confinement, Claire would lodge separately, as 'Mrs. Clairmont', a little further up the hill, at the slightly less expensive 12, New Bond Street, where 'her wants were looked after by good Mrs. Gilbert, a "party" who kept lodgers'. On September 20th, Claire wrote to Mary (who was visiting Marlow for a week or so):

Elise complains that they say nothing but 'don't'ee' which after many searches into Antiquity I define to be 'don't' . . . I just stooped down to ask 'itty Babe' [William] if I should send his love which he returned by putting his heel with great composure into my eye. Will you be so kind to send some Money directly for on Thursday Mrs. Gilbert sent her Bill for lodgings which though it is no great thing to put off is better paid . . . I cannot bear to be without a single farthing.

The day after moving into New Bond Street, Claire had written to Byron:

Bath is a very fine airy town, built up the sides of hills in high terraces but it seems very dull to me as does everything.

She added a joke about his abstemious diet, referring to memories of 'petit pois for dinner and a smooth lake to look upon'.

Shelley presented to Byron a picture of (temporary) domestic bliss, in a long, amiable letter written at the same time. It, too, sounded a tad dull after all the excitements of the summer:

We are all now in Bath, well and content. Claire is writing to you at this instant. Mary is reading over the fire; our cat and kitten are sleeping under the sofa; and Little Willy has just gone to sleep. We are looking for a house in some lone place . . .

There was, however, one consolation, Claire added on September 20th:

. . . this city contains numerous excellent libraries . . .

Mary Godwin made full use of these, between mid-September and mid-February 1817, including the one beneath her lodgings. After all, she did not know anyone in Bath: the main reason they were staying there was to keep Claire's pregnancy as secret as possible from their London circle. She read books about 'old voyages' on the wide ocean, voyages of exploration including Commodore Anson's circumnavigation in the warship *Centurion*, 1740–44 (which Rousseau had featured in *La Nouvelle Héloïse*, another book she was reading or re-reading) and several others plus *Gulliver's Travels*. She was digesting these as she wrote the new opening of her novel—explorer Robert Walton's letters about his travels from St Petersburg to Archangel, to hire a vessel and collect a crew before setting out for 'unexplored regions' to find the northwest passage. Polar exploration would be added to the topical science of *Frankenstein*. She read Humphry Davy's *Chemistry*, as she expanded the *short* version of Victor Frankenstein's scientific education at Ingolstadt. She read Rousseau's *Émile* and part of 'Locke's essay' about understanding the world through the senses. And she noted that Percy was re-reading Plutarch's *Lives* (as he had on August 18th–20th in Geneva) and Milton's *Paradise Lost* in mid-November—the same books as the creature reads—and a translation of *Don Quixote*. She attended lectures at Bath's Literary and

Philosophical Society Rooms in Queen's Square, and took drawing lessons from a 'Mr. West'—the standard method of instruction in figure-drawing at the time was to master each individual part of the body (legs, arms, torso, head), then encourage students to bring them all together. Which must have struck a chord with her. Towards the end of the year, she complained about 'that tedious ugly picture I have been so long about'.

Meanwhile, Mary continued to 'write'—according to her *Journal*—on a total of at least fifty-eight days between September 16th and January 10th. On September 25th and 26th, Mary and Percy talked 'of our plans'; a month later, Percy noted that 'Mary writes her book' (the first explicit reference to 'book' rather than 'story'); and on October 27th, Mary was writing 'Ch. 3½', which she amended to 'Ch. 2½'—the enhanced version of Victor's scientific education—coinciding with her reading of Humphry Davy and following her most concentrated period of drafting so far. By December 5th, she had completed 'the 4 Chap. of *Frankenstein* which is a very long one and I think you would like it' (probably the account of Safie's family background, and language teaching at the De Lacys). The last of these references to 'write', in Bath, was on January 10th. So Mary was drafting the full-length version of *Frankenstein* on fifty-eight out of a possible total of one hundred and twenty-two days, usually five pages a day from the evidence, and reading background books on many other days.

She kept writing, with astonishing self-discipline, through a series of devastating domestic crises. William Godwin had been so right when he observed: '. . . her perseverance in everything she undertakes [is] almost invincible': and he had taught her to deflect personal problems through routine and concentrated study. On the night of October 9th, her half-sister Fanny (Imlay) Godwin—Mary Wollstonecraft's daughter with a different father—committed suicide in a small upper room at the Mackworth Arms pub, Swansea, by overdosing on laudanum. She had taken the coach to Wales from London, via Bath and Bristol, before she died. Fanny was wearing stays with the letters 'M.W.' on them—they had been her mother's—and among her meagre possessions she had a 'small French gold watch' which Mary had bought for her in Geneva as a present. Fanny left a note:

I have long determined that the best thing I could do was to put an end to the existence of a being whose birth was unfortunate.

It seems that a mixture of a desire to be more useful with her life, distress at the Godwin-Shelley feud which had lasted over two years since the first elopement, regular verbal abuse from her stepmother Mary Jane Godwin (earlier 'Clairmont'), a feeling that she had let down her late mother and become a burden—and unrequited love for Percy Shelley whom she may or may not have met in Bath on the morning of October 8th—all proved too much for her. Did she perhaps ask to join the 'well and content' couple in Bath, since everyone else had let her down? Did Shelley refuse her request, partly because of Claire's secret pregnancy? Fanny's suicide note implied,

above all perhaps, that she was suffering from the depression (then called 'melancholia') she had inherited from her mother. Mary Wollstonecraft had attempted to kill herself twice, once by taking an overdose of laudanum. Mary Godwin, too, tended to suffer from occasional bouts of depression, usually following traumatic events—such as the death of her baby daughter in February 1815, or after particularly difficult confrontations, and she always tended to be an anxious, touchy, thin-skinned sort of person. The stays Fanny was wearing may have had a deeper significance too: Mary Wollstonecraft had, famously, encouraged women to shed the constricting clothing imposed on them by men.

Mary Godwin was busy writing her book on October 7th, and, on the 10th and 11th, she put 'work and read' in her *Journal*. Percy, meanwhile, was distraught, 'Jumped up thrust his hand in [his] hair—I must be off', rushed to Bristol and Swansea, and reported the sad news to Mary for definite on the 12th: on that day, Mary wrote 'buy mourning and work in the evening'. No-one went to Fanny's burial in an unmarked grave. Her name had been torn—or burned—off the end of her suicide note. William Godwin was desperate to avoid yet another family scandal. He wrote—his first communication to Mary since July 1814—begging her to 'go not to Swansea . . . do nothing to destroy the obscurity she so much desired'. Only later, at the beginning of December, did Mary Godwin express her grief, and her regret that their home could not be a haven: 'Poor dear Fanny if she had lived untill this moment she would have been saved for my house would have been a proper assylum [sic] for her'. In the same letter, she poured out her repressed emotions—her vulnerability and her fear of being abandoned—to Percy:

Ah! my best love to you do I owe every joy every perfection that I may enjoy or boast of—Love me, Sweet, for ever—But I (do) not mean—I hardly know what I mean I am so agitated.

Then, on December 15th, news arrived in Bath that the body of Harriet Westbrook Shelley had been discovered in the deep end of the Serpentine 'far advanced in pregnancy'. She, too, had evidently committed suicide some considerable time before. Because Mary and Percy left their *Journal* behind at 5, Abbey Churchyard when they went to London, we do not know Mary's immediate reaction. In the frantic ensuing weeks, many rumours circulated—the nastiest coming from the Godwins. Harriet had, it was said, been living with an army officer—or was it a groom by the name of Smith?—who had deserted her, and in desperation she had taken her own life. This was Percy Shelley's preferred version, at least as written to Mary in a letter the day after the suicide. Harriet's sister Eliza Westbrook had, it was said, driven her from her father's house in order to get her hands on his inheritance: Harriet had then 'descended the steps to prostitution'. *Anything* but admit that Percy Shelley himself might have been partly or even largely to blame. Harriet's unborn child *could*—just—even have been his: but as his letters to Mary emphasised, 'every one does *me* full justice'. While Percy was blaming everyone else, he even wrote

to Harriet's sister Eliza of 'your feelings towards the lady whose union with me you may excusably regard as the cause of your sister's ruin'. *Excusably?* One hopes that he never shared the contents of this letter with Mary, who was already feeling partly responsible.

The immediate concern of the Godwins was that Mary should become Percy's lawful wife as soon as decently possible—now that he was freed from his marriage to Harriet. Percy's most immediate concern was about the custody of his children Ianthe and Charles—whom he had not seen for two and a half years—and he rushed off to consult lawyers about this in London. Their advice, Percy told Mary, was that marriage would indeed improve his chances of gaining custody. A *London* marriage, which would avoid unwelcome gossip in Bath about the surprising news that they were not already married, and which could well, if in Bath, reveal the subterfuge about Claire to the Godwins. He did not of course mention the grief-stricken Westbrooks.

The lawyers' advice was wrong as it turned out, but at the end of December in a ceremony at St Mildred's Church, Bread Street, London—with only the Godwins to witness it: Claire, for obvious reasons, was not on the invitation list—Mary Godwin at last really *did* become Mary Shelley. She noted in her *Journal*: 'a marriage takes place on the 29th'. It in fact took place on the 30th. To Lord Byron she wrote: 'Another incident has also occurred which will surprise you, perhaps . . .' Godwin personally wrote to his brother in Norfolk—who had supplied the turkey for the wedding feast—that Mary had married the eldest son of a baronet. She had married up. His radical views on the tyranny of marriage seemed a long, long time ago. Mary Shelley would write of how the many sadnesses in her life could perhaps be a kind of atonement for poor Harriet's fate. Percy Shelley made light of the marriage in a letter to Claire, but that may have been to make her feel better about missing the ceremony and missing Lord Byron. He congratulated her on 'not expressing much of what you must feel—the loneliness and the low spirits which arise from being entirely left'.

Two suicides and a wedding. And Percy Shelley in a very volatile state of mind. Three weeks before the wedding ceremony, while he was house-hunting in Marlow, he had written to his recent acquaintance the radical journalist and poet Leigh Hunt:

. . . But thus much I do not seek to conceal from myself, that I am an outcast from human society; my name is execrated by all who understand its entire import,—by those very beings whose happiness I ardently desire.—I am an object of compassion to a few more benevolent than the rest, all else abhor and avoid me . . .

It was as if he was casting himself in the role of Victor Frankenstein's creature—another 'outcast from human society'.

By January 1st 1817—a couple of days after the wedding—Mary Shelley was back in Bath and two days after *that* was hard at work again on *Frankenstein*—followed by another concentrated period of writing, until January 12th when Claire Clairmont safely gave birth to a baby daughter she called Alba—after Albe/LB—a name later changed at Byron's insistence to Allegra, which he claimed was Venetian. Mary

wrote in her *Journal*, somewhat caustically: 'CC Sunday Jan 12' and '4 days of idleness'. She wrote a formal letter to Byron, letting him know the news that Claire was safely delivered of a little girl. A fortnight after the birth, she celebrated her son William's first birthday. The *Journal* entry provides a revealing contrast with 'CC Sunday Jan 12':

William's birthday—how many changes have occurred—during his little year—May the ensueing one be more peaceful.

Her views on 'CC' were hardening. She had written to Shelley at the beginning of December, 'give me a garden and *absentia Clariae* and I will thank my love for many favours'. And yet, through all the turbulence, she somehow managed to persevere with her novel. How many of the research students studying aspects of Mary Shelley's work today—usually in their mid-twenties—would have been able to write an *article* in these tragic circumstances, let alone a major novel? And she was still *nineteen years old*.

By 10th–17th April, Mary Shelley was able to write 'Correct F' in her *Journal*, and it was around this time that she made the decision to restructure her two-volume draft version into a three-volume fair copy: volume one, mainly Victor Frankenstein's confessions, as told to Robert Walton, up to his reaction to Justine Moritz's judicial murder in Geneva; volume two, the creature's tale—'long and strange'—told to his creator in a remote hut near the Mer de Glace, up to Victor's reluctant agreement to create a mate for him; volume three, Victor Frankenstein's journey to 'one of the remotest of the Orkneys' through to the final confrontation, and the creature's departure on an ice-raft 'lost in darkness and distance'. An intricate structure of three autobiographies—Walton's, Frankenstein's, the Creature's—which in 1831 would be supplemented by hers as well.

Mary seems to have put aside the draft for the six-week period between January 12th and February 23rd, a period when Claire had her baby, William celebrated his birthday, and Mary travelled to London to support Percy in his complex legal custody battle—eventually to be joined by Claire, William, Alba and Elise. Between March 18th and April 9th, she made up for lost time by writing 'every day'—twenty-three days in a row—creating her manuscript draft of the final volume of *Frankenstein*, the one which is now in the Bodleian Library. After that, instead of saying 'write' each day, she began to put 'transcribe' and 'correct'. March 18th was a significant date for another reason, because it was then that she moved from Bath to Marlow—to Albion House, just outside the centre of Marlow, a wide two-storey house facing onto West Street, with a mock-Gothic balustrade, a substantial walled garden with a cedar tree and an impressive library-room ('very fit for the luxurious literati', wrote Mary). It was just a couple of minutes from the Thames, where Shelley's skiff was to be moored, across the coach road and along a path through a field. This was Mary Shelley's first settled home, and Percy's one attempt at a fixed abode in England: he had purchased a twenty-one-year lease—a triumph of hope over experience. It also enabled Claire to become 'Aunt Claire', with 'a little cousin' she had

The Dog strove to attract his attention.—
He said, Thou wilt not leave me!

Published by J. Johnson, Sept.ʳ 1, 1791.

OPPOSITE: *Henry Fuseli,* The
Rosicrucian Cavern, *engraved
in 1805 for* The Spectator: *a man
opens the tomb of Rosicrucius, and
activates a mechanical figure in
armour, with truncheon and lamp.*
RIGHT: *One of William Blake's
illustrations for the second edition
of Mary Wollstonecraft's* Original
Stories *(1788/1791). A larger-than-life
man stands over two dead children.
Shades of Frankenstein's creature?*

agreed to look after: or, as Shelley wrote to Byron, 'Claire has re-assumed her maiden character'. The house was far enough away from London, but it was also on a main coaching route. The first design decision they made was to place two full-sized classical statues in the garden—one of Apollo, representing creativity, the other of Venus, representing love: these had apparently been left behind by an earlier tenant. Mary was three months pregnant: her second daughter Clara Everina would be born on September 2nd. The couple managed to spend (without apparently paying for) well over a thousand pounds on soft furnishings, curtains, fixtures and fittings. Their home-building was interrupted by the unwelcome news that Percy Shelley had been denied custody of Ianthe and Charles, his children with Harriet, by the Court of Chancery. The Court ruled that the children should be brought up not by a hot-headed adulterer but in godliness and good learning by a provincial man of God. As Mary put it: '. . . the children are to go to this old clergyman in Warwickshire who is to stand instead of a parent'. Shelley never saw the children again. It must have been the principle of the thing which made him so angry. Mary seemed more concerned about the children *as children* than he was.

But Albion House was at least a settled place in which to concentrate on finishing *Frankenstein*. After correcting her draft version, between April 18th and May 13th, Mary transcribed her text into a fair copy, and the manuscript was ready for publishers and the press. Percy Shelley wrote out the final thirteen pages, and Mary re-copied them. On Wednesday May 14th, almost exactly eleven months after the ghost-story session in the Villa Diodati, and no doubt with some relief after twenty-six days of solid transcription, Mary wrote 'S . . . corrects F. write Preface—Finis'. Her *Preface* was subsequently discarded to make way for one written by Percy ('As far as I can recollect', she later wrote, 'it was entirely written by him') which she dated 'Marlow, September, 1817'. The fair copy had been much more of a shared endeavour than the draft. Since arriving in Marlow, Mary had somehow managed to finish a triple-decker novel, read a formidable number of books, move into and decorate a new home, act as hostess to Percy's guests (the Leigh Hunts, with their four children, were regular vistors between April and June), help Percy to hide in the lane at the bottom of the garden when unwelcome visitors—usually creditors—knocked on the door, cope with Claire and Alba, try to balance the books, catalogue the library and order extra shelves, worry about Percy and Claire or about her father's persistent requests for cash or about William's health . . . and, as if all those were not enough, she also decided to set herself, in her earnest and disciplined way, a crash course in Roman history (Pliny, Suetonius, Tacitus) in Latin. And to do charity work with local paupers. Whatever the challenges of the day, she liked to go to bed at 10.00 p.m., after reading and talking with Percy. In her later notes (1839) to Shelley's poems, she recalled of the local community:

Marlow was inhabited . . . by a very poor population. The women are lacemakers, and lose their health by sedentary labour, for which they are very ill paid. The Poor-laws ground to the dust not only the paupers, but those who had risen just above that state, and were obliged to pay poor-rates. The changes produced by peace following a long war [1815 onwards], and a bad harvest, brought with them the most heart-rending evils to the poor. Shelley afforded what alleviation he could. In the winter . . . he had a severe attack of ophthalmia, caught while visiting the poor cottages.

'Our house', she perceptively wrote, 'is very political as well as poetical'. That summer, Shelley penned an effusive dedication to her—at the beginning of his political poem *Laon and Cythna* (named after a brother and sister who were freedom fighters as well as being incestuous lovers), later to be given the less suggestive title *The Revolt of Islam*—which must have come as a great consolation. Mary would look back on these words, in dark times, for the rest of her life:

> *And what are thou? I know, but dare not speak:*
> *Time may interpret to his silent years.*
> *Yet in the paleness of thy thoughtful cheek,*
> *And in the light thine ample forehead wears,*
> *And in thy sweetest smiles, and in thy tears,*
> *And in thy gentle speech, a prophecy*
> *Is whispered, to subdue my fondest fears:*
> *And through thine eyes, even in thy soul I see*
> *A lamp of vestal fire burning internally.*
>
> *They say that thou wert lovely from thy birth,*
> *Of glorious parents, thou aspiring Child.*
> *I wonder not—for One then left this earth*
> *Whose life was like a setting planet mild,*
> *Which clothed thee in the radiance undefiled*
> *Of its departing glory; still her fame*
> *Shines on thee, through the tempests dark and wild*
> *Which shake these latter days, and thou canst claim*
> *The shelter, from thy Sire, of an immortal name.*

Perhaps at the time this made up for another passionate poem Shelley had written in Albion House, which was dedicated to Claire—or rather 'To Constantia, Singing'—in celebration of the candlelit evenings they'd spent together, with Claire accompanying herself on the concert piano he had bought her at the end of April, with borrowed money, as a present:

> *Even though the sounds which were thy voice, which burn*
> *Between thy lips, are laid to sleep;*
> *Within thy breath, and on thy hair, like odour, it is yet,*
> *And from thy touch like fire doth leap.*
> *Even while I write, my burning cheeks are wet,*
> *Alas, that the torn heart can bleed, but not forget!*

Much later, Claire revealed that they 'wd not let Mary see it', and it was thought best for the poem to be published anonymously in a 'country paper'—which it was. Did they manage to keep it from Mary? Apart from singing—she had a beautiful voice by all accounts—Claire found the experience of looking after Alba to be very fulfilling, and began deeply to regret the arrangement she had

made with Lord Byron. Mary noticed that Claire was having second thoughts. In spare moments, Claire worked on—and finished—the ghost story she had told in the Villa Diodati.

On May 26th 1817, Mary wrote in their *Journal*, 'Murray likes F'. The Shelleys were visiting London for a few days. Percy had delivered the text to John Murray at 50, Albemarle Street—presumably letting him know that it had been written by an anonymous 'friend'. The last time he'd visited Murray was to deliver *Childe Harold* and *The Prisoner of Chillon*. Since Mary had by then probably re-copied the last thirteen pages, there were no tell-tale signs on the manuscript to give away Shelley's personal involvement. And since it was 'anonymous', and did not yet have a *Preface*, Murray had no way of knowing the connections with Lord Byron and Geneva. Murray's personal reaction was promising. But three days later, Mary wrote to Percy—who had immediately returned to Marlow from London, before her—with disappointing news:

Of course [Murray's editor William] Gifford did not allow this courtly bookseller to purchase F. I have no hope on that score but then I have nothing to fear.

Gifford was a critic and journalist as well as an editor—well-known in literary circles to be a crusty conservative with a sharp tongue. The 'courtly' reference suggests that he thought the novel was too unorthodox, or maybe its subversive theme of godless creation was thought to be too strong; a case of self-censorship. 1817 was a tense year for publishers, with numerous high-profile prosecutions for sedition, riot and blasphemy, about which the Shelleys knew a great deal. Percy was involved in defending some of the victims. Or maybe Gifford thought the business case had not been made: the Gothic craze was by then on the wane; Jane Austen's *Northanger Abbey*, though written many years before, had just satirised it (published late December 1817), and especially 'horrid novels' with titles such as *The Castle of Wolfenbach* or *The Necromancer; or, The Tale of the Black Forest*. Or *Frankenstein*?

The manuscript was returned on June 18th: 'Frank. sent back—send it to G.'. The dedication to William Godwin had yet to be written (another identifying feature), but Mary was keen to hear her father's reaction. Since the wedding, relations between them had been going better, though Godwin was again losing patience with Shelley over the money he thought he had been promised. As we have seen, *Frankenstein* revisited many of the themes from Godwin's thrillers, and his *Political Justice*—themes which represented a younger Godwin's passionate beliefs. They were summarised by Percy in the book review of *Frankenstein* he wrote later that year, but which was not published until after his death:

In this the direct moral of the book consists; and it is perhaps the most important, and of the most universal application, of any moral that can be enforced by example. Treat a person ill, and he will become wicked. Requite affection with scorn . . . divide him, a social being, from society, and you impose upon him the irresistible obligations—malevolence and selfishness.

Besides, perhaps William Godwin could help find a publisher through his extensive network of contacts in the book trade. He was sent the manuscript on June 18th, though he does not seem to have started reading the book in earnest until he received the proofs on October 13th, when he wrote in his *Diary* 'Frankenstein, Vol I'. He read Vol III, in proof, on 22nd–24th November. And, much to Mary's relief, he was very impressed: this was, he later told her, 'the most wonderful work to have been written at twenty years of age that I have ever heard of'. Actually, she was nineteen years of age when she wrote it. William Godwin added that he thought *Frankenstein* was far too good ever to be a popular success . . .

On August 3rd, Percy wrote to Charles Ollier, who was a friend of Leigh Hunt and who was known to sympathise with (some of) Shelley's radical ideas. Ollier was an ex-banker who had recently (in 1816) become a publisher in Vere Street, off Oxford Street, with his brother James. He was *one of us*—and what is more had agreed to publish Percy's latest poetry:

I send with this letter a manuscript which has been consigned to my care by a friend in whom I feel considerable interest.—I do not know how far it consists with your plan of business to purchase the copyrights, or a certain interest in the copyrights of any works which should appear to promise success. I should certainly prefer that some such arrangement as this should be made if on consideration you could make any offer which I should feel justified to my friend in accepting. How far that can be you will be the better able to judge after a perusal of the Mss.—Perhaps you will do me the favour of communicating your decision to me as early as you conveniently can.

By now, Percy was acting as Mary's agent—he had earlier acted as her editor—in a very persistent and businesslike way. The options he offered—outright purchase of the copyright, shared purchase, or 'a certain interest' in profit-sharing after deduction of costs which might be borne by publisher or the author, the option for authors 'new to the world'—were typical of publishing deals at the time. Catching the same post, Percy wrote an anxious note to Leigh Hunt, who was in the know about the real authorship of the novel, and who could well reveal all in a casual conversation with Ollier:

Bye-the-bye I have sent an MS to Ollier concerning the true author of which I entreat you to be silent, if you should be asked any questions.

Ollier would easily have recognised Percy's distinctive handwriting, so Mary must definitely have re-copied the ending of *Frankenstein* by this stage.

The novel may 'appear to promise success', but Charles Ollier was not convinced. Just three days later, by return of post in fact, the manuscript came back. Percy had asked for an early decision, but this was not at all what he had in mind. On August 6th, he wrote a rather desperate postscript to a gloomy letter from Mary to Leigh Hunt's wife, the painter and sculptor Marianne, also in the know, sent from Marlow to Hampstead:

Poor Mary's book came back with a refusal, which has put me rather in ill spirits. Does any kind friend of yours Marianne know any bookseller or has any influence with one? Any of those good-tempered Robinsons? All these things are

affairs of interest and preconception.—

The Robinson brothers of Paternoster Row had been William Godwin's publishers in the 1790s—*Political Justice* (1793), *Caleb Williams* (1794), *Memoirs* (1798)—risking prosecution at a time when the government was clamping down hard on what was seen as the infection of the French Revolution. *Political Justice* was issued at the same time as Louis XVI was executed in Paris. The brothers had also published Ann Radcliffe's *The Mysteries of Udolpho* (1794), a seminal Gothic novel which helped to make the genre respectable. Radical ideas plus the Gothic . . . Shelley's postscript suggests that he was becoming increasingly jaded with the publishing business—self-interest, prejudice, who you know—and that he had run out of suggestions. Except the Robinsons, who had gone out of business four years before. A couple of days later, Percy added a barbed aside to the end of another letter to Ollier:

I hope Frankenstein *did not give you bad dreams.*

Maybe Charles Ollier didn't want the unsettling manuscript to lie around his house: was that why the package had been turned around so quickly? Or maybe he hadn't read beyond the first few letters and chapters, and never even reached the frightening bits.

But on August 21st or thereabouts a letter arrived at Albion House from the firm of Lackington, Allen and Co. Mary wrote excitedly, 'A letter from Lackington' and Percy wasted no time before replying. William Godwin was a friend of George Lackington—a fellow professional in the book trade—and he may well have made the introduction. Lackington ran a circulating library as well as a bookshop in Finsbury Square (known as 'Temple of the Muses') selling books in bulk at the cheaper end of the market. The 'Temple' boasted that it contained half a million volumes and that one could—literally—drive a coach and horses through the first floor, a feat which had actually been performed as a publicity stunt. The back catalogue included many occult and Gothicky titles: *The Magus, or Celestial Intelligencer* (1801) and *The Lives of Alchemystical Philosophers* (1815), both by Francis Barrett, and *The Life of Merlin. His Prophecies and Predictions Interpreted* (1813) by Thomas Heywood as well as *Tales of the Dead* (1813), which had been translated by Sarah Utterson from Eyriès' *Fantasmagoriana*, the very same book as was being read aloud in French by Lord Byron on the night of June 17th at the Villa Diodati. So the auguries looked good. The Shelleys had sent Lackington the manuscript some time during the fortnight since Ollier's rejection. This was a far cry from the 'courtly' publisher of Lord Byron, or the sometimes radical publisher of Shelley—the Shelleys' enquiries had been descending gradually downmarket, to a publisher of cheap and spooky books by hack writers. Percy Shelley replied to Lackington on August 22nd:

I ought to have mentioned that the novel which I sent you is not my own production, but that of a friend who not being at present in England cannot make the correction you suggest. As to any mere inaccuracies of language I should feel myself authorised to amend them when revising proofs.

He offered the same range of contractual options as he had to Ollier.

During the first three weeks of September, there was much toing and froing between Percy Shelley and his wife's publisher. Mary wrote in her *Journal*, 'Bargain with Lackington concerning *Frankenstein*'. It emerged that the publisher did not wish to 'purchase the copyrights', or even to share them. George Lackington preferred to share *profits* with the author, after deduction of expenses—the first-timers' option—and his initial bid was that any profit-sharing should be postponed until a second edition (should there ever be one). Percy Shelley countered with a fifty–fifty share of the profits of the *first* edition. They agreed in the end on seventy–thirty in the publisher's favour—with the author retaining the copyright. Lackington had driven a hard bargain, but then again Percy Shelley had never managed to achieve as generous a deal on any of his own writings. *Queen Mab* and *Alastor* had been published on commission at the author's own expense. *Any* profits would have been welcome.

The book was to be anonymous, with five hundred copies printed. Shelley had formally committed himself to supervising amendments to the text (Lackington had evidently insisted on one of them), stylistic changes, and to correcting the proofs. It has recently been suggested that his involvement in the reshaping of the text was significant enough to amount to a battle with his wife over authorial control. She was—goes the argument—fighting for maternity of her own text. James Rieger, in his 1974 edition of the 1818 version, wrote, controversially:

Percy Bysshe Shelley worked on Frankenstein *at every stage, from the earliest drafts to the printers' proofs, with Mary's final 'carte blanche to make what alterations you please' . . . Should we grant him the status of minor collaborator? Do we or do we not owe him a measure of 'final authority'?*

In other words, he was virtually the co-author. In fact, as the publication of the full Abinger manuscripts makes clear, Percy Shelley's interventions were those of an attentive editor, or close colleague, helping out a first-time author. No more than that. Just 4,000 words out of a total of 72,000. Many of his interventions were genuinely clarifying; others were more 'poetic' and mannered. But when it came to the proofs, his contribution seems to have become more significant: since the proofs have not survived, however, it is impossible to say just *how* significant. He also wrote the new *Preface* to *Frankenstein* which was to be dated 'September, 1817', superceding the one written by Mary during the previous month. Why this was abandoned we do not know. Maybe it revealed too much about the identity of the author. In her *Introduction* to the 1831 edition, she was to recall:

I certainly did not owe the suggestion of one incident, nor scarcely of one train

Title-page of Volume One of the first, anonymous edition of **Frankenstein,** *published on New Year's Day 1818.*

FRANKENSTEIN;

OR,

THE MODERN PROMETHEUS.

---◆---

IN THREE VOLUMES.

---◆---

Did I request thee, Maker, from my clay
To mould me man? Did I solicit thee
From darkness to promote me?——
<div align="right">PARADISE LOST.</div>

VOL. I.

London:

PRINTED FOR

LACKINGTON, HUGHES, HARDING, MAVOR, & JONES,
FINSBURY SQUARE.

1818.

of feeling, to my husband, and yet but for his incitement, it would never have taken the form in which it was presented to the world. From this declaration I must except the preface. As far as I can recollect, it was entirely written by him.

The negotiation with the publisher coincided with the final weeks of Mary Shelley's pregnancy at Albion House. Indeed, she was to call her novel her 'progeny' and her 'offspring'. Her second daughter Clara Everina was born on September 2nd, and the birth was followed by a period of postnatal depression: births were always difficult for Mary, and besides, there was much else to be depressed about. Albion House was proving to be cold and damp (the books in the library were growing mildew), Percy Shelley was not feeling well (he was back in the care of William Lawrence), Mary was becoming anxious that the extent of her husband's debts was being kept from her, and she was increasingly intolerant of the boorish behaviour of some of his friends. It was clearer by the day that Albion House would not after all work as a settled home. Percy was talking about moving to Italy—or perhaps to the Kent coast: he wasn't sure at first—and the remainder of the twenty-one-year lease was put up for sale towards the end of September: there were no takers for several months, but there was a queue of creditors who were alarmed at the prospect of the Shelleys quitting the neighbourhood. Mary was even reluctant to join Percy in London, for fear of leaving the house empty. She had had an earlier experience of the bailiffs forcing entry, at their lodgings in Bishopsgate near Windsor. The lease was finally sold four months later. Mary was unsure about what should happen next:

You tell me to decide between Italy and the sea—I think—dearest—if, what you do not seem to doubt but which I do a little, our finances are in sufficiently good a state to bear the expense of the journey—our inclination ought to decide—I feel some reluctance at quitting our present settled state . . . At any rate, my love, do not let us encumber ourselves with a lease again.

When Percy had been house-hunting in Marlow, she had written:

A house with a lawn a river or lake—noble trees and divine mountains that should be our little mousehole to retire to . . .

But that was ten long months ago . . .

In October 1817, Percy wrote his preface to *Laon and Cythna* with its celebrated words:

. . . Danger, which sports upon the brink of precipices, has been my playmate. I have trodden the glaciers of the Alps, and lived under the eye of Mont Blanc. I have been a wanderer among distant fields . . .

And he still was. Mary wrote in her *Journal* at the end of the year the words 'le rêve est fini', then crossed them out. As if to remind her of the fact, throughout August and September Mary was preparing for publication her *History of a Six Weeks' Tour*—largely about their first travels together in summer 1814, padded out with two long letters written to her half-sister Fanny from Sécheron in May and June 1816 which she turned into literary versions for the purpose at the beginning of October, and considerably enhanced by the poem *Mont Blanc*. The *History* was to be co-published on November 12th 1817 by Charles Ollier, the man who had turned down *Frankenstein* after

skimming the manuscript. Like *Frankenstein*, the book was published anonymously. The novel has often been described as Mary's first publication. It wasn't. And it made no money; there were not even enough profits to pay the printer.

By September 24th, Percy Shelley was already correcting the proofs of volume one in Marlow and London, and Mary was writing to him: 'I am tired and not very clear headed so I give you carte blanche to make what alterations you please'. He was also negotiating with Lackington to publish '[Claire Clairmont's] book', the expanded version of the story she had told at the ghost-story session in the Villa Diodati, on which she had been working over the summer. This time, Lackington rejected the manuscript, which has not survived. By mid-October, Percy and Mary had finished reading the proofs of volume two, and were working through volume three. At the same time, the journal *The British Critic* made the first-ever public announcement of a forthcoming publication which was 'in the press':

A Work of Imagination, entitled Frankenstein, or The Modern Prometheus, *in three volumes.*

It was time for Percy Shelley to turn his attention to marketing. On October 23rd, he wrote to Lackington:

I do not see that I can amend your announce of Frankenstein. *On my part I shall of course do my utmost for my friend, and no quarter in which I think it can [be] successfully recommended shall be neglected. You are of course aware how much depends upon extensive and judicious advertising: a part of the question which you are the most competent to understand. I have paid considerable attention to the correction of such few instances of baldness of style as necessarily occur in the production of a very young writer, and beg . . . to request that the printer, as a particular accommodation to me should be urged to expedition.*

And five days later, he returned the proofs of the opening of Volume III—Victor Frankenstein and Henry Clerval travelling from Strassburg, along the Rhine, via Holland to London, Windsor and Oxford—with 'considerable alterations', notably an extra quotation about 'the sounding cataract' from Wordsworth's *Tintern Abbey* (1798), a shorter one about the 'very poetry of nature' from Leigh Hunt's *The Story of Rimini* (1816) and a new reference to the tomb outside Oxford of the illustrious parliamentarian John Hampden following a pilgrimage there on October 20th with William Godwin. By September 28th, Percy Shelley could write from Albion House:

Mr Shelley presents his compts to Mess Lackington and begs to inform them that he has, as yet, recieved [sic] no proof of the preface or the title of Frankenstein.

He continued, reiterating his advice about 'judicious advertising' and word-of-mouth:

Mr. S. suggests the advantage of announcing it by advertisement once before publication; as much expectation of its success has been excited in a particular circle, which such an announce might improve into a demand.

A final addition was made on December 3rd when Lackington was sent by Shelley 'a dedication which has been transmitted to me by the Author of *Frankenstein*, and which should be printed as is customary

immediately subsequent to the Title—.'

<center>
TO

WILLIAM GODWIN

author of Political Justice, Caleb Williams *& c*

THESE VOLUMES

are respectfully inscribed

by

THE AUTHOR
</center>

Maybe Mary had been waiting for her father's reaction to the proofs before sending the dedication at the eleventh hour, or maybe it was thought that if the dedication had been sent earlier, it would have given too much of a clue as to the real author's identity. Her father had shunned her, ignored her, disapproved of her elopement, married the wrong woman, but she was still deeply attached to the 'author of *Political Justice, Caleb Williams* & c'. So by December 3rd 1817, Lackington at last had the complete, corrected text of *Frankenstein*. At the end of the month, *The Times* was able to announce: 'On Thursday, Jan 1 1818, will be published in 3 vols, price 16s 6d, a Work of Imagination, to be entitled *Frankenstein, or The Modern Prometheus*'. On January 1st, the advertisement was amended to 'This day is published . . .' Mary wrote in her *Journal*: 'Fran(kens)tein comes'. The parcel which arrived in Marlow contained six bound author's copies—as per the contract with Lackington—and Percy ordered ten more for 'personal friends of the author'. One of them he sent to Charles Ollier with the note 'I should like to hear your opinion of *Frankenstein*' even though—surely—he already knew it only too well. The Shelley household celebrated on Christmas Eve at Albion House, with a blood-curdling rendition by Percy of Gottfried Bürger's ballad *Lenore* (1773, tr. 1790) about a young man called Wilhelm who returns from the war as a ghost, to claim his fiancée, and rides her through the night on his black stallion to a shared grave: its best-known line was 'the dead travel fast'. Shelley loved this poem. A local village girl called Polly Rose, who was there on Christmas Eve, 'quite expected to see Wilhelm walk into the drawing room'. She also remembered, many years later, Shelley claiming to have tried raising the devil—through various esoteric spells—in nearby Bisham Woods. He enjoyed scaring people like that, she said. One of the games he played was called 'Frightful Creatures'; it involved him making faces and ruffling his hair.

The first edition of *Frankenstein* was published on January 1st 1818, eighteen and a half months after Mary Godwin had first told the creation scene in Geneva. Claire Clairmont wrote to Lord Byron a few days later:

Mary has just published her first work a novel called Frankenstein or, the Modern Prometheus. *It is a most wonderful performance full of genius and the fiction is of so continued and extraordinary a kind as no one would imagine (to belong to) could have been written by so young a person.*

She proceeded to 'write part of a Critiscism [sic] on *Frankenstein*', but soon lost interest. Byron did not in fact receive the book until the end of April 1818, when Percy Shelley brought a copy of *Frankenstein* to him from Milan to Venice: 'It has met with considerable success in England, but she [Mary] bids me say that she . . . would regard your approbation as a more flattering testimony of its merit'. It was inscribed on the flyleaf 'To / Lord Byron / from the author'—one of only two copies known to have been signed by Mary Shelley—and was re-discovered as recently as 2012. Byron wrote to John Murray, from Venice, on May 15th:

Mary Godwin (now Mrs. Shelley) wrote Frankenstein—*which you have reviewed thinking it Shelley's [in the* Quarterly Review*]—methinks it is a wonderful work for a Girl of nineteen—not nineteen indeed—at that time.*

He evidently associated the novel with the Geneva summer, before Mary turned nineteen on August 30th 1816.

Sixteen copies of *Frankenstein* were sent to the author (Lackington charged £6 for the extra ten), sixteen more were sent out as review copies, and eight unbound versions became free gifts to booksellers as rewards for selling twenty-five three-volume sets. Lackington asserted that in addition to these, eleven copies had been 'Claimed under Copy Right' for libraries—though in fact there is only evidence of a single copy being registered; the publisher may well have quietly sold the other ten himself . . . The remaining books—459—were sold unbound to retail booksellers at a discount price of 10s 6d rather than the cover price of 16s 6d, shifting the risk on to them. Ten of *these* were sold to Mary and Percy Shelley—making a total to them of 26. Mary Shelley earned £41.13.10d from the Lackington edition—one-third of the overall £125.1.6d profit, after expenses, the deal specified in the contract: not much money, but more than Percy Shelley had managed to make from all his publications added together. According to the Bank of England's inflation calculator, Mary's earnings were the equivalent of £3,301.77p today—not bad for an unknown, anonymous, first-time novelist recommended by a little-known poet. Then again, £41.13.10d would scarcely have made a dent in the Shelleys' debts. It would not even have paid back the loan of £75 used to purchase a concert piano to accompany Claire Clairmont's singing.

For the first six years of its public life, there were only 459 copies of *Frankenstein* in circulation. Lackington never published a second edition, and probably never intended to. The book was expensive to buy, and confined to a small circle of readers. *The Times* on July 1st and 2nd 1818 and the *Morning Chronicle* on August 15th and 16th carried advertisements about *Frankenstein* which suggested that Lackington, and the other booksellers, were still trying to shift unsold stock. Nearly all the biographies of Mary Shelley, and studies of *Frankenstein*, claim that it was 'an immediate bestseller' or 'an instant success'. It certainly wasn't. Byron's poem *The Corsair* sold ten thousand copies on its first day in print: *that* was a bestseller.

Frankenstein only became a popular success, and only entered the cultural bloodstream, when the story was adapted for another medium altogether . . .

V.

'I bid my hideous progeny go forth and prosper'

AT THE END OF JULY 1818, seven months after publication, Percy Shelley summarised the reaction of the critics to *Frankenstein*, in a letter written from Bagni di Lucca in Italy:

Frankenstein *seems to have been well received, for although the unfriendly criticism of the* Quarterly *[Review] is an evil for it, yet it proves that it is read in some considerable degree, and it would be difficult for them, with any appearance of fairness, to deny it merit altogether.*

He was being kind. The review by John Wilson Croker (ex-Secretary to the Admiralty) in the right-wing *Quarterly Review* (issue for January 1818, published June 12th) was worse than 'unfriendly'. After summarising the plot, and gleefully pointing out its improbabilities, Croker had concluded:

Our readers will guess from this summary, what a tissue of horrible and disgusting absurdity this work presents.—It is piously dedicated to Mr. Godwin, and is written in the spirit of his school. The dreams of insanity are embodied in the strong and striking language of the insane, and the author, notwithstanding the rationality of his preface, often leaves us in doubt whether he is not as mad as his hero . . . When we have . . . admitted that Frankenstein *has passages which appal the mind and make the flesh creep, we have given it all the praise (if praise it can be called) which we dare to bestow. Our taste and our judgement alike revolt at this kind of writing, and the greater the ability with which it may be executed the worse it is—it inculcates no lesson of conduct, manners or morality; it cannot mend, and will not even amuse its readers, unless their taste have been deplorably vitiated . . .*

William Godwin, like Shelley, preferred to look on the bright side of this. After reading the *Quarterly*'s review, he wrote to his son-in-law:

I was anxious to see the numbers, lest they might mention names, or say anything else that might be painful to me. But the article is very innocent. They say that the gentleman who has written the book is a man of talents, but that he employs his powers in a way disgraceful to them. They do not, however, pretend to find anything blasphemous in the story.

His worries were that the piece might lead to scandal involving the family name—and that an accusation of 'blasphemy' might lead to the book being banned, or worse: after all, the *Quarterly* was campaigning to revive the offence of blasphemy. On these scores, he was reassured. He even seemed relieved that Croker thought the novel had been written by 'a gentleman'. But the *Quarterly* critique, by picking up on the dedication to William Godwin and the tone of the *Preface*, was not alone. In fact, most of the early reviews focused on the *Dedication* and the *Preface*. Some assumed that *Frankenstein* had been written by Shelley; most noted that it was full of Godwinian ideas and therefore probably suspect; nearly all pointed out the improbabilities of the plot—notably in volume two, the self-education of the creature. The mystery of who 'anonymous' was, was treated as the most newsworthy element. There were several comparisons between the monster and Caliban ('on whose nature nurture can never stick'), and even the negative reviews (reluctantly) enjoyed the descriptions of the Alpine scenery. Nine reviews appeared in 1818—four unfavourable, two mixed, two favourable and one supportive review article by Walter Scott. *The Edinburgh Magazine* (March 1818) echoed the concern about whether the novel had a moral purpose, or had simply been written to shock. If it didn't have a moral purpose, what was its point? But the review was more positive than the *Quarterly* overall:

Here is one of the productions of the modern school in its highest style of

Sketch by Richard Wynn Keene—later known as the designer Dykwynkyn—of the actor O. Smith as the Monster in the first revival of **Presumption! or the Fate of Frankenstein**, *at the English Opera House, Lyceum, in summer 1828, published here for the first time.*

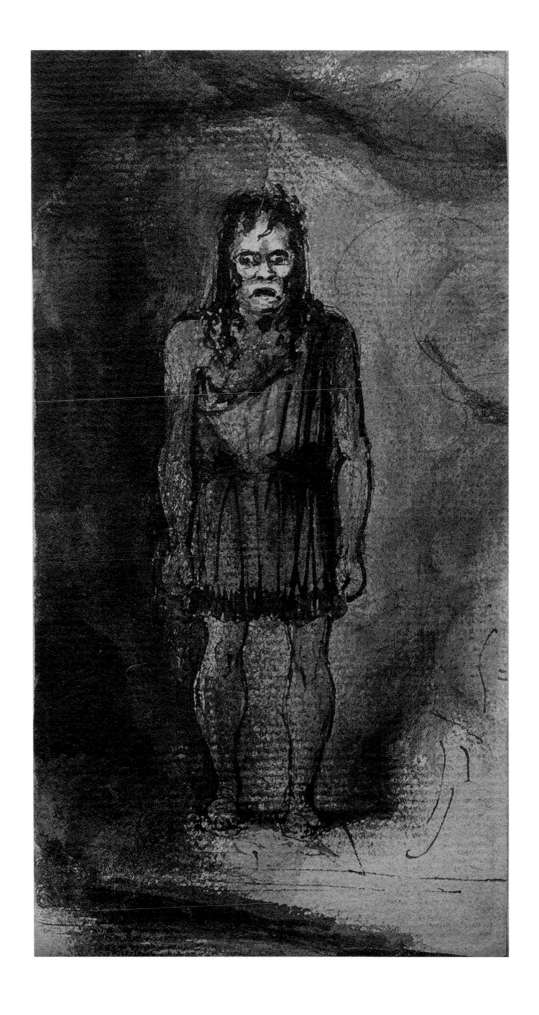

caricature and exaggeration. It is formed on the Godwinian manner, and has all the faults, but many likewise of the beauties of that model. In dark and gloomy views of nature and of man, bordering too closely on impiety,—in the most outrageous improbability,—in sacrificing every thing to effect,—it even goes beyond its great prototype; but in return, it possesses a similar power of fascination, something of the same mastery in harsh and savage delineations of passion, relieved in like manner by the gentler features of domestic and simple feelings. There never was a wilder story imagined, yet . . . it has an air of reality attached to it, by being connected with the favourite projects and passions of the times.

The Monthly Review (April 1818), in a shorter notice, was not prepared to take the novel seriously at all:

An uncouth story, in the taste of the German novelists, trenching in some degree on delicacy, setting probability at defiance, and leading to no conclusion either moral or philosophical. In some passages, the writer appears to favour the doctrines of materialism: but a serious examination is scarcely necessary for so excentric [sic] a vagary of the imagination as this tale presents.

The Gentleman's Magazine (also April), in another short notice, was 'shocked at the idea of the event on which the fiction is founded' (or so the writer claimed) but prepared to concede that 'many parts of it are strikingly good, and the description of the scenery is excellent'. It quoted the *Preface*'s remarks on the three 'friends' who had told each other ghost stories in Geneva, and speculated that one of the friends 'if we mistake not . . . was a Noble Poet'. The association between 'anonymous' and the *Dedication* was proving an intriguing one.

The British Critic (April) thought that *Frankenstein* was 'of the same race and family as [William Godwin's] *Mandeville*'—only inferior to it—and, the writer went on, 'if we are not misinformed, it is intimately connected with that strange performance, by more ties than one'. This coy reference to the author's identity became more specific, and aggressive, as the review article continued:

The writer of it is, we understand, a female; this is an aggravation of that which is the prevailing fault of the novel; but if our authoress can forget the gentleness of her sex, it is no reason why we should; and we shall therefore dismiss the novel without further comment.

The Literary Panorama (1st June) compared *Frankenstein*—to its disadvantage—with another Godwin novel:

[Frankenstein is] a feeble imitation of one that was very popular in its day,—the St. Leon of Mr. Godwin. It exhibits many characteristics of the school whence it proceeds; and occasionally puts forth indications of talent; but we have been very much disappointed in the perusal of it . . . and it exhibits a strong tendency towards materialism.

The review concluded with the most specific suggestion so far as to the authorship:

We have heard that this work is written by Mr. Shelley; but should be disposed to attribute it to even a less experienced writer than he is. In fact we have some idea that it is the production of a daughter of a celebrated living novelist.

But, where Percy and Mary Shelley were concerned, there was one review which would count more than all the others. On January 2nd, the day after publication, Percy had written from Albion House

to William Godwin's friend Walter Scott—Godwin had stayed at Abbotsford—enclosing one of Mary's presentation copies:

The Author has requested me to send you, as a slight tribute of high admiration and respect, the accompanying volumes.

My own share in them consists simply in having superintended them through the press during the Author's absence. Perhaps it is the partial regard of friendship that persuades me that they are worthy of the attention of the celebrated person whom I have at present the honour to address.

By February 20th, *Blackwood's Edinburgh Magazine* could announce to Correspondents that Scott's lengthy 'criticism on *Frankenstein*' had been delivered. It was published on March 20th. Scott began by contrasting novels which depended for their interest solely on 'the marvels of the narrations', with those which opened 'new trains and channels of thought, by placing men in supposed situations of an extraordinary and preternatural character, and then describing the mode of feeling and conduct which they are most likely to adopt'. *Frankenstein* was, for him, firmly in the latter category, like 'the well known *Saint Leon* of William Godwin':

. . . it is said to be written by Mr Percy Bysshe Shelley, who, if we are rightly informed, is son-in-law to Mr. Godwin; and it is inscribed to that ingenious author.

Scott, too, was less than convinced by the monster's '*lengthy* oration' in volume two, which tended to lose 'some part of the mysterious sublimity annexed to his first appearance', but praised the 'uncommon powers of poetic imagination' which were sustained through the novel—even if it 'shook a little even our firm nerves':

It is no slight merit in our eyes, that the tale, though wild in incident, is written in plain and forcible English, without exhibiting that mixture of hyperbolical Germanisms with which tales of wonder are usually told, as if it were necessary that the language should be as extravagant as the fiction . . . Upon the whole, the work impresses us with a high idea of the author's original genius and happy power of expression.

Mary Shelley wrote to Walter Scott that she was delighted to read 'approbation of such high a value as yours'. But she was concerned that the *Preface*, and Shelley's covering letter, had been misinterpreted by him. She wrote on June 14th 1818 from Bagni di Lucca:

Mr. Shelley soon after its publication took the liberty of sending you a copy but as both he and I thought in a manner which would prevent you from supposing that he was the author we were surprised therefore to see him mentioned in the notice as the probable author,—I am anxious to prevent your continuing in the mistake of supposing Mr. Shelley guilty of a juvenile attempt of mine; to which—from its being written at an early age, I abstained from putting my name—and from respect to those persons from whom I bear it. I have therefore kept it concealed except from a few friends.

This was, so far as we know, the first time she had admitted her authorship to anyone outside family and close friends. She had, she said, remained anonymous up to now out of respect for William Godwin and Mary Wollstonecraft—and indeed Percy Shelley: this was partly because it was 'a juvenile attempt' and partly because of the novel's far-reaching implications which could be misinterpreted.

The Shelleys received some of these reviews direct from the publisher Lackington, and some in parcels sent by their Marlow friend Thomas Love Peacock (May 30th, July 5th 1818). They had left from Dover to Calais for Italy—Mary, Percy, the two children William and Clara, Claire and Allegra (baptised March 9th), Elise Duvillard and a young maid from Marlow called Milly Shields—on March 12th, before most of the reviews had been published. Mary Shelley was to note in her *Journal* on October 24th 'read the *Quarterly*'. How she reacted to the reviews we do not know. Perhaps she would have shrugged them off, as she did when her manuscript was rejected by Murray: 'I have no hope on that score but then I have nothing to fear'. So long as the book remained anonymous.

One criticism she would *not* have seen was from the Gothic novelist William Beckford, who wrote in his copy of the novel: 'This is, perhaps, the foulest Toadstool that has yet sprung up from the reeking dunghill of the present times'. His *Vathek*, in its day, had been treated by some as in questionable taste. But, for him, the bounds of

acceptability had now been stretched too far and, besides, the post-war literary world was like a midden. Mary would also not have seen the various reactions to Polidori's *Vampyre*, published April 1st 1819, which re-energised debate and gossip about the Geneva summer. Because of the public attribution to Lord Byron, *The Vampyre* outsold *Frankenstein* many times over. In its book form, in England, there were seven printings in 1819 alone. In mid-July 1819, just after Cantos I and II of Byron's *Don Juan* had been issued, a parody was produced by William Hone which brought together *The Vampyre*, *Frankenstein*, the Villa Diodati and 'Lord Harold's Pilgrimage'. The vampire and the creature: a double-bill which would long outlive the century.

In rival conclave there and dark divan
He met and mingled with the Vampyre crew
Who hate the virtues and the form of man,
And strive to bring fresh monsters into view;
Who mock the inscrutable Almighty's plan
By seeking truth and order to subdue—

ABOVE: (Left) The play text of Peake's melodrama, also known as Presumption!*—the first ever adaptation; (Right) Playbill for* Presumption!*, English Opera House, 1823.*

CAUTION
TO
Playhouse Frequenters.

A sincere well-wisher to the Moral and Religious Conduct of the Population of Birmingham, has witnessed with much regret the announcement of a Piece named "FRANKENSTEIN, or PRESUMPTION," for representation on Monday next. As if the impious description of the NOVEL were not enough, we must here have the very horrid and unnatural details it contains embodied and presented to the view. This Piece, when acted in London, drew down the indignation of every devout and moral man, and was publicly exposed by the Society for the Suppression of Vice and Immorality. In giving this Caution, the Author has but the best feeling towards his Fellow Townsmen, and he will be amply rewarded by observing it attended to.

WHY do not the Proprietors of the Theatre interfere to prevent this impiety?---it reflects highly on them! They should remember "The Wages of Sin are Death," and that the rent of *such* a place will poorly compensate them for the Sin and Sorrow they are daily heaping on the deluded frequenters of this "Grave of the Soul."

Scribblers, who fright the novel reading train
With mad creations of th'unsettled brain.
There Frankenstein was hatched—the wretch abhorred,
Whom shuddering Sh—y saw in horrid dream
Plying his task where human bones are stored,
And there the Vampyre quaffed the living stream
From beauty's veins—such sights could joy afford
To this strange coterie, glorying in each theme,
That wakes disgust in other minds—LORD HAROLD
Sung wildly too, but none knew what he carolled.

A footnote joined the hue and cry against 'that knot of scribblers, male and female, with weak nerves, and disordered brains, from whom have sprung those disgusting compounds of unnatural conception, bad taste, and absurdity, entitled *Frankenstein*, or the *Modern Prometheus*, the *Vampyre*, & c & c'. 'Disgusting' echoed the *Quarterly Review*. William Godwin had evidently been right to react badly to the *Extract* introducing *The Vampyre*: it fanned the flames, and did no favours to his daughter. But it was too late. *Frankenstein*, and the circumstances of its creation, were well on their way into the bloodstream of popular culture.

Godwin wrote to Mary, in February 1823, that 'though [*Frankenstein*] can never be a book for vulgar reading, [it] is everywhere respected' He couldn't have been more wrong about the 'vulgar'—or indeed the respect—as he was to discover only a few months later. Because on July 22nd, he wrote again, just as Mary was preparing to leave Italy and return home via Paris:

It is a curious circumstance that a play is just announced, to be performed at the English Opera House in the Strand next Monday, entitled, Presumption, or the Fate of Frankenstein. *I know not whether it will succeed. If it does, it will be some sort of feather in the cap of the author of the novel, a recommendation in your future negociacions [sic] with booksellers.*

Mary Shelley had not bothered to secure her theatrical copyright by writing her own dramatisation—if indeed she'd had the time—so this 'curious circumstance' came as a complete surprise. Even if she *had* written her own, theatrical managements tended to ignore the copyright-holders. The news amused her. But Godwin made sure he was there on the opening night of the play, and moved fast on 'future negociacions with booksellers'. He immediately arranged for a second, two-volume edition of *Frankenstein* to be rushed out, this time with the name Mary Wollstonecraft Shelley proudly displayed on the title page. It was an open secret by now anyway—and Godwin had been reassured that the reviews of 1818 had not said anything 'painful' to him and his family. Plus there was by then the Shelley factor, following the poet's death the previous summer. *Frankenstein* was published by G. and W.B. Whittaker of Ave-Maria Lane, price 14 shillings, reset from the 1818 edition and corrected by Godwin himself: most of the 123 corrections were of single words, repetitions or minor grammatical errors, none in volume one, mainly in volume two. *Frankenstein* was issued on August 11th: it was expensive, luxurious, and with limited circulation. A month later, Mary wrote: 'On the strength of the drama, my father had published *for my benefit*, a new edition of *F.* and this seemed all I had to look to . . .' The edition was reissued—probably from unsold stock—by Henry Colburn on April 4th 1826 and there were still advertisements at the full price as late as 1835. Mary Shelley kept her father's corrections, when *she* came to revise her text.

Presumption, by Richard Brinsley Peake, opened at the English Opera House (a.k.a. the Lyceum Theatre, capacity 1,300) on July 28th, was performed thirty-seven times in its first season, and often revived at different theatres throughout the 1820s. (It opened in New York on January 5th 1825—the first-ever *Frankenstein* performance in the United States.) The mute, pantomimic performance of Thomas Potter Cooke as the Monster—fresh (if that is the word) from playing *The Vampyre* at the same theatre—was much admired in the press, the dialogue far less so. The critic for *The Drama* wrote of Cooke, '. . . with the art of a Fuseli, he powerfully embodied the horrible, bordering on the sublime and the awful'; this was a compliment. *Presumption* was immediately greeted by a series of protests, with placards and leaflets, organised by the London Society for the Prevention of Vice and Immorality:

Do not go to the Lyceum to see the monstrous Drama, founded on the improper work called Frankenstein.—*Do not take your wives and families—The novel itself is of a decidedly immoral tendency; it treats of a subject which in nature*

ABOVE: *A warning to theatregoers in Birmingham (1824).* OPPOSITE: *Actor Thomas Potter Cooke's entrance as the toga-wearing Monster in Peake's* Presumption!, *towering over his creator Frankenstein with a broken sword in his hand. Cooke was the first to play the part, the Boris Karloff of his day. He too was billed as '?'*

Dessiné par H. Platel.

Gently, éditeur, rue St Jacques, N.º 38.

M.ʳ Cooke, dans le rôle du monstre.
(Théâtre de la porte St. Martin, 3.ᵐᵉ Acte.)

Lith. de A. Chegire.

MR O. SMITH AS THE MONSTER.

in

FRANKENSTEIN.

OPPOSITE: T.P. Cooke, in the third act of Le Monstre et le magicien *at the Théâtre de le Porte Saint-Martin in 1826, from a drawing by Platel. The Monster kills little William Frankenstein. RIGHT: O. Smith holding up his cloak in Henry Milner's* The Man and the Monster *(1826), stipple and etching from a drawing by J. Duncombe. The production established O. Smith as a credible rival to T.P. Cooke, better at 'the fiercer passions of uncontrollable hate'.*

ABOVE: O. Smith as The Bottle Imp *in Richard Brinsley Peake's two-act melodrama, which opened at the Lyceum in July 1828; coloured sketch from a scrapbook of Richard Wynn Keene's work, published here for the first time. William Godwin saw the play on 19 July and wrote in his diary 'theatre. Bottle Imp'. Robert Louis Stevenson was later to credit 'O. Smith' as the inspiration for his short story,* The Bottle Imp. *OPPOSITE: Souvenir print of O. Smith as* The Bottle Imp, *published to cash in on the summer of 1828 production at the Lyceum, part of the Gothic craze in 1820s theatres stimulated by* Presumption!

N.º 29.

London Published by O. Hodgson, 72 Maidenhill Street, City Road.

M.ʳ O. SMITH as the BOTTLE IMP.

cannot occur. *This subject is pregnant with mischief; and to prevent the ill-consequences which may result from the promulgation of such dangerous doctrines, a few zealous friends of morality, and promoters of this Posting-bill . . . are using their strongest endeavours.*

The references to 'immoral tendency' and 'dangerous doctrines' suggest that the real targets were Percy Shelley and William Godwin, rather than a melodrama which had transformed Mary Shelley's complex fantasy with a conventional parable about daring to 'play God', and Victor Frankenstein into an equally conventional mad scientist who 'presumes' to tamper with mother nature. None of the journal reviews of the novel, in 1818, had even suggested that the book might be a parable about 'presumption'—or that it contained *any* moral lessons apart from Godwinian ones. Most of them had complained that *Frankenstein* did not contain a moral at all. But *Presumption* was there to fill the gap. The theatre's playbills were in no doubt about this:

The striking moral exhibited in this story, is the fatal consequences of that presumption which attempts to penetrate, beyond prescribed depths, into the mysteries of nature.

In one of the many 1820s spin-offs from *Presumption*, a poem, Dr Faustus himself was to make a guest appearance, in case the audience hadn't quite understood the point. Christopher Marlowe's *Dr Faustus* (1588–93) had, after all, fantasised about bringing the dead 'to life again—that would be something . . .'

But the advice to fathers, 'Do not take your wives and families', in time-honoured fashion, helped to ensure the play's success. The *Theatrical John Bull*, summarising the controversy, observed acerbically:

You have only to tell a Cockney that an Exhibition is shocking—abominable—impious, and off he starts to bear witness to the fact, without even staying to wash his face!

But this was no publicity stunt. The leaflets were disturbing the audience and encouraging even more rowdiness in the pit than usual. When they continued to be circulated for five nights in a row, the management of the Opera House felt obliged to write an open letter:

It is to be remembered that the Right Honourable the Lord Chamberlain [the state censor] sanctioned the piece by granting his License, which License would certainly have been withheld, had the Drama been of an IMMORAL TENDENCY. The piece also continues to be performed to crowded and fashionable Audiences; and whatever difference of opinion may exist respecting its merits as a dramatic work, not one Critic has objected to it on the score of morality.

And so the leaflets stopped. And *Presumption*, with the word *Frankenstein* more prominently featured, became a hit. The *Drama* (August 1823) described the atmosphere in the auditorium:

There was much boisterous applause throughout the whole of the performance, especially where the 'walking pestilence' deals death and destruction around. It has been repeated several times since with varied success, and we cannot but deny that this strange melo-drame [sic] has excited a very considerable degree of curiosity in the town.

The article could not resist reminding readers of the play's distant, scandalous parentage:

[Mary Shelley is] the widow of PERCY BYSSHE SHELLEY, and the daughter of Mr. GODWIN, the author of Political Justice *and other celebrated works. The novel itself is one of the boldest of fictions; and did not the authoress [actually Percy], in a short preface, make a kind of apology, we should almost pronounce it* impious.

The second edition of *Frankenstein* had by now been published, with its new title-page . . .

By August 14th, some garbled news of the play had reached Mary Shelley, who had just checked into the Hôtel Nelson in Paris:

. . . they brought out Frankenstein at the Lyceum and vivified the Monster in such a manner as caused the ladies to faint away and hubbub to ensue—however they diminished the horrors in the sequel, and it is having a run.

Actually, in *Presumption* the creation scene took place offstage, so it was unlikely to cause fainting in the stalls, and there were plenty of horrors to come in Acts Two and Three.

Four days later, Mary Shelley visited the jolly Irish playwright James Kenney, a friend of her father's, at Bellevue in Versailles, the source of the rumours about the play—and discovered:

. . . it was not true that the ladies were frightened at the first appearance of Frankenstein—K[enney] says that the first appearance of the Monster from F's labratory [sic] down a dark staircase had a fine effect—but the piece fell off afterwards—though it is [indeed] having a run.

On August 29th, Mary Shelley was back in London—after five years five months on the Continent—and her first outing was to see *Presumption* for herself, with her father, in the fourth week of its first run. Mary began her account of the experience—written to Leigh Hunt in Florence—with a joke about Byron, who, as everyone knew, awoke one morning and found himself famous:

But lo and behold! I found myself famous!—Frankenstein had prodigious success as a drama and was about to be repeated, for the twenty-third night, at the English Opera House. The play bill amused me extremely, for in the list of dramatis personae came '——— by Mr. T. Cooke': this nameless mode of naming the unameable [sic] is rather good . . . [F.] is at the beginning full of hope and expectation—at the end of the 1st Act the stage represents a room with a staircase leading up to F's workshop—he goes to it and you see his light at a small window, through which a frightened servant peeps, who runs off in terror when F. exclaims 'It lives!'—Presently F. himself rushes in horror and trepidation from the room and while still expressing his agony and terror, '———' throws down the door of the laboratory, leaps the staircase and presents his unearthly and monstrous person on the stage. The story is not well managed—but Cooke played ———'s part extremely well—his seeking, as it were, for support—his trying to grasp at the sounds he heard—all, indeed, he does was well imagined and executed. I was much amused, and it appeared to excite a breathless eagerness in the audience—it was a third piece, a scanty pit [of cheap seats] filled at half price—and all stayed till it was over. They continue to play it even now.

By the time she wrote this, a rival play—Henry Milner's *Frankenstein; or, The Demon of Switzerland*, in which the creature actually 'holds a long conversation with his maker', a first on stage—had already opened

at the Royal Coburg Theatre (a.k.a. the Old Vic, capacity 3,800), and a farcical burlesque—*Humgumption; or, Dr. Frankenstein and the Hobgoblin of Hoxton*—was about to open at the New Surrey Theatre. There would be many others, including *Frank-in-Steam; or, The Modern Promise to Pay* (Olympic Theatre, December 1824), which ended with the hero ('in love and debt') on the Margate Steam Boat pursued by his creditor Snatch. In all, *Presumption* would inspire at least *fourteen* English and French versions or burlesques within three years of its opening. The first translation of *Frankenstein*, subtitled *ou le Prométhée moderne*, had been published in Paris on July 21st 1821, and the play *Le Monstre et le magicien* by Jean-Toussaint Merle and Antoine-Nicolas Béraud opened at the Théâtre de la Porte Saint-Martin on June 10th 1826—again with T.P. Cooke as 'Le Monstre, personnage muet': his mime presented no language problems—where it ran for a record 94 performances in its first season. The complicated special effects were much praised, and *Le Journal de Paris* noted that by the end of the play there were so many dead bodies on the stage that 'it would have been difficult to do more unless one killed also the prompter and the musicians in the orchestra'. The success of the play, wrote *La Quotidienne*, was as monstrous as the story itself. All in all, T.P. Cooke was to give 365 performances in *Presumption* and *Le Monstre*. Mary Shelley was evidently keeping in touch with developments. The day after the opening in Paris, she wrote to an acquaintance there: 'How goes on Frankenstein of Porte St Martini?' Victor Frankenstein had become a Venetian alchemist called 'Zametti', and instead of being smothered by an avalanche at the final curtain, the Creature—and his creator—were drowned following a struggle aboard a schooner in a storm; perhaps a reference, in very poor taste, to the death of Percy Shelley in the Gulf of Spezia on July 8th 1822. *Le Monstre* inspired another innovation, according to the *New Monthly Magazine*: 'pamphlets, ribands and sweetmeats were called by its name' and sold on the streets of Paris—a very early example of tie-in merchandising.

After *The Demon of Switzerland* had closed at the Coburg, Henry Milner wrote another *Frankenstein* adaptation, *The Man and the Monster*, which opened at the same theatre on July 3rd 1826. This proved much more popular, and established the actor O. Smith as a credible rival to T.P. Cooke. The Creature had become mute again (the talkative version had gone down badly with critics and audiences), he met his end after stabbing his creator by leaping into Mount Etna 'now vomiting burning lava', and—the most significant innovation—the creation scene now took place on stage, in a laboratory with 'Bottles, and Chemical Apparatus—and a brazier with fire':

(Music.—He rolls back the black covering, which discovers a colossal human figure, of a cadaverous livid complexion; it slowly begins to rise, gradually attaining an erect posture, Frankenstein observing with intense anxiety. When it has attained a perpendicular position, and glares its eyes upon him, he starts back with horror.) Merciful Heaven! And have the fondest visions of my fancy awakened to this terrible reality; a form of horror, which I scarcely dare to look upon:—instead of the fresh colour of humanity, he wears the livid hue of the damp grave. Oh, horror! horror!—let me fly this dreadful monster of my own creation!

(He hides his face in his hands; the Monster, meantime, springs from the table, and gradually gains the use of his limbs; he is surprised at the appearance of Frankenstein,—advances towards him, and touches him; the latter starts back in disgust and horror, draws his sword and rushes on the Monster, who with the utmost care takes the sword from him, snaps it in two, and throws it down. Frankenstein then attempts to seize it by the throat, but by a very slight exertion of its powers, it throws him off to a considerable distance; in shame, confusion, and despair, Frankenstein rushes out of the Apartment, locking the doors after him. The Monster gazes about it in wonder, traverses the Apartment; hearing the sound of Frankenstein's footsteps, without, wishes to follow him; finds the opposition of the door, with one blow strikes it from its hinges, and rushes out.)

These three melodramas—*Presumption, Le Monstre et le magician* and *The Man and the Monster*—set the tone for future dramatisations and helped to stage-manage popular perceptions of the novel for those many who had not read it. *Frankenstein*, with its linked structure of three autobiographies—the letters of Arctic explorer Robert Walton, the reminiscences of Victor Frankenstein and his Creature's own intellectual formation—its three perspectives, was fiendishly difficult to adapt: a novel within a novel within a novel, with no conventional hero and no conventional villain, and a *doppelgänger* theme of hunter and hunted. There were some wild improbabilities in the plot, as some of the earliest reviews of the novel had pointed out: such as, how does Victor create a being eight foot tall out of the body parts of ordinary people (could this be something to do with the fact that he gathers his materials from animals as well as humans?); how does the creature become so fluent in English and French, majoring in literature, in the space of less than a year; how exactly could the creature have found a cloak lying around that just happens to fit him? Mary Shelley was not particularly interested in the literal facts of the case. As late as 1930 Hollywood scriptwriters were despairing of ever adapting the property successfully—even though stage adaptations had by then been proliferating for just over a century, including most recently one called *Frankenstein: An Adventure in the Macabre* (1927) by the playwright, novelist and former child actress Peggy Webling, which in revised form became one of the main sources used by Universal Studios. One big difficulty was turning all the flashbacks—and unreliable narrators—into a linear, chronological story.

The three melodramas recount the story as a conventional moral allegory, and established a series of theatrical conventions which were to have a very long shelf-life. These included alchemy and the elixir of life, rather than chemistry; a laboratory assistant (in *Presumption* called Fritz) who provided rustic comic relief as well as narration spoken directly to the audience; a demon-creature who does not speak, but who through dumb-show and grunts seeks for support from his creator and tries to grasp the sights and sounds around him (the element Mary Shelley enjoyed); a laboratory at the top of a flight of stairs—with coloured flashing lights seen through a window, or

a laboratory with lots of glassware, and a door for the monster to break; the triumphant line 'It lives!'; the characters reduced to four basic types—hero, villain, threatened heroine, comic rustic; the key scenes reduced to creation, abduction of the heroine and destruction; a moment when the monster (never the creature) leaps from the top of the stairs, snaps Frankenstein's sword, and another when he is captivated by a musical interlude; and an emphasis on the Gothic elements throughout. Robert Walton disappeared completely, as did de Lacy's lessons and Justine's locket, and instead there would be a spectacular finale—an avalanche, a boat in a storm, the 'craggy precipice' of Mount Etna—which destroys both Frankenstein and the monster. The avalanche is triggered by a bullet from the scientist's pistol. Instead of Victor Frankenstein's post-partum nightmare, interrupted by the creature, scientist and monster went head to head immediately after the creation. Instead of people *treating* the creature as ugly, in their different ways, he becomes hideous for all to see: in the case of *Presumption*, Cooke had a shock of dark hair, wore yellow and green greasepaint and a blue body-stocking, a slate-coloured scarf around his middle; the blue body-stocking was to become a tradition; a critic recalled of *Presumption*, the 'green and yellow visage, . . . straggling black locks . . . and blue hue of arms and legs'. Cooke also wore a toga for some reason, perhaps because this made it easier to explain how it fitted him off the peg. Instead of Victor's inner emotional life, a gestural, melodramatic mode of acting. In short, the melodramatisations tried to turn internal into external, and to distil a three-volume novel into a series of *tableaux*. The Lord Chamberlain was more lax with licences for operas, musicals and pantomimes than he was for straight plays: hence the amount of music, dumb-show and clowning in the *Frankensteins*; as much melo- as drama . . .

There were a few nuances. Frankenstein behaves obsessively, before seeing the error of his ways. The monster views his own reflection and burns his fingers as he tries to understand the world—like a grown-up child; the scene in the novel where the creature learns 'to distinguish between the operations of my various senses' and beholds 'a radiant form rise from among the trees' before he comes to understand that it is the moon, proved particularly influential to the melodramatists.

Frankenstein was in the process of turning from literature into myth—a parallel text to the novel, within the public realm, which made a different kind of sense and which responded to the anxieties of the moment. As Chris Baldick has written, 'The truth of myth . . . is not to be established by authorising its earliest versions.'

Here is the Monster's first entrance into popular culture, in *Presumption*:

(Music.—Frankenstein sinks on a chair; sudden combustion heard, and smoke issues, the door of the laboratory breaks to pieces with a loud crash—red fire within. The Monster discovered at door entrance in smoke, which evaporates—the red flame continues visible. The Monster advances forward, breaks through the balustrade or railing of gallery immediately facing the door of laboratory, jumps on the table beneath, and from there leaps on the stage, stands in attitude before Frankenstein, who has started up in terror; they gaze for a moment at each other.)

Frankenstein (to audience): Behold the horrid corpse to which I have given life!

(Music.—The Monster looks at Frankenstein most intently, approaches him with gestures of conciliation. Frankenstein retreats, the Monster pursuing him.)

Frankenstein: Fiend! dare not approach me—avaunt, or dread the fierce vengeance of my arm!

(Music.—Frankenstein takes the sword from off nail, points with it at Monster, who snatches the sword, snaps it in two and throws it on stage. The Monster then seizes Frankenstein—loud thunder heard—throws him violently on the floor, ascends the staircase, opens the large window and disappears through the casement. Frankenstein remains motionless on the ground—Thunder and lightning until the drop falls.)

The name 'Frankenstein' began from the mid-1820s to be applied to the monster rather than the scientist—possibly the result of presenting the monster as nameless: Cooke = Frankenstein—and the adjective *Frankenstein-ish* began to appear in reviews. The Franken-label was beginning to catch on. The monster himself came to be associated, in political cartoons, with a whole range of perceived social dangers—in the form of agitating workers, Irish peasants, radical reformers, Russians—which were thought to be out of control: the monster of mob rule; a symbol for readers who were anxious about change. One of the first of these associations occurred during a debate on the Slave Population of the West Indies and whether its condition should be ameliorated, in the House of Commons March 16th 1824: the Foreign Secretary George Canning said in his speech that:

To turn [the negro] loose in the manhood of his physical strength, in the maturity of his physical passions, but in the infancy of his uninstructed reason, would be to raise up a creature resembling the splendid fiction of a recent romance; the hero of which constructs a human form . . . but being unable to impart to the work of his hands a perception of right and wrong, he finds too late that he has only created a more than mortal power of doing mischief, and himself recoils from the monster which he has made.

So the story of *Frankenstein* had been about the *dangers* of reform all along, and by extension the monster's behaviour—as a mindless 'infant'—showed what could well happen if slaves were to be emancipated. Canning had evidently seen or read about *Presumption* as moral allegory, rather than studied the novel. Mary Shelley's Godwinian ideas had become an argument *against* social change.

She was thrilled to be mentioned in a major speech in the House of Commons, but seems not to have noticed how her story had been distorted. She wrote in a letter on March 22nd 1824 that the House of Commons was 'introducing some amelioration in the state of

Anxiety about technological change: the monster of the railroad tramples on the rights of the little people in its way, with the cloak of 'justice', a cartoon by Frank Bellew entitled **The American Frankenstein** *(c.1874).*

THE IRISH FRANKENSTEIN.

THE BRUMMAGEM FRANKENSTEIN.

John Bright. "I HAVE NO FE—FE—FEAR OF MA—MANHOOD SUFFRAGE!"—*Mr. Bright's Speech at Birmingham.*

THE IRISH FRANKENSTEIN.

"The baneful and blood-stained Monster * * * yet was it not my Master to the very extent that it was my Creature ? * * * Had I not breathed into it my own spirit?" * * * (*Extract from the Works of C. S. P—rn—ll, M.P.*)

the slaves in some parts of the West Indies—during the debate on that subject Canning paid a compliment to *Frankenstein* in a manner sufficiently pleasing to me', a sentiment she repeated in August 1827 when she called his speech 'gratissimi a me'. She seems to have thought that the 'compliment' was *in favour* of amelioration rather than against it.

The successful melodramatisations, and attendant publicity, indelibly associated Mary Shelley in the public mind with *Frankenstein*—in time with little else. But they did not help her precarious finances. She was dependent on a meagre allowance from Sir Timothy Shelley, with strings attached, plus her freelance earnings as a journalist. At the beginning of 1831, she wrote to Charles Ollier that 'things can never be worse than now—unless London were on fire'. Ollier was by then working as an adviser to Henry Colburn and Richard Bentley, who had joined forces as publishers in New Burlington Street. Bentley had recently launched his 'Standard Novels' series of cheap, small-format, clothbound versions of out-of-print novels—with a couple

of illustrations and an introduction—and William Godwin's *Caleb Williams* had been one of the first in the series (1830). Bentley's clever idea was to ask authors (or their survivors) to revise the existing texts, and to provide an Introduction—so the new copyright would now belong to him, and the clock would start again. In time, by this means he would claim the rights to many of the best-known novels of the period. The books would be marketed as new editions rather than bargain reprints. Mary Shelley's *Perkin Warbeck* had also been published in 1830, not by Colburn and Bentley but by Henry Colburn alone—after John Murray had turned it down, just as he had turned down *Frankenstein*. So there were existing connections between Mary and both Colburn and Bentley.

On February 18th 1831, she asked Ollier 'Have they any idea of publishing *Frankenstein* in their edition?' This time, she would be the initiator, not her husband or father. By the end of June, she had agreed terms with Colburn and Bentley—she sold the copyright for £30 (her father had been paid £50 for *Caleb Williams*)—and on September

The Monster, and the Franken-label, came to be associated in political cartoons with a wide range of perceived social 'dangers'. OPPOSITE: repealer Daniel O'Connell unleashing a monster of his own creation (by Charles Keene, for Punch, *November 1843). ABOVE: (Left) Reformer John Bright confronted by a massive working man after a Birmingham rally (by John Tenniel, for* Punch, *September 1866); (Right) Nationalist Charles Parnell cowering before a violent, simian Irishman (by Joseph Swain, for* Punch, *May 1882).*

3rd the *Morning Chronicle* featured the first advertisement for 'Mrs. Shelley's popular Romance, *Frankenstein*, Revised by the Author, with a New Introduction explanatory of the origin of the Story'. This 'New Introduction' was completed by Mary Shelley on October 1st, and it was first published, free-standing, a week later. The *Chronicle* cannily added, in subsequent advertisements, that *Frankenstein* had already 'had such a marked effect on society', and that the *Introduction* contained 'original Anecdotes of Lord Byron, and c'.

The single-volume edition of *Frankenstein*—'Revised, Corrected, and Illustrated, with a New Introduction by the Author'—was published as the ninth of the Standard Novels on October 31st 1831, at 6 shillings, or less than half the price of the 1823 edition. Four thousand and twenty copies were printed, of which 3,170 had been sold by summer 1832 according to Colburn's accounts. A week after publication, the *Chronicle* noted that 'the demand for the ninth Number of The Standard Novels' had been so great that supplies had been exhausted but that 'those who were disappointed in their applications' could now find copies in all good booksellers. Coburn and Bentley were very good at publicity.

The text of *Frankenstein* was substantially revised by Mary Shelley, to become a Standard Novel. She claimed in her *Introduction* that 'the alterations . . . are principally those of style', but they in fact went a lot further. The parallel between Robert Walton's 'love of the marvellous' and Victor Frankenstein's project was given new emphasis, from the beginning of the novel onwards. Walton now wrote:

. . . how gladly I would sacrifice my future, my existence, my every hope, to the furtherance of my enterprise. One man's life or death were but a small price to pay for the acquirement of the knowledge which I sought; for the dominion I should acquire and transmit over the elemental foes of our race . . .

Victor spots a kindred spirit, and replies:

Unhappy man! Do you share my madness? Have you drunk also of the intoxicating draught? Hear me—let me reveal my tale, and you will dash the cup from your lips.

So the reason Victor recounts his autobiography to the explorer has now changed. In 1818, it was in the hope that Walton would find it 'useful' and that 'it may enlarge your faculties and understanding'. Now, it is intended to convey a moral lesson. In this, as in many of her revisions, Mary Shelley was absorbing the lessons of the 1820s (the plays; the commentaries; the political clichés) and looping them into her own work.

Elizabeth Lavenza became the daughter of a Milanese nobleman, 'a sweet orphan' or 'my sweet Elizabeth'—much sweeter than in 1818—rather than Victor's cousin: the scandalous whiff of incest might, perhaps, in 1831 reflect badly on the author. Her golden hair 'seemed to set a crown of distinction on her head', and she becomes of 'loveliness surpassing the beauty of her childish years', like the fragrant heroine of a melodrama. Where Victor's scientific education is concerned, an eminent natural philosopher rather than Victor's father explains to him the principles of electricity and galvanism,

leading him to muse on 'Destiny . . . and her immutable laws' which have decreed 'my utter and terrible destruction'; as Victor leaves home for the University of Ingolstadt, he reflects on 'Chance—or rather the evil influence, the Angel of Destruction, which asserted omnipotent sway over me from the moment I turned my reluctant steps from my father's door', and he recalls of M. Waldman's lecture 'such the words of fate, enounced to destroy me'. The presentation of scientific education and research has become much darker and more doom-laden. So when deciding whether or not to confess, at the time of Justine Moritz's trial, Victor now adds:

My tale was not one to announce publicly; its astounding horror would be looked upon as madness by the vulgar. Did any one indeed exist, except I, the creator, who would believe, unless his senses convinced him, in the existence of the living monument of presumption and rash ignorance which I had let loose upon the world?

The word 'presumption' is especially significant: it echoes the title of the play; presumption in challenging the Almighty, and tampering with 'the laws of nature'. This goes with the word 'madness'—added several times in 1831—as in mad scientist. Shortly before Justine's execution, in the 1818 text Elizabeth Lavenza tries to comfort her with a homily—*Political Justice*-style—about the shortcomings of retribution as a reason for punishment ('Hateful name!') and about the inhumanity of the death penalty ('the executioner's hands yet reeking with the blood of innocence'). In the Standard Novels edition, Mary Shelley deletes this and substitutes a pious farewell speech by Justine:

'I do not fear to die . . . Learn from me, dear lady, to submit in patience to the will of Heaven!'

Victor's reaction to her judicial murder is to feel:

. . . torn by remorse, horror and despair; I beheld those I loved spend vain sorrow upon the graves of . . . the first hapless victims to my unhallowed arts.

Later, when he journeys through the Alps to Chamonix, Victor responds to the ravine of the Arve in ways which Mary Godwin in 1816 would scarcely have recognised—and would probably have mocked as too conventional:

The immense mountains and precipices that overhung me on every side—the sound of the river raging among the rocks, and the dashing of the waterfalls around, spoke of a power mighty as Omnipotence—and I ceased to fear, or to bend before any thing less almighty than that which had created and ruled the elements, here displayed in their most terrific guise.

The slowly advancing glacier, near 'the sources of the Arveiron', becomes not a symbol of arbitrariness any more, but instead a 'glorious presence-chamber of imperial Nature' which is broken by 'the silent working of immutable laws'.

Following the creature's plea at the end of his autobiography, Victor agrees at first to create for him a mate:

. . . to save them [my family] I resolved to dedicate myself to my most abhorred task . . .

I had an insurmountable aversion to the idea of engaging myself in my loathsome task in my father's house . . . I knew that a thousand fearful accidents

might occur, the slightest of which would disclose a tale to thrill all connected with me with horror . . . I must absent myself from all I loved while thus employed.

[I had experienced] so long a period of an absorbing melancholy, that resembled madness in its intensity and effects . . .

After abandoning his 'loathsome task', Victor returns from the Orkneys, with his father; but still finds it difficult to amuse himself in society, even in Paris:

I abhorred the face of man. Oh, not abhorred! they were my brethren, my fellow beings, and I felt attracted even to the most repulsive among them, as to creatures of an angelic nature and celestial mechanism . . . How they would, each and all, abhor me, and hunt me from the world, did they know my unhallowed acts, and the crimes which had their source in me!

And at the end, in the Arctic, Robert Walton, too, sees the error of his ways:

It is terrible to reflect that the lives of all these men are endangered through me. If we are lost, my mad schemes are the cause.

These additions or revisions of 1831 confine some of the complexities and ambiguities of the 1818 edition, give Victor Frankenstein more of a conscience, introduce references to Christianity and Destiny, present scientific research as potentially dangerous and incorporate some of the melodramatic conventions of the popular stage versions of the 1820s. They also absolve the novel from associations with William Lawrence's ideas of 1816 and 1819. Some commentators have treated the 1831 edition as the text of which Mary Shelley was 'the sole author, acting independently'— as more authentically hers and therefore more interesting than 1818. It is certainly true that the 1831 version is the one on which nearly all modern editions have been based, the one which has become *the* text outside academe. It is also true that the Mary Shelley of 1831 was a very different person to the Mary Godwin of 1816—and writing at a very different time; the new reign of William IV had begun the year before, and his coronation was at the beginning of September 1831. There was growing agitation for parliamentary reform. Mary, meanwhile, was concerned to downplay her late husband's radical past and passion for reform and to distance herself from them, for all sorts of reasons. Even her new *Introduction*—which has become as well-known as the novel it precedes, perhaps more so—draws a veil over her elopement in 1816, by implying that she was already married to Percy Shelley when she visited Geneva. Those things said, the original three-volume version is surely the more original and satisfying novel. Mary Shelley's new *Introduction* stresses the blood-and-thunder aspects, as do a number of her revisions. And she needed a commercial success.

One striking feature of Standard Novels number 9 is the two illustrations—the first-ever attempts to visualise the novel rather than the dramatisations, which we must assume Mary Shelley approved. They were the work of the young painter and illustrator Theodor von Holst, pupil and disciple of the Zurich-born Henry Fuseli, also the earliest British artist to illustrate Goethe's *Faust* in the late 1820s

(which he read in the original) and a fan of extreme Gothic subjects. He was just twenty-one years old when *Frankenstein* was published in 1831, and pleased to have been commissioned by Henry Colburn after leaving the Royal Academy Schools. Each of the Standard Novels was to have two illustrations—a frontispiece and a title page vignette—and von Holst had already supplied these for Schiller's *The Ghost-Seer* earlier in 1831, engraved by W. Chevalier. Born in London to Livonian/Russian parents, his favourite reading by his own admission was Bürger, Hoffman and Goethe. In his student days, he had made an etching of *Faust standing in his library reading* which strongly resembles his frontispiece to *Frankenstein*—the Gothic window, the bookcase, the skull, the medieval-ish setting. The subjects of the two steel engravings (again engraved by W. Chevalier) he created for Mary Shelley's novel were 'Frankenstein and his Monster'—illustrating the moment when the scientist sees 'the dull yellow eye of the creature open'—and, for the title-page vignette, 'Frankenstein Departs from Elizabeth'—showing Victor's leaving home for the University of Ingolstadt. The former emphasises the youth of the scientist, and his description of the creature:

His limbs were in proportion, and I had selected his features as beautiful. Beautiful!—Great God! His yellow skin scarcely covered the work of muscles and arteries beneath; his hair was of a lustrous black, and flowing . . . but these luxuriances only formed a more horrid contrast with his watery eyes . . . Unable to endure the aspect of the being I had created, I rushed out of the room . . .

This larger-than-life creature is very muscular—his skin seems too tight for him—and looks as though Frankenstein has aimed at classical proportion: but his eyes are bulging and he seems to owe something to the theatrical performances. The props lying around the laboratory are Faust-like. The vignette shows Victor, in vaguely Renaissance outfit, turning away from Elizabeth with his hand to his cheek in the conventional acting gesture, a Swiss tower in the background. The scene does not look at all as if it is happening in the late eighteenth century—it looks more like the same period as von Holst's *Ghost-Seer* illustrations: early modern. Von Holst was taught by Henry Fuseli in the last few years of the veteran artist's life, in the early 1820s, and was profoundly influenced by his style and choice of subject-matter. He also copied a number of Fuseli's drawings— leading to much confusion ever since about which works were Fuseli's, which von Holst's. So his selection by Colburn to illustrate *Frankenstein* was fortuitous, for many reasons.

Mary's mother had developed a hopeless passion for Fuseli in the late 1780s and early 1790s, and had even suggested a *ménage à trois* with the artist's young wife Sophia; Mary Godwin had met Fuseli, knew something of his background—William Godwin had written about him in his *Memoirs* (1798), in which he insisted that the passion had been based on 'refined sentiment' and a meeting of minds—and would certainly have been familiar with Fuseli's best-known painting *The Nightmare* (1782). Fuseli was still dining at the Godwin house as late as 1813. In *Frankenstein* (Volume 3, chapter VI of the 1818 edition),

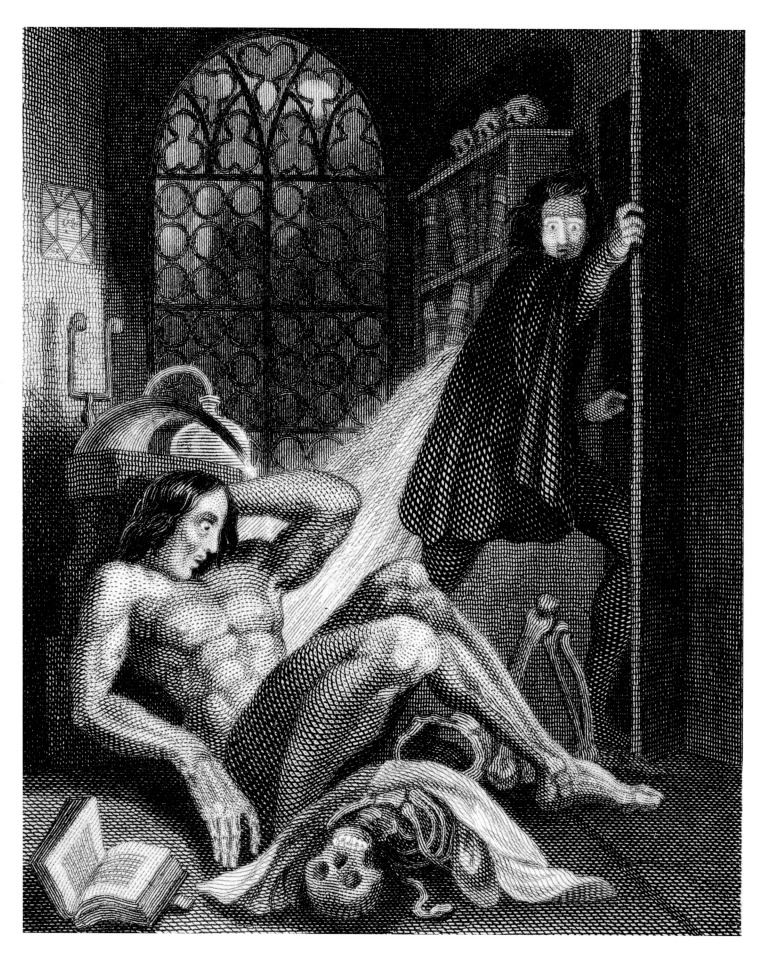

Mary Shelley based the chilling scene of the creature fulfilling his prophecy 'I shall be with you on your wedding-night' directly on the design of the painting:

Great God! [says Victor Frankenstein when he discovers what has happened to his new wife Elizabeth], why did I not then expire! . . . She was there, lifeless and inanimate, thrown across the bed, her head hanging down, and her pale and distorted features half covered by her hair. Every where I turn I see the same figure—her bloodless arms and relaxed form flung by the murderer on its bridal bier. Could I behold this, and live? Alas! Life is obstinate, and clings closest where it is most hated. For a moment only did I lose recollection; I fainted.

A recent scholar has justly described this scene as 'straight out of Fuseli's *Nightmare*'. Art historian Peter Tomory has noted 'the Fuselian nature of her [Mary Shelley's] invention', especially in the description of the superheroically proportioned creature cited above. Immediately after the young scientist has rushed out of the room, he too has a wild nightmare in which he embraces his beloved Elizabeth in the bloom of health—only to see her face become 'livid with the hue of death', before transforming into 'the corpse of my dead mother' in a worm-infested funeral shroud: this nightmare is interrupted by the 'miserable monster whom I had created' holding

up the curtain of the bed, and staring at him. The monster has taken over from the blind horse in Fuseli's painting, or even from the imp: *this* nightmare is evidently about expelling the female from the process of reproduction, and the birth of a motherless child. Fuseli had died in April 1825. His protégé Theo von Holst had become the keeper of his flame.

The £30 she received for the copyright—no royalties—was the last financial reward Mary Shelley ever earned from *Frankenstein*. There was talk in autumn 1838 of publishing the novel in the even cheaper series *The Romanticist and Novelist's Library*, which would have made her a little money, but the copyright owners refused permission. 'Bentley and Colburn', Mary Shelley explained, 'bought the copyright of *Frankenstein* when it was printed in the Standard Novels'. Where this left the *original* 1818 edition, she was not sure: 'I do not know what the laws are'. So *Frankenstein* remained virtually out of print—even beyond the expiry of the 1831 copyright—until the 1880s. As William St Clair has observed:

Unable to think of a way of enjoying the intellectual property themselves, the then owners were determined, like a dog in the manger, to deny others the opportunity. While in copyright, Frankenstein *was never issued as a yellow*

*OPPOSITE: The first ever illustration to **Frankenstein**, the engraved frontispiece by Theodor von Holst in the 1831 Standard Novels edition.*
*ABOVE: (Left) Von Holst's engraved frontispiece to the 1831 edition of **Frankenstein**, with Faust-like props; (Right) Etching by the young von Holst of **Faust Standing in his Library Reading** (1820-3): note the window, the bookcase and the skull.*

back, as a shilling shocker, never abridged, turned into a cheap book, or otherwise adapted for the lower-income readers who were joining the reading nation in the middle nineteenth century . . . During its first forty years, a total of between 7,000 and 8,000 copies [at most] were printed and sold, still fewer than Byron . . . commonly sold in the first week . . . During most of the nineteenth century, it was not the reading of the text of the book, but seeing adaptations of the story on the stage which kept Frankenstein *alive in the culture.*

And these adaptations, he continues, 'conveyed a message which was contrary to the plain meaning of the original text'. The 1818 text, that is.

After 1880, there were numerous editions, abridgements, reprints—and illustrations—which at last presented the book to a wider readership beyond the upper middle class. But the literary establishment remained unconvinced. The paperback *Routledge World Library* edition of 1886 was introduced by Hugh Reginald Haweis with the cautionary words:

I issue Frankenstein *with some degree of hesitation, but after mature reflection. The subject is somewhat revolting, the treatment of it somewhat hideous. The conception is powerful, but the execution very unequal . . . [The] tale of horror is unrelieved by any real poetical justice, and the moral threat—if there is any—is vague and indeterminate. Still,* Frankenstein *retains its popularity as the first of a class of fiction—not of a very high order . . .*

And *that* tempting introduction, written from on high, was followed by the *1831 version!* Clearly, the book required a health warning, even in its revised form, before being offered to the masses of late-Victorian Britain and the Empire.

Richard Church, in his book *Mary Shelley* (1895)—one of the *Representative Women* series—saw *Frankenstein* as an aberration in Mary Shelley's life and, probably, a bit of an embarrassment. The novel was, he wrote, 'marred very seriously by a certain haste, an indolence, a vagueness of construction'. Percy Shelley should surely have done something about this example of 'girlish romanticism'. The thing about Mary Shelley was that she 'suffered from an overtrained literary conscience'. In asserting this, Church was echoing a criticism which had been around for a very long time.

Reviewing the Standard Novels edition, the *London Literary Gazette* had written way back in November 1831:

. . . Frankenstein *is certainly one of the most original works that ever proceeded from a female pen. The merits our feminine writers possess, are tact, feeling, the thoughtfulness born of feeling, a keen perception of the ridiculous, or a touching appeal to sympathy. Not one of all these is the characteristic of the work before us; it appeals to fear, not love; and, contrary to the general* matériel *in the writings of women, has less of the heart in it than the mind . . . We should recommend [its pages] on the same principle that physicians prescribe alteratives.*

That is, herbal purifiers of the blood . . .

Mary Shelley's *Introduction* of 1831 could rearrange and embellish the events of June 1816 in the knowledge that all the men who had taken part in that ghost-story session were dead: Dr Polidori had died of a head injury and brain damage following a coach accident (both

John Murray and Lord Byron thought he had committed suicide) on August 24th 1821; Percy Shelley had drowned when his yacht—the *Don Juan*—had capsized in a storm in the Gulf of Spezia, on July 8th 1822; and Lord Byron had died a miserable death, from infection and fever, at Missolonghi in Greece on April 19th 1824. All, in their very different ways, ripe for mythologisation.

Of Mary's five children, only one had survived infancy. Her first child, a daughter, born three months early in February 1815, died twelve days later. Her other daughter, Clara Everina, born at the beginning of September 1817, died just over a year later. William died, as she always feared he would, when he was three-and-a-half years old, in June 1819. Her fifth pregnancy led to a haemorrhage and miscarriage which almost killed her, in June 1822. Only Percy Florence Shelley, born in November 1819, still lived. Allegra Byron died of typhus fever at the Convent of Bagnacavallo, on April 22nd 1822, at the age of five-and-a-quarter years. Of Percy Shelley's children with Harriet, Charles died of tuberculosis in 1826 at the age of twelve, while Ianthe died in 1876 at the ripe old age of sixty-three. No wonder some commentators have described *Frankenstein* as amongst many other things a 'phantasmagoria of the nursery'—reflecting anxieties about motherhood and post-partum depression; about a motherless child who grows up to destroy his parent's family. By the age of twenty-seven, the age when most scholars studying *Frankenstein* today are just finishing their doctoral theses, Mary Shelley felt 'as an old woman might feel. I may not love any but the dead'. The morbidity of *Frankenstein*—especially when viewed in retrospect—certainly had roots in the real world.

The remainder of her life was spent struggling to earn her living as a writer, often a hack writer, begging for an allowance from the Shelley family (who initially wanted custody of young Percy in exchange), quarrelling—one by one—with her late husband's fair-weather friends, confiding in a few close female companions, defending and enhancing Shelley's posterity, and slowly withdrawing into herself and her books. As she wrote in her *Journal* shortly after Percy died, 'I bear at the bottom of my heart a fathomless well of bitter waters, the workings of which my philosophy is ever at work to repress . . .' She tried to be likeable and emotionally fulfilled—but somehow 'misfortune' always got in the way. And so she earned the reputation of being cold and reserved and detached. 'A cold heart', she wrote in her *Journal*, 'have I a cold heart? God knows! But at least the tears are hot'.

Mary Shelley died in London at the age of fifty-three, after a series of strokes, on February 1st 1851—the year of the Great Exhibition, with its celebration of science, technology and design; mid-Victorian notions of progress. Shortly before she died, a one-act *Frankenstein; or the Model Man*—which combined the old story with a harlequinade, the Creature as Clown—had closed at the Adelphi Theatre after fifty-four performances. Reviewing it, *Punch* had written: 'six children in arms were taken from the pit to the nearest apothecary's, in convulsions of

laughter'. At one point, the Harlequin-figure called Otto Rosenberg turned to the audience and begged:

> *You must excuse a trifling deviation*
> *From Mrs. Shelley's marvellous narration.*

Mary was buried on a sloping patch of high ground in St Peter's Churchyard, Bournemouth, near the family home of her surviving son. Her father William Godwin and mother Mary Wollstonecraft were exhumed from St Pancras Churchyard and reburied next to her (as she had requested): the commemorative family plaque listed their best-known works, but not *Frankenstein*. The local vicar drew the line at that. By the mid-Victorian age, the authorised version of Mary's early life had become that Percy was an angelic hero and martyr—the 'Ariel' tendency— Harriet was irrelevant, and Mary was the virtuous wife and helpmeet of the poet. *Frankenstein* was an unfortunate piece of juvenilia.

Most of the obituaries were short; all of them said that her main claim to fame was as 'the faithful and devoted wife of Percy Bysshe Shelley'—a view which continued, in the literature, until at least the middle of this century. The inscription on her gravestone reads 'Mary Wollstonecraft Shelley, Daughter of William and Mary Wollstonecraft Godwin, and widow of the late Percy Bysshe Shelley'—just as the nineteenth-century plaques on the places with which she was associated (Sécheron, Diodati, Albion House Marlow) mentioned Byron and Shelley but never Mary. Only very recently have these omissions on the plaques begun to be rectified.

Towards the end of her life, in the mid-1840s, she had revisited the Villa Diodati, and looked up at the imposing house from the shore of Lake Geneva. 'Was I the same person who had lived there', she asked herself, 'the companion of the dead. For all were gone, even my young child had died in infancy . . . Storm and blight and death had destroyed all, while yet very young.' She had no way of knowing it, but one thing *had* survived the storm and the blight—to take on a life of its own which its creator would scarcely recognise—the thing she called her 'hideous progeny'. In her lifetime, it was the stage which turned her novel into a myth: later, it would be the turn of the cinema to develop that myth and turn it into a global brand.

The first new twentieth-century adaptation of *Frankenstein*, in 1910, was a film. Some have called it the first American horror film, with a story, worthy of the name—and yet it inherited the theatrical tradition. *Frankenstein*, a one-reeler for the Thomas Edison Film Company which ran for sixteen and a half minutes, featured the Monster (Charles Ogle) crashing through some French windows; had the mad scientist (Augustus Phillips) create him by alchemical means from a huge bubbling pot which transmutes a skeleton into a hideous

The one-act **Frankenstein, or the Model Man**, *a Christmas entertainment, which was performed in 1850 (shortly before Mary Shelley died).*

The EDISON KINETOGRAM

VOL. 1　　　LONDON, APRIL 15, 1910　　　No. 1

SCENE FROM

FRANKENSTEIN

FILM No. 6604

EDISON FILMS TO BE RELEASED FROM MAY 11 TO 18 INCLUSIVE

figure with bulbous eyes, a misshapen body and frizzy hair; and included a servant who helped out. One clever touch had the scientist looking into a mirror and seeing the Monster, until he banishes the Monster's image, it fades, and 'Frankenstein sees himself in his young manhood'. Another had the hand of the Monster opening the studded iron door of the laboratory and the scientist rushing off in terror—like in the 1831 illustration. The actual creation was achieved by setting a skeleton on fire and running the resulting film backwards. Edison's publicity stressed:

In making the film the Edison Company has carefully tried to eliminate all the actually repulsive situations and to concentrate its endeavours upon the mystic and psychological problems that are to be found in this weird tale.

Long thought lost, a print of this *Frankenstein*, which was written and directed by J. Searle Dawley, surfaced in the 1970s in the collection of a Wisconsin film collector—and has now become generally available. The film's publicity in 1910 was at pains to point out that the story was based on an acknowledged classic—a form of cultural legitimation which was usual for horrific subjects in the early days of cinema. It was as if the horror was only thought to be palatable if it had a respectable literary pedigree. So, for example, *The Raven* (1912 and 1915), based on Edgar Allan Poe's 1845 poem, was always billed as 'an American classic'. And the second American version of *Frankenstein*, the feature-length (fifty-five-minute) *Life Without Soul* (1915), shed the 'F' word completely: the film (now lost) had the British actor Percy Darrell Standing as the 'brute man', William Cohill as his creator William Frawley, and it concentrated on a steamship and a chase across Europe to catch the monster who has killed the scientist's sister; in the end, it all turns out to have been a dream. *Il mostro di Frankenstein* (1920), directed by Eugenio Testa, with Italian producer Luciano Albertini as the scientist and a troglodytic *mostro* played by Umberto Guarracino, was the first European take on the story. It, too, is now lost.

*OPPOSITE: Announcement of Edison Film number 6604, the first film version of **Frankenstein**, with Charles Ogle as the Monster: 'all the actually repulsive situations', the publicity claimed, had been eliminated. ABOVE: The Monster (Charles Ogle) plagues his creator on his wedding night, in the Edison **Frankenstein** (1910).*

Universal Studios' *Frankenstein* (1931) had a difficult birth: two directors (Robert Florey then James Whale), two creatures (Bela Lugosi then Boris Karloff), three or more screenplays, and two possible endings (one where the scientist survives, the other where he perishes: both were shown at previews to gauge audience reaction). But one consistent feature, during its long gestation, was a viewing of some German Expressionist films—horror films made between 1919 and 1927 in the Germany of the unstable Weimar Republic which grew out of the earlier Expressionist movement in painting, literature and theatre, a remarkable example of an advanced art movement being thoroughly absorbed, after a short time-lag, into commercial cinema. The craze had begun with *The Cabinet of Dr. Caligari* (late 1919), one of the most influential horror films of all time—if not *the* most influential. Its fusion of Gothic and Romantic traditions with a

style best described as Expressionist—jagged buildings and cracked walkways; perpendicular lines replaced by diagonals; broad gestural performances and the sense of a visual world which is an outward sign of inner turmoil; high-contrast black-and-white photography—as the most effective way of giving visible form to the old stories, exported to Hollywood, came to define the look of horror in the early sound era and how it was best to be performed by over-the-top (usually) British actors. 1919 was also the year when Sigmund Freud published the first version of his essay on *The Uncanny*, centred on an analysis of E.T.A. Hoffman's short story *The Sandman*: familiar things presented in unfamiliar or heightened or off-centre ways, he wrote, were particularly unsettling. And the old stories still had the power to reach dark places, by playing to everyday anxieties. There had, of course, been individual fantasy and horror films before *Caligari*, in

LEFT: The Golem (Paul Wegener) on the streets of medieval Prague in the 1920 German expressionist film, also directed by Wegener.
RIGHT: Original German poster for The Golem: How He Came into the World *(1920) by the painter, architect and set designer, Hans Poelzig.*

both Europe and America, (such as the 1910 *Frankenstein*) although they did not yet amount to a distinctive or even an identifiable genre. 'As soon as one ventures into the domain of the fantastic, the strange, the unusual', wrote the historian of film design Léon Barsacq, 'one invariably finds oneself caught in the wake of the great age of German cinema'. The creation scene in James Whale's *Frankenstein*—the cavernous laboratory, the flash-bang equipment, the arc of electricity delivering the spark of light—owes much more to the sequences set in Rotwang's laboratory in Fritz Lang's *Metropolis* (1926) than to Mary Shelley; and Karloff's Monster is closely related to the sleepwalking Cesare in Caligari and to Paul Wegener's *The Golem* (1920 version). Universal's *Frankenstein* fused a domesticated form of Expressionism, overacting, an irreverent adaptation of an acknowledged classic, European actors and visualisers—and the American carnival tradition—to create an American genre. It began to look as though

Hollywood had actually invented *Frankenstein*, *Dracula* and *Dr. Jekyll*. The screenplay of *Frankenstein* (1931) was loosely—very loosely—based on Peggy Webling's play of 1927 *Frankenstein: An Adventure in the Macabre*, as revised by John Balderston and completely rewritten by at least five others. The play retained the alchemy theme from 1820s versions, called both creator and created 'Frankenstein' and presented the Monster as a shambling, childlike, talkative brute, but added an epilogue in which Prof. Waldman lectures him about the importance of Christian repentance. So the Monster's last words are:

'Friend . . . God! *(Stretches up arms).* God help me.'
(Lightning strikes hut—some of which crumbles. Lamp goes out—darkness but for brazier. Frankenstein [the Monster] falls, dead, face near brazier, look of peace . . .)

The play was commissioned by actor-manager Hamilton Deane to tour Britain in repertory with *Dracula*—which it did for two years

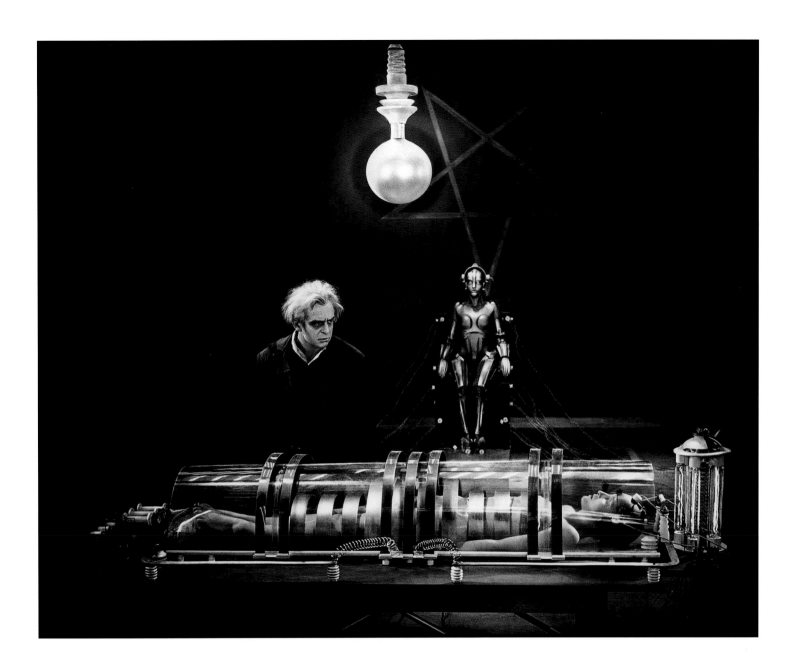

with Deane playing the Creature and the Count, just as T.P. Cooke had played ———— and *The Vampyre*—and shortly after Universal's *Dracula* opened to big business in 1930, the studio purchased the rights. *Frankenstein* created the definitive movie image of the mad scientist, and in the process launched a thousand imitations: all subsequent film versions of Mary Shelley's novel have had to take into account how plot, characterisations and makeup conform to or differ from the Universal Studios template. The screenplay kept Fritz (turning him into a hunchbacked and vertically challenged lab assistant) and a childlike, grunting monster (mimed, touchingly, by the forty-four-year-old Boris Karloff), but changed the line 'it lives!' from the original play into 'it's alive', added a jar containing 'Dysfunctio

Celebri' or 'Abnormal Brain'—Robert Florey's idea—and in the end destroyed the monster in a burning mill. The laboratory was at the top of a flight of stairs, and Prof. Waldman was the scientist's conscience. So far, the Hollywood version stuck more or less to theatrical tradition. But then the serious changes began. Instead of a blazing alchemical cauldron and some loud bangs, Henry Frankenstein (as he was called, as in Webling's play) now had a fully equipped laboratory which was a curious mixture of 1816 and 1931: incomprehensible dials, a huge Voltaic battery, a Wimshurst machine, lightning-arc generators, piles of Bakelite bric-a-brac and Leiden jars and an adjustable metal hospital bed. Result: 'It's moving—it's alive—it's alive—it's alive. It's ALIVE.'

OPPOSITE: Nikola Tesla dramatically demonstrating the safety of 'alternating current' in his laboratory (1899).
ABOVE: The evil scientist Rotwang, in his alchemical laboratory in Metropolis *(1926).*

In addition to *Metropolis*, as cultural historian David Skal has pointed out, this owes something to the spectacular public demonstrations in America of the eccentric Serbian-American engineer Nikola Tesla, the man who patented alternating current and who was said to be able to recite whole chunks of Goethe's *Faust* as a party piece. A famous photo of Tesla (possibly double-exposed) showed him sitting near a metal cage with 'twelve million volts' being chucked at it. Instead of Mary Shelley's well-proportioned but scary creature, her new Adam, and instead of *Presumption*'s dark-haired brute in a blue body-stocking, the Monster became a more literal thing of scars and stitches and skewers—with makeup by Jack Pierce seemingly based on an image of the madhouse entitled *The Chinchillas* from Goya's series of prints *Caprichos/Caprices* (1799). His huge dome-like forehead and big feet made him resemble someone with an acromegalic condition and a serious pituitary problem: an image of disability (like many of the 'monsters' designed by Hollywood makeup people in the 1930s) rather than of beauty gone wrong. Universal Studios briefly toyed with the idea of making their monster look like a robot, half-human and half-machine—an idea from *Metropolis* that continued into some of the posters and pre-publicity: but the only remnant of that design idea was the steel bolt through Karloff's neck, something to plug him into. The climactic confrontation between the Monster and Elizabeth (Mae Clarke)—and the image of Elizabeth lying across her bed on the posters—were closely based on the design of Fuseli's *The Nightmare*. Instead of a story set in the 1790s or 1816, the period was a wild mixture of medieval (the angry peasants), romantic Gothic (the castle where Frankenstein works) and the present day: the village was already on the backlot, courtesy of *All Quiet on the Western Front*. Instead of the young research student of the novel, who has worked his way through the history of scientific experiment from medieval alchemy via various paradigm shifts to the latest natural sciences as studied at the University of Ingolstadt, and instead of the mature, fatherly figure of *Presumption*, Henry Frankenstein himself became, in Colin Clive's performance, a manic, histrionic aristocrat who manages to keep a straight face while yelling lines like 'Now I know how it feels to be God!' Instead of Mary Shelley's subtle allegory about cybernetic birth, social exclusion and the destruction of a family, the plot of *Frankenstein* now hinged on a lab assistant who tries to steal a 'normal brain' in a jar from a nearby medical university, only to drop it by mistake and substitute that 'abnormal brain' instead.

In short, the original novel had been reworked as a fast-moving, audience-grabbing melodrama. Although *Frankenstein* was an early talkie, Karloff's performance as the Monster really belonged to the world of silent film. The film distilled the complexities of the novel to a simple Faustian morality tale about the social responsibility of science, and the transgression of God's/nature's laws, at a time—just after the Wall Street Crash of 1929—when scientists and 'experts' were being regularly vilified in the popular press for all their broken promises of the 1920s. Karloff's costume made him look like a larger-than-life American working man. He encourages a negative reaction from everyone because he has a nasty brain and because he looks grotesque: in the book, as Percy Shelley wrote, the creature becomes ugly because he is treated as ugly; lacking a family of his own, he destroys his creator's brother, best friend and wife; his real tragedy is that he possesses the whole range of human feelings. Apart from the idea of Frankenstein as mad scientist, the film gave much more emphasis than the novel to his isolation from the mainstream scientific community (the 'peer group', in today's terms)—his DIY experiments are like those of a back-street abortionist—and to the fact that his work seems to have no practical value, for the betterment of society: there is a strong distrust of intellectuals, and of abstract thinking—a distant memory of the Puritan tradition, perhaps—plus a critique of Henry Frankenstein for not being more down-to-earth, more like a cracker-barrel Tom Edison. He is too European: not enough Yankee knowhow. Hollywood here becomes the great leveller: if the audience doesn't understand it, or grasp the thought process, then it *must* be evil. Science is expected to stay within certain boundaries—represented by trustworthy Prof. Waldman and the Academy—and it is expected to be not only comprehensible, but practical or applied as well. The boundaries are set by God and nature, through the wisdom of age and maturity. The scientist is expected to value domesticity and to keep his emotions on an even keel, rather than sacrifice his life to some BIG IDEA. Big ideas had led to the Crash: they were also causing big trouble in Europe. It was fine to use British actors, a British director, European visualisers, and a makeup man who was a Greek immigrant, but that was about as far as it went.

James Whale's *Frankenstein* was a huge box-office hit, and it opened the floodgates. The 'F' word, the Franken-label, was from now on well and truly established as a badge to be attached by the press to any questionable *scientific* discovery. Somehow, *Frankenstein* struck a chord, in a campy sort of way, with post-Depression audiences. Within eighteen months, at least six more 'mad scientist' movies had been unleashed by Hollywood, several of them from rival studios. In 1933, Walt Disney could make a Mickey Mouse animated short called *The Mad Doctor* (directed by David Hand), which showed Mickey dreaming about a lab-coated psychopath with a carving-knife and large rubber gloves who tries to graft a chicken's gizzard onto the wishbone of Pluto the dog, before strapping Mickey himself onto the operating table.

Some moral guardians were concerned about where all this might lead. Kansas City demanded thirty-two cuts in the film, and the British censor excised two scenes—one where a hanged corpse is cut by Fritz from a gibbet (this *Frankenstein* made much of grave-robbing—a new feature), and another where the Monster throws the little girl into the water to see if she will float like a flower. In the latter case, the censor actually *created* the implication that the dead child had been abused. Such notoriety, as in 1823, ensured the film's success. *Frankenstein* made in excess of $1 million on first release (twice as much as *Dracula*), and has been called 'the most important and influential

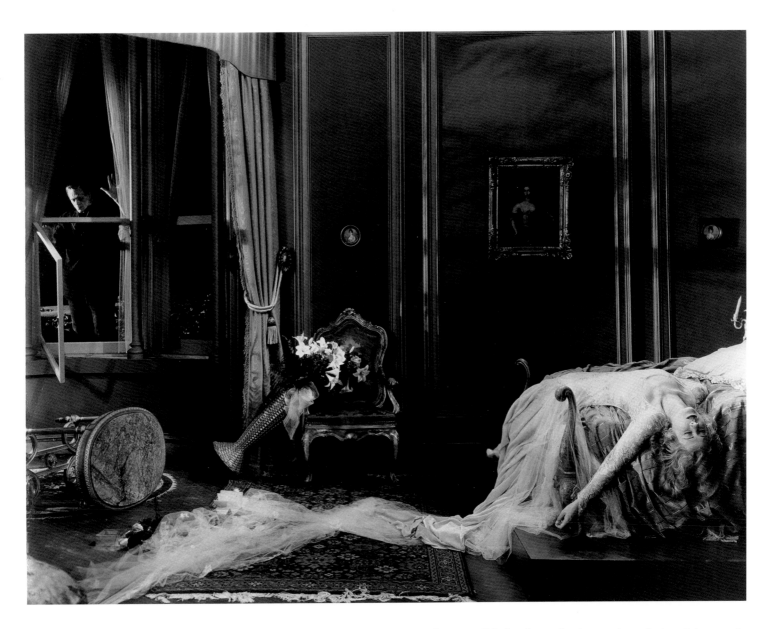

of all American horror films'. Its innovations effectively superseded the source material in the public imagination. A sequel, *The Return of Frankenstein*, was announced in 1933, but Universal then delayed for a couple of years before bringing together the old firm of James Whale, Karloff, Colin Clive, Dwight Frye (ex-Fritz, now Karl), the designers and the makeup department for *The Bride of Frankenstein* (1935), which was filmed under the title *The Return*.

The scriptwriters, journalist, playwright and Anglophile John L. Balderston and prolific Hollywood screenwriter William Hurlbut, went back to the book, for the Creature staring at his own reflection, finding a blind man (now called The Hermit) in a cottage which later burns down, learning to speak, and asking Frankenstein for a mate. *Not* from the book were the effete Dr Septimus Pretorius (Ernest Thesiger), a devilish, high-camp version of Prof. Waldman (who

creates homunculi in bottles and enjoys a glass of gin—'it's my only weakness'), the hissing bride (played by Elsa Lanchester with makeup based on the celebrated ancient Egyptian portrait bust of Nefertiti (c.1340 BC), which had been exhibited in Berlin, amid much publicity, since the mid-1920s) and the dialogue. Instead of reading Milton, Plutarch and Goethe and learning verbal articulacy, the Monster just about manages to say 'smoke—good' as he puffs on a cigar. Above all, *The Bride of Frankenstein* boasted a prologue, set in a solitary villa perched on a mountaintop during a violent thunderstorm, where Lord Byron (Gavin Gordon), Percy Shelley (Douglas Walton) and Mary Shelley (Elsa Lanchester—it should have been Mary Godwin, but still) discuss a sequel to *Frankenstein*—in a giant Regency salon—before the book has even been published. 'My purpose was to write a moral lesson', says the apparently prim, demure Mary, 'the

Elizabeth (Mae Clarke), in her wedding gown, lies across her bed—with the monster (Boris Karloff) at the window: this sequence in **Frankenstein** *(1931) was inspired by Fuseli's* **The Nightmare** *(the original, 1782 version).*

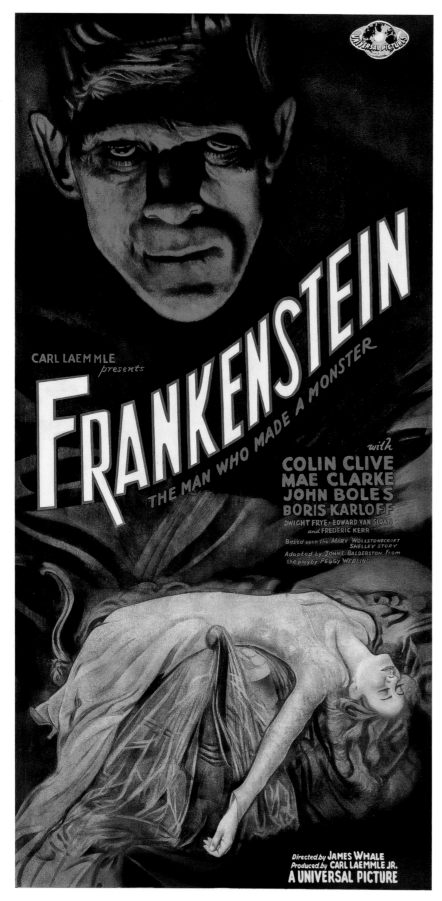

ABOVE: The powerful image of Elizabeth (Mae Clarke) lying across her bed was featured on much of the American publicity for Frankenstein (1931).
OPPOSITE: Henry Fuseli's painting The Nightmare (1782 version), a key visual source for horror movies.

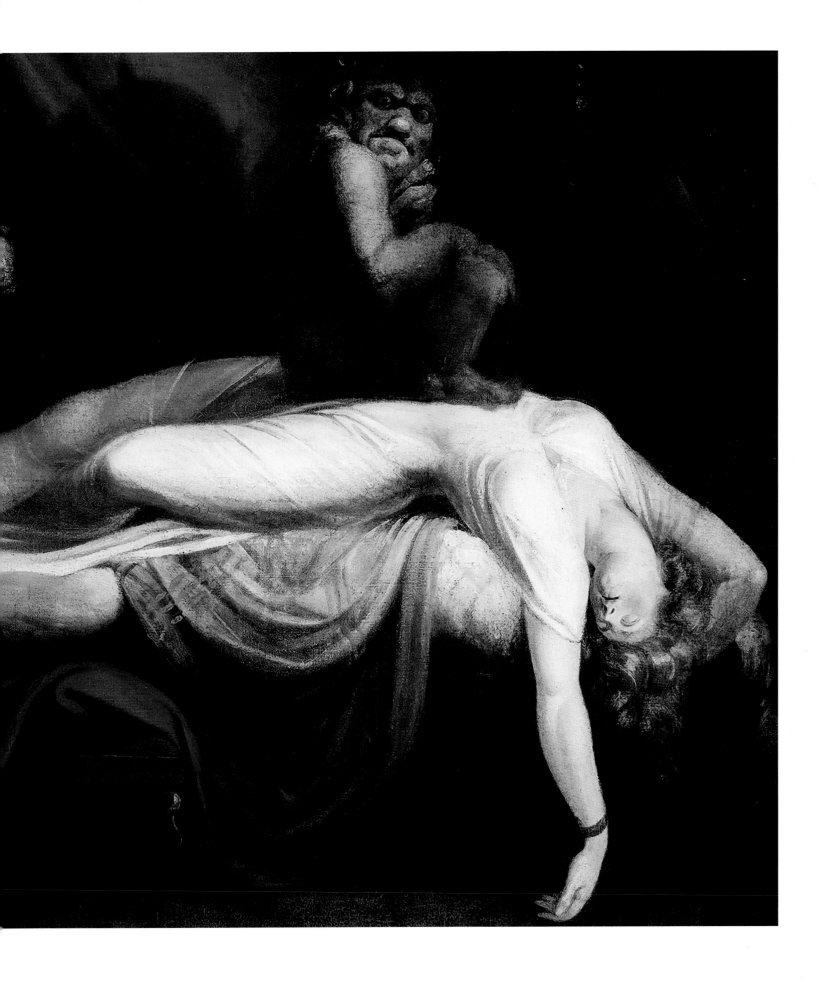

punishment that befell a mortal man who dared to emulate God'. She squeals at the sight of a pinprick resulting from her embroidery. And yet she is wearing a particularly low-cut dress (which worried the censors), and when Byron says 'she is an angel' she replies, archly, 'You think so?' The script specifies: 'at this moment there is a rolling peel of thunder as though it were in the nature of applause'. 'Look at her, Shelley,' adds Byron, 'can you believe that bland and lovely brow conceived of Frankenstein—a monster created from cadavers out of rifled graves—Isn't it astonishing.' Ignoring the fact that Byron has misunderstood the book by confusing scientist and monster, she then says—in a speech filmed but mostly cut after previews, possibly for censorship reasons:

Mary: I don't know why you should think so—what could you expect? *We are all three infidels, scoffers at all marriage ties, believing only in living fully and freely in whatever direction the heart dictates.* Such an audience needs something stronger than a pretty little love story. *You say look at me; I say look at Shelley—who would suspect that pale pink and white innocence, gentle as a dove, was thrown out of Oxford University as a menace to morality, had run away from his lawful spouse with innocent me but seventeen, that he was deprived of his rights as a father by the Lord Chancellor of England and reviled by society as a monster himself. I am already ostracised as a free thinker,* so why shouldn't I write of monsters?

Byron: No wonder Murray has refused to publish the book—says their reading public would be too shocked.

Mary (in her mild, calm voice): It will be published . . . I think.

The few lines which survived into the film as released are the ones not in italics. Shelley's custody dispute, in the Court of Chancery, actually took place in March 1817, nine months after Diodati, and Murray's rejection in May of the same year. The sequence continued, regardless:

Shelley: I do think it a shame, Mary, to end your story quite so suddenly . . .

Mary (continuing in her bland manner): Oh no, that wasn't the end at all . . . I think you will find the new horrors are far more entertaining, Lord Byron. Would you like to hear what happened after that?

What follows is as much black comedy as horror. A happy ending was added to the film, after previews: Henry and Elizabeth Frankenstein somehow survive the total destruction of the watchtower-laboratory, for a final embrace. *The Bride of Frankenstein*—with a bigger budget, a wittier script, a new musical score and more confidence—made less money than its predecessor, but still led to a franchise, which like the title often confused scientist and creature. The 'F' word had become a brand, a name on the tin. And even the prologue inspired a sub-genre of its own, of films devoted to alleged goings-on in the Villa Diodati: these have included to date Ken Russell's *Gothic* (1987—with Gabriel Byrne as Byron and Natasha Richardson as Mary, with a Scottish accent); Gonzalo Suárez's *Rowing with the Wind* (1988—with Hugh Grant as Byron and Lizzy McInnerny as Mary) and Ivan Passer's *Haunted Summer* (1988—with Philip Anglim as Byron and Alice Krige

as Mary): usually, the emphasis is on mind games, drugs and sex, and on the contrast between Regency manners and dark imaginings; Mary somehow turns the hothouse atmosphere, and the weird happenings, into a novel about scientific licence. In Roger Corman's *Frankenstein Unbound* (1990), Mary Shelley (Bridget Fonda) is visited through time-travel by a modern scientist (John Hurt) who helps her make sense of the Frankenstein story which is actually happening around her: he prints out a copy of the book on his computer just after she has started to write it. She has become a journalist rather than a creative writer. In all these films, Mary becomes an onlooker or a recorder—not an active participant: the *real* story is about Lord Byron. Her novel *Frankenstein* is either based on fact, or on a literal haunting. Evil genius Dr Pretorius from *The Bride* was reincarnated in *Frankenstein: The True Story* (1973), co-written by Christopher Isherwood and Don Bachardy, as Dr Polidori himself (James Mason), who becomes a manipulative mesmerist. This introduced a queer element to Victor's experiment, with the handsome creature (Michael Sarrazin) able to say the one word 'Beautiful'.

Boris Karloff agreed to play the Monster for Universal just one more time for *Son of Frankenstein* (1939). 'There was not much left in the Monster to be developed', he later said, 'we had reached his limits'. He was right. After Baron Wolf von Frankenstein (Basil Rathbone) has resurrected him, at the request of broken-necked Ygor (Bela Lugosi), the Monster becomes little more than a simple-minded murderer. *Son of Frankenstein* was to have been filmed in Technicolor—a first—but director Rowland V. Lee discovered that Karloff's Monster did not look good in colour, he looked like something out of a pantomime, and so the idea was abandoned. Universal, unlike Karloff, reckoned that there was still life in the franchise—hence *Ghost of Frankenstein* (1942), *Frankenstein Meets the Wolf Man* (1943), and the studios' monster rallies *House of Frankenstein* (1944) and *House of Dracula* (1945). The series bowed out with *Abbott and Costello Meet Frankenstein* (1948), the equivalent of the burlesque versions of the late 1820s stage.

Universal's rights to the Jack Pierce/Boris Karloff makeup meant that although the book was in the public domain, subsequent film versions were forced to adopt a different tack—such as the 'drive-in' modern-day Frankensteins of the 1950s *I Was a Teenage Frankenstein* (1957, a follow-up to the hit film *I Was a Teenage Werewolf*), *Frankenstein 1970* (1958, with Karloff as Baron Victor this time, he'd started playing mad scientists in the 1940s, saving up for an atomic reactor and celebrating the 230th anniversary of the book in his *schloss!*) and *Frankenstein's Daughter* (1958—with rock 'n' roll interludes). But the Boris Karloff look, and performance, were to be lovingly parodied in Frank Capra's *Arsenic and Old Lace* (1944—with Raymond Massey, who everyone in the film says 'looks like Boris Karloff', playing the part Boris Karloff himself played on the Broadway stage); in *The Munsters* (CBS television 1964–66, with benign, cuddly Fred Gwynne as father Herman, also a feature film in 1966 set at Munster Hall, England) which inverted the all-American family of the Eisenhower

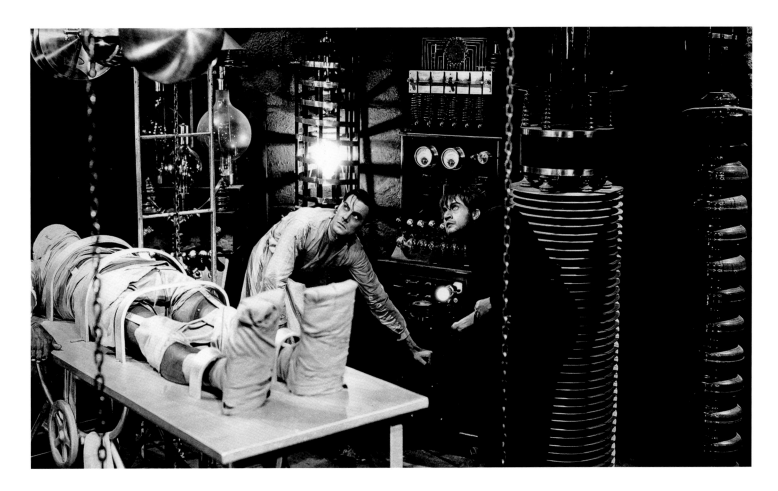

era using Hollywood horror-movie conventions; and in the hit record *The Monster Mash* (1962) by Karloff impersonator Bobby Pickett with the Crypt Kickers, which led to a dance craze involving jerky 'Monster' movements and was initially banned by the BBC as 'too morbid'. This tradition was revived in *The Monster Squad* (1987), which had young horror geeks meeting the Universal monsters for real.

And the early Universal adaptations of *Frankenstein* were to be homaged, too, in Victor Erice's *Spirit of the Beehive* (1973), which involves a little girl imagining that Boris Karloff's Monster is a real companion, in a Castilian village and forest, in 1940 under the Franco regime; Mel Brooks's *Young Frankenstein* (1975; musical stage version 2007), an affectionate, monochrome homage/parody which has Peter Boyle channelling Karloff, uses the original laboratory equipment from 1931 discovered in a store, and has Dr Frederick Frankenstein (Gene Wilder—'That's Franken*steen*') memorably performing with his creature the Fred Astaire number 'Puttin' on the Ritz' in white tie and tails; and Tim Burton's *Frankenweenie* (1984, animated version 2002), in which ten-year-old science nerd Victor reanimates his dead dog Sparky in an American suburbia which has the look and texture of Universal's sets.

It took Britain's Hammer Films to start a different tradition—in colour, with a repressive Victorian setting, more gore and a new

repertory company of performers—with Terence Fisher's *The Curse of Frankenstein* (1957, Peter Cushing as a ruthless Baron Victor and Christopher Lee as his cadaverous, scarred monster). The success of this film founded the 'Hammer House of Horror' brand, and it was followed by Fisher's *The Revenge of Frankenstein* (1958), *Frankenstein Created Woman* (1967), *Frankenstein Must Be Destroyed* (1969) and *Frankenstein and the Monster from Hell* (1973); also Freddie Francis's *The Evil of Frankenstein* (1964) and Jimmy Sangster's remake/parody of *The Curse*, the script of which he had written thirteen years earlier, now called *Horror of Frankenstein* (1970). Whereas the Universal series seemed more interested in the Monster, Hammer made Baron Victor the focus of attention. As in *Frankenstein* (1931), he was promoted to the aristocracy: in the novel, he is a member of a 'distinguished' middle-class family with a tradition of public service as chief magistrates; now he had become a Baron. And with that came elegance, ruthlessness, arrogance and also, in a double life, a public image of charity work: philanthropist by day, Byronic villain by night. He was also old, unlike the young research student of Mary Shelley's imagination. With each film in the cycle, Fisher and Cushing played variations on the heroic and the villainous, until in the final film he behaves like Dr Mengele. The creature, meanwhile, evolved from the brutish (in Curse), to the cannibalistic (in *Revenge*, which has him crashing through the French

Henry Frankenstein (Colin Clive) and his assistant Fritz (Dwight Frye) watch the lightning, in the mountaintop laboratory of **Frankenstein** *(1931).*

windows to interrupt a high-society ball), to the seductive (in *Woman*, played by 1966 *Playboy* model Susan Denberg, who has had 'the soul of a man' somehow transplanted into her body by an 'energy machine'), to the pathetic (in *Destroyed*, where scientist Dr Brandt's brain is sewn into Professor Richter's body), to brutish again (in *Hell*, where he is played by British Heavyweight weightlifting champion Dave Prowse, in a simian bodysuit). The series began in a lunatic asylum and ended in one. Its distinctive features include a cynicism about mainstream society—it is usually official obstructiveness which stands in the way of Victor's research—an awareness of current events (permissiveness, transplants, medical ethics) and a critique of home-counties Victorian values. For *Evil*, one of the weakest, Hammer concluded a deal with Universal and so the makeup of the Monster (Kiwi Kingston) was allowed to resemble Karloff's. At the end of *Destroyed*, the Monster (a touching performance by Freddie Jones) carries the scientist through the door of a burning house, just like the burning mill in 1931. Hammer's *Frankenstein* owed a lot to the greater box-office success of their Dracula cycle (Baron/Count), and—partly because less identifiable as a formula—was not often referenced in other films: but notable examples include *Carry On Screaming* (1966, with Dr Watt creating Oddbod) and Paul Morrissey's *Andy Warhol's Flesh for Frankenstein* (1973, a gaudy homage to Hammer with the Baron, who is the Baroness's brother as well as her husband, trying to create a Serbian super-race and saying things like 'To know death, you must fuck life in the gall bladder'). *Flesh* ends with the Frankenstein children, who have been silently watching their father at work throughout the film, preparing the equipment for a new experiment . . . *Flesh* also referenced the 1960s soft pornographic versions of *Frankenstein*, of which there had been several such as *House on Bare Mountain* (1962, where a phoney Monster does the twist with Miss Hollywood at a fancy-dress ball), *Kiss Me Quick* (1964, with a transgender Monster called Frankie Stein), *Hollow-My-Weenie, Dr Frankenstein* (1969, a gay fantasy about a very well-endowed Monster, created in the basement) and *The Sexual Life of Frankenstein* (1970).

The cult hit *The Rocky Horror Picture Show* (1975, based on Richard O'Brien's stage musical) presented the clichés of horror movies as if they were an alternative sexual universe, revelling in campery as 'sweet transvestite from the planet Transylvania' Dr Frank N. Furter (Tim Curry) unveils his latest creation, the beautiful blond and muscular Rocky Horror. Here, the flirtation of the horror movie— since its origins—with subversion, transgression and 'the other' is moved joyously centre stage, and becomes the point of the story: hard rock versus romantic duets. Also in the 1970s, there were several television adaptations which claimed—usually mendaciously—to be going back to the original source. It was out of these, rather than out of the Universal and Hammer cycles, that Kenneth Branagh's *Mary Shelley's Frankenstein* (1994)—the most elaborate, big-budget version to date—emerged. This really *did* attempt to adapt the novel (complete with the Robert Walton framing device). It treated the creation scene

as a laboratory birth (gigantic bellows ejaculating electric eels into a womb-shaped vat full of amniotic fluid, the creature as grown-up baby), the creature (Robert De Niro) had the full range of human emotions for once ('he was my father'), and part of the motivation of young Victor Frankenstein (Branagh) was his own anxieties about childbirth having seen his mother die while delivering his younger brother. This fidelity to a famously difficult-to-adapt novel—which also showed awareness of critical debates surrounding *Frankenstein*— confused critics and audiences. It went against the longstanding conventions of 'mad science' films—Universal, Hammer, the lot—and did not seem frightening enough. Cinema had left Mary Shelley behind a long time ago . . . The film was not a box-office success in the U.S.A.

Today, as a result of film versions from 1931 to the present day, *Frankenstein* has become part of the very air we breathe (as David Skal has put it)—a shared set of visual images and a cultural myth, a crucible in which to express our anxieties about progress. Victor and his creature are up there with Sherlock Holmes and Dracula as the most-filmed literary characters: over ninety direct adaptations, between 1931 and 2016's *Victor Frankenstein*, and literally hundreds of others involving mad scientists, creations and nasty consequences. In the nineteenth century, the anxieties were more broadly-based: social, political, economic as well as scientific. In the twentieth, the strong emphasis in the public domain has been on the scientific. Where the films are concerned, the anxieties about science may change— medicine in the 1930s, nuclear physics in the 1950s (after Hiroshima), DNA, cloning and molecular biology in the 1960s, 'test-tube babies' as they were called in the late 1970s—the *New York Times* wrote of the first IVF birth in 1978 'The Frankenstein myth becomes reality'— the Human Genome Project in the 1990s, robotics and artificial intelligence in the 2000s, 'Frankenstein foods', synthetic microbes, three-parent families, animal-human interfaces (growing human organs in animals and vice-versa), and the new eugenics today—but the iconography and the foundation myth have proved surprisingly resilient as ways to express them: from vitalism to medicine to physics to biology to genetic engineering to computer science . . . to who knows? Anxieties about biology—as 'indecent and unnatural'—go particularly deep. And bio-chemical blueprints of humanity beg the question 'is this all there is?' Is our humanity more that simply our material fabric? Mary Shelley could scarcely have put it better herself. There is even a 'Frankenstein Complex' in contemporary psychoanalysis—the label given to the horror of perinatal rejection between infant and mother. And the myth has even had an impact on *doing* science—beyond the obvious one of perpetuating and constantly updating the negative image of the mad scientist. The heart pacemaker was invented by Dr Jean Rosenbaum after watching the creation scene in James Whale's film of 1931: Rosenbaum started wondering if it really was possible to stimulate the human heart with electricity. When the British government floated shares in electricity, in 1990 during privatisation, Frankenstein's Monster was

prominently featured on the publicity—not as a threat any more, but as a reassuringly familiar image. The Monster was smiling. And the myth has proved flexible enough to outlive the era of the lone scientist working in a garret-laboratory, to thrive in the era of the helpless scientist working—with the rest of his/her team—for a powerful corporation. In Steven Spielberg's *Jurassic Park* (1993) Jeff Goldblum's Dr Ian Malcolm berates the faceless scientists and corporate backers of the dinosaur emporium, for their misuse of genetic research:

You didn't earn the knowledge for yourselves, so you don't take any responsibility for it. You stood on the shoulders of geniuses to accomplish something as fast as you could . . . [but] your scientists were so preoccupied with whether or not they could that they didn't stop to think if they should.

Back in David Cronenberg's *The Fly* (1986), the same actor playing 'systems manager' Seth Brundle explains that the company behind his experiments are Bartok Science Industries, who 'leave me alone because they know they'll end up owning it, whatever it is . . .'. It's Frankenstein Inc. rather than a single 'pale student of unhallowed arts'. The villagers with flaming torches are now the anti-capitalist rioters. The myth evolves, develops, recombines—but it remains. Commentator on the counterculture and the wasteland Theodore Roszak—who himself published the novel *The Memoirs of Elizabeth Frankenstein* in 1995—wrote of the myth in 1974, preferring to call it 'a persistent folklore':

Asked to nominate a worthy successor to Victor Frankenstein's macabre brainchild, what should we choose from our contemporary inventory of terrors? The bomb? The cyborg? The genetically synthesized android? The behavioural brain-worker? The despot computer? Modern science provides us with a surfeit of monsters, does it not? I realize there are many scientists—perhaps the majority of them—who believe that these and a thousand other perversions of their genius have been laid unjustly at their doorstep. These monsters, they would insist, are the bastards of technology: sins of applied, not pure, science. Perhaps it comforts their conscience somewhat to invoke this much-muddled division of labour . . . Dr Frankenstein, Dr Moreau, Dr Jekyll, Dr Cyclops, Dr Caligari, Dr Strangelove. The scientist who does not face up to the warning in this persistent folklore of mad doctors is himself the worst enemy of science. In these images of our popular culture resides a legitimate public fear of the scientists' stripped-down, depersonalized conception of knowledge—a fear that our scientists, well-intentioned and decent men and women all, will go on being titans who create monsters. What is a monster? The child . . . of power without spiritual intelligence.

Meanwhile, it has justly been said that if a six-year-old can eat it, drink it, read it, play it or cuddle it, Frankenstein's Monster has been on it. In a recent, pre-Trump, survey of American children, it emerged that 'Frankenstein' as a name was more recognisable than that of the President. Mary Shelley's novel has been turned into films, plays, ballets, operas, musicals, television shows and series, novels and graphic novels, cartoons, paintings and prints, illustrations, advertisements and poems. In July 1935, in his review of *The Bride of Frankenstein* for the *Spectator*, the novelist Graham Greene predicted some of this:

Poor harmless Mary Shelley, when she dreamed that she was watched by pale, yellow, speculative eyes between the curtains of her bed, set in motion a vast machinery of actors, of sound systems and trick-shots and yes-men. It rolls on indefinitely . . . presently, I have no doubt, it will be colour-shot and televised; later in the Brave New World to become a smelly.

So far as I know, *Frankenstein* has not yet been made into a smelly. Give it time.

In academic studies, Mary Shelley has been reclaimed as a major writer—making up for cinema's predominantly male perspective on the myth. She stars in courses on Women and Literature, and she has become one of the most popular subjects for research into the Romantic period, second only to Wordsworth. *Frankenstein* has recently been interpreted in the resulting specialist literature as a feminist allegory of birthing, or an ecological reading of mother earth, or a critique of Romanticism, or a response to the French Revolution, or an attack on 'masculinist science', or an analysis of slavery, or a reaction to the rise of the industrial proletariat, or a dramatisation of the conflict between an ethic of care and an ethic of control, or the story of a *doppelgänger*, or a humanisation of Percy Shelley's views, or an exorcism of a bad father . . . or . . . much, much else besides. *Frankenstein* seems inexhaustible. It contains legions. One commentator has even suggested (in 2000) that when Victor describes his creation experiment as 'the work of my hands', he implies that his great secret is that he has masturbated in order to produce life: 'Victor Frankenstein . . . is less the mad scientist than the reluctant parent, or semen-donor'. Biographers have presented Mary Shelley as a bad-tempered wife, a courageous depressive, a passionate and independent woman, a campaigner for her mother's causes, and an optimist in very difficult circumstances. Outside academe, she is almost exclusively associated with *Frankenstein*: inside, her other writings—novels, short stories, articles—have been reappraised and sometimes overpraised. Two of the most active debates have been about whether too much emphasis has been given to *Frankenstein* among her works, and about whether science or biography (or both) are the most fruitful way into her best-known novel.

In short, after its first two hundred years, **Frankenstein lives!** Maybe the novel is more talked about than read—like Stephen Hawking's *Brief History of Time* (1988)—but it still lives. And Mary Shelley has proved to be as influential as her father, her mother, and her husband—if not more so, which would have surprised her mightily. With *Frankenstein*, she has provided us with a creation myth which works for today.

And it all began with a ghost-story contest, a parlour-game, a serious young woman of eighteen years old who had run away with her boyfriend, and some very stimulating company—and a thunderstorm which kept them indoors . . .

Queuing for **Frankenstein** *(1931) in Depression-hit America.*

VI.
Frankenstein—a visual celebration

LEFT: Makeup artist Jack Pierce combs the Monster's wig: according to Boris Karloff, 'it took from four to six hours a day to make me up . . .'
OPPOSITE: Pierce leads Karloff onto the Universal backlot, during the shoot, before the public was allowed to see the face of the Monster. Variety called this 'the kind of secrecy that makes publicity'.

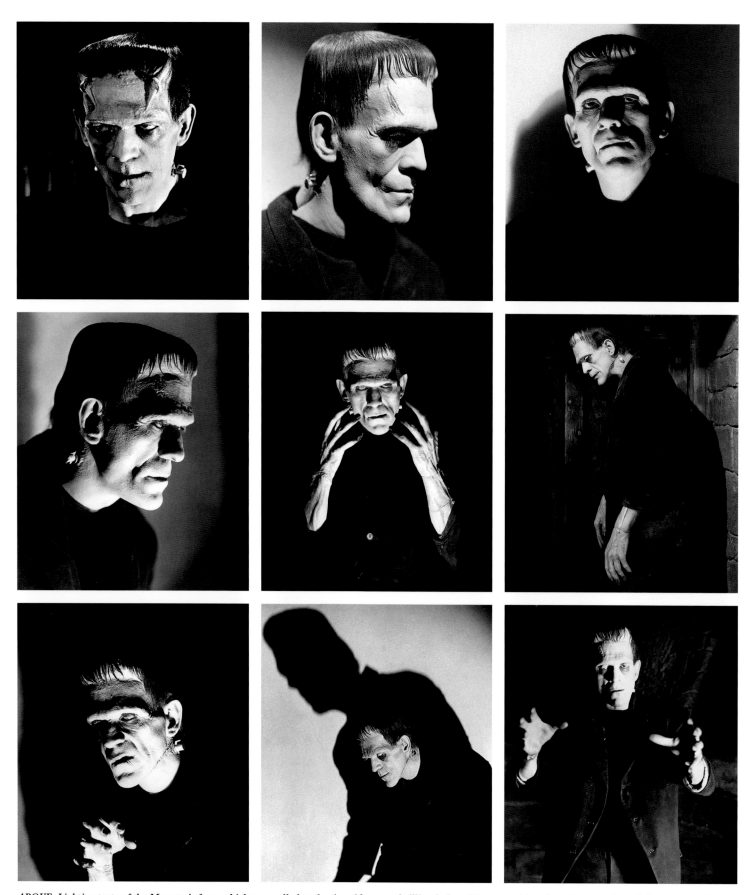

ABOVE: Lighting tests of the Monster's face, which was called at the time 'the most brilliantly horrible ever achieved on the screen': top left was an early version, co-designed by Pierce and James Whale. OPPOSITE: Studio portrait of Boris Karloff as the Monster (1931). Jack Pierce was later to say: 'If the Monster looks like something I dreamt after something I ate, don't blame me—blame science!'

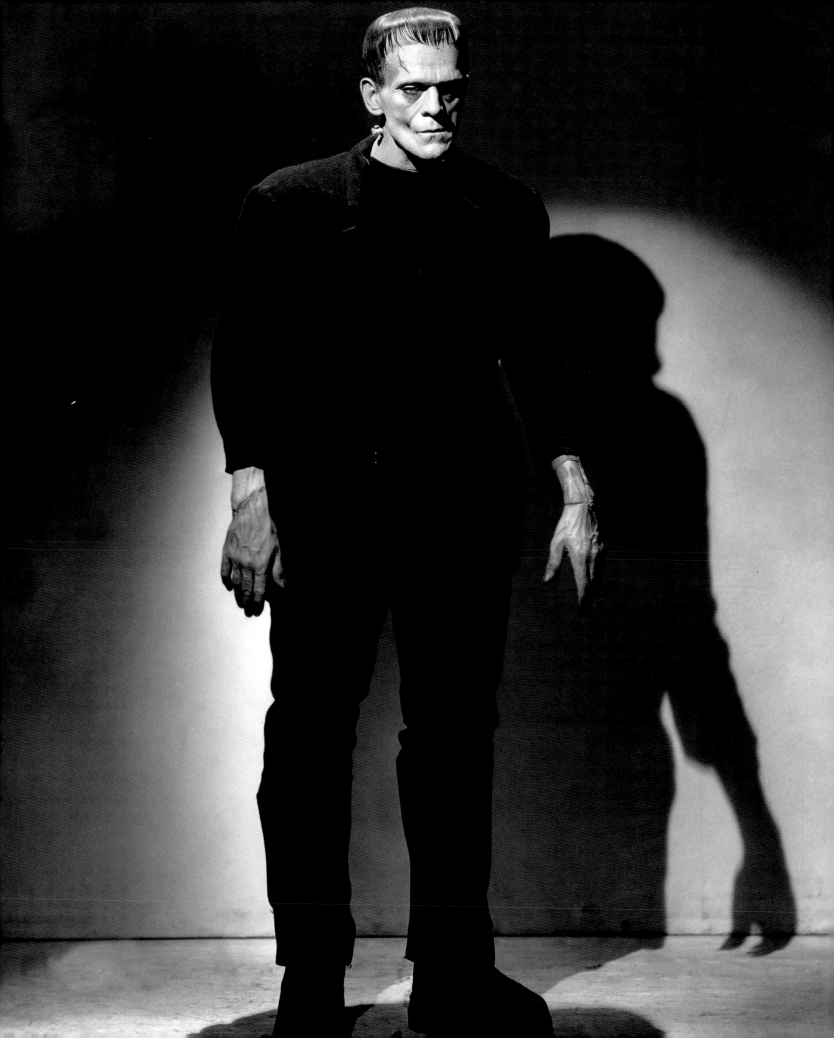

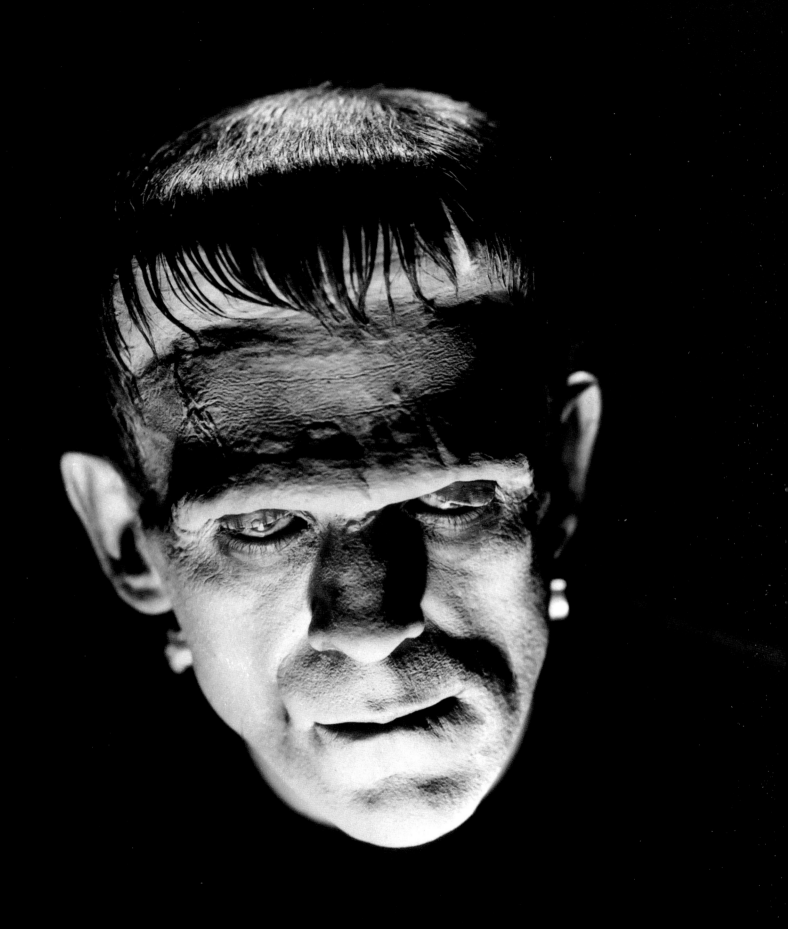

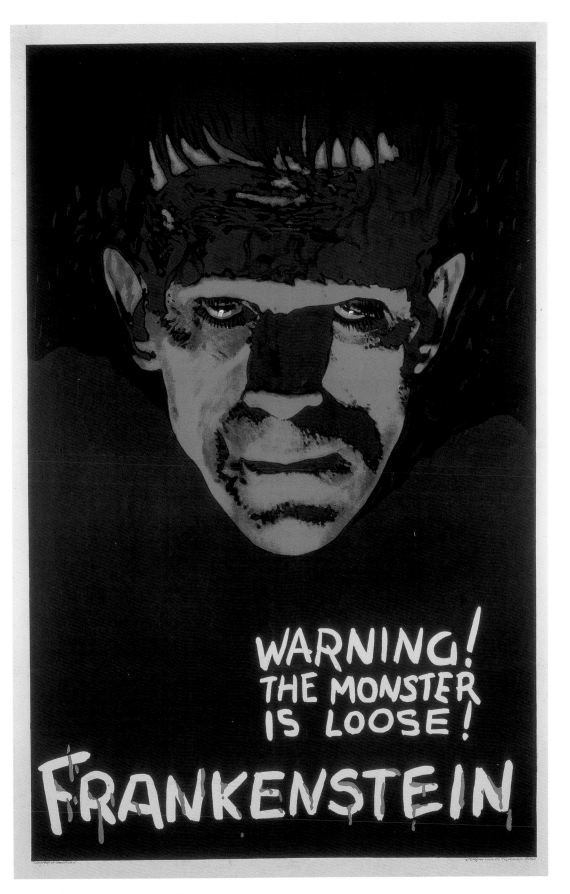

WARNING!
THE MONSTER
IS LOOSE!

FRANKENSTEIN

OPPOSITE: Portrait of Boris Karloff as the Monster, used as the basis for several posters.
RIGHT: Advance American poster (or 'teaser') designed by the Hungarian Karoly Grosz, who was responsible for many Universal posters in the 1930s. This is said to be the first-ever 'teaser' in the history of movie publicity.

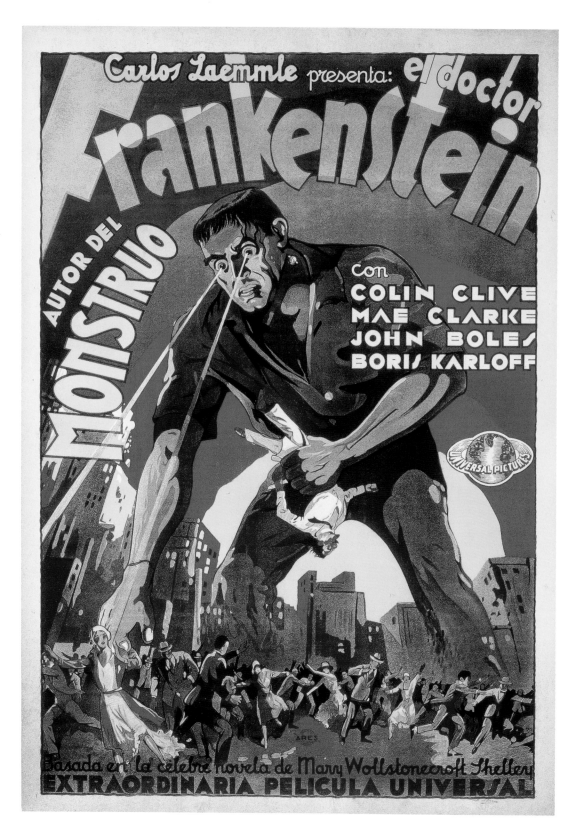

OPPOSITE: Early trade advertisement, when Bela Lugosi—the studio's first choice—was to play the Monster, and when the illustrator had no idea what he was going to look like.
LEFT: The final Spanish poster used the same design, this time plus flat head and scars—with rays still coming out of the Monster's eyes.

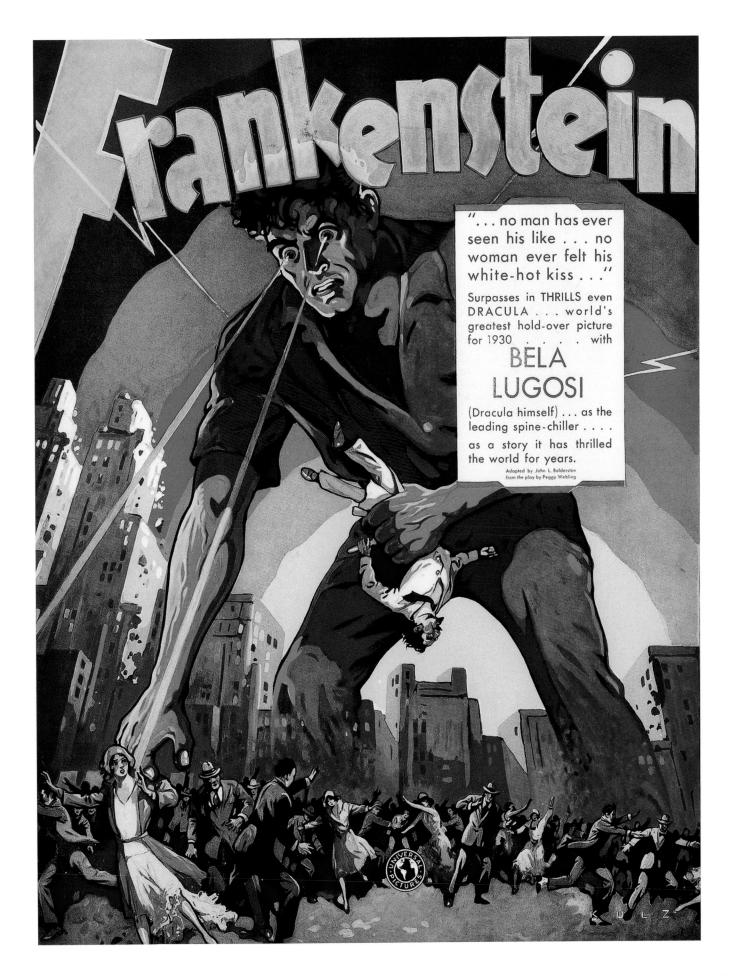

ABOVE: French poster (1931) designed by Roland Coudon. OPPOSITE: Alternative French poster designed by Jacques Faria, crediting Robert Florey as co-writer: Florey, a French film director and screenwriter, was originally to direct Frankenstein. *Only in France was he credited on a poster for his contribution.*

ABOVE: Original French billboard poster by artist Jacques Faria.
OPPOSITE: Italian billboard poster emphasising the climax in the burning mill, and with Boris Karloff now as the name above the title.

ABOVE: Dr. Septimus Pretorious (Ernest Thesiger) and Dr Henry Frankenstein (Colin Clive), about to unwrap the Monster's mate (Elsa Lanchester) in **The Bride of Frankenstein** *(1935): the three actors were old friends. OPPOSITE: Advance American 'teaser' Style E poster for* **The Bride of Frankenstein** *(1935) with artwork by Karoly Grosz.*

ABOVE: Ancient Egyptian portrait bust of Nefertiti (c.1340 BCE), exhibited in Berlin amid much publicity from the mid-1920s . . .
OPPOSITE: . . . and Jack Pierce's makeup for Elsa Lanchester as the Bride, based on visual ideas supplied by James Whale and Ernest Thesiger.

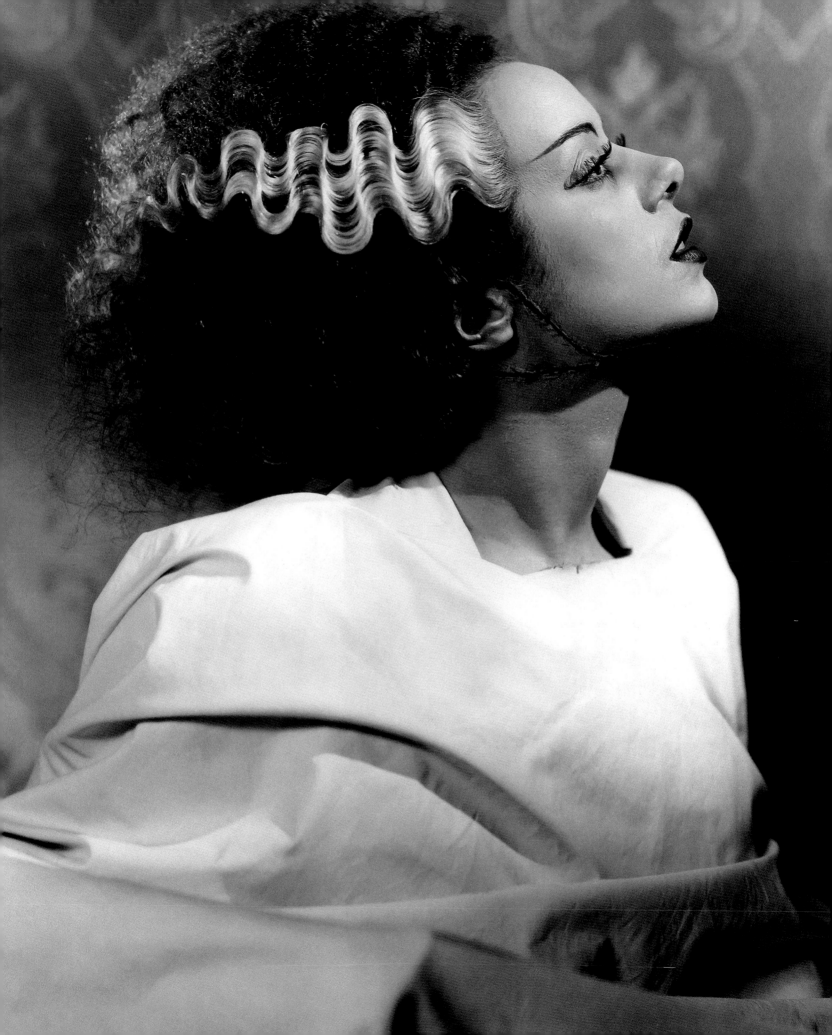

LEFT: Selection of road show posters from the original pressbook of The Bride of Frankenstein (1935). OPPOSITE: Original Style D American poster—note the 'metallic' lettering and the new emphasis on Karloff.

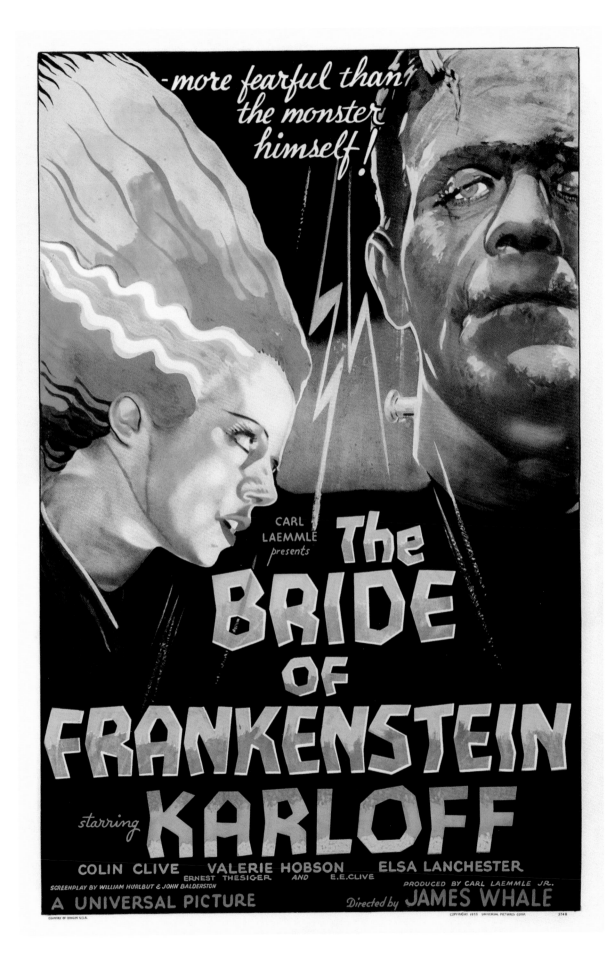

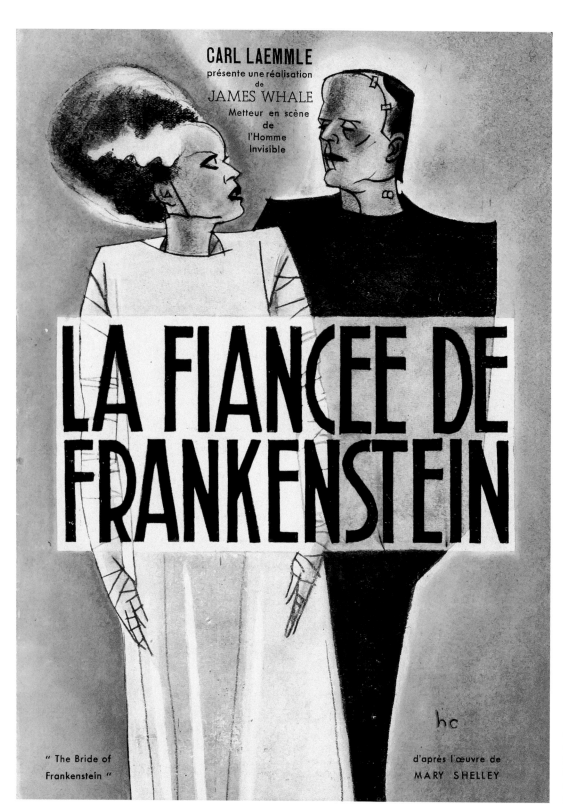

CARL LAEMMLE
présente une réalisation
de
JAMES WHALE
Metteur en scène
de
l'Homme
Invisible

LA FIANCEE DE FRANKENSTEIN

" The Bride of
Frankenstein "

d'après l'œuvre de
MARY SHELLEY

LEFT: Front cover of the original French pressbook for The Bride *(1935). OPPOSITE: Poster page from the French pressbook with all the various versions created by prominent designers—all of them credited.*

A

B

C

D

E

Vos Façades seront attractives avec nos affiches collées sur contre-plaqué et découpées

F

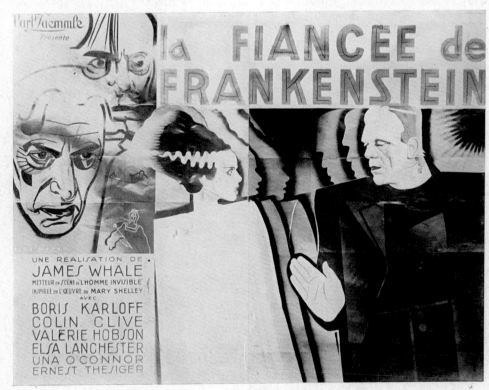

G

A - Format 40×60
Maquette
de Belinsky

B - Format 80×120
Maquette
de H. Cerutti

C - Format 80×120
Maquette
de J. Faria

D - Format 120×160
Maquette
J. Koutachy

E - Format 160×240
Maquette
de Marino

F - Format 160×240
Maquette
de H. Cerutti

G - Format 240×320
Maquette
de R. Péron

ABOVE: *Original American poster for Universal's* Son of Frankenstein *(1939), the third in the cycle and the last to feature Boris Karloff. Colin Clive had died of consumption at the end of June 1937. OPPOSITE: Studio portrait of Basil Rathbone as Baron Wolf von Frankenstein, with reflections of Boris Karloff as the Monster and Bela Lugosi as the broken-necked assistant Ygor.*

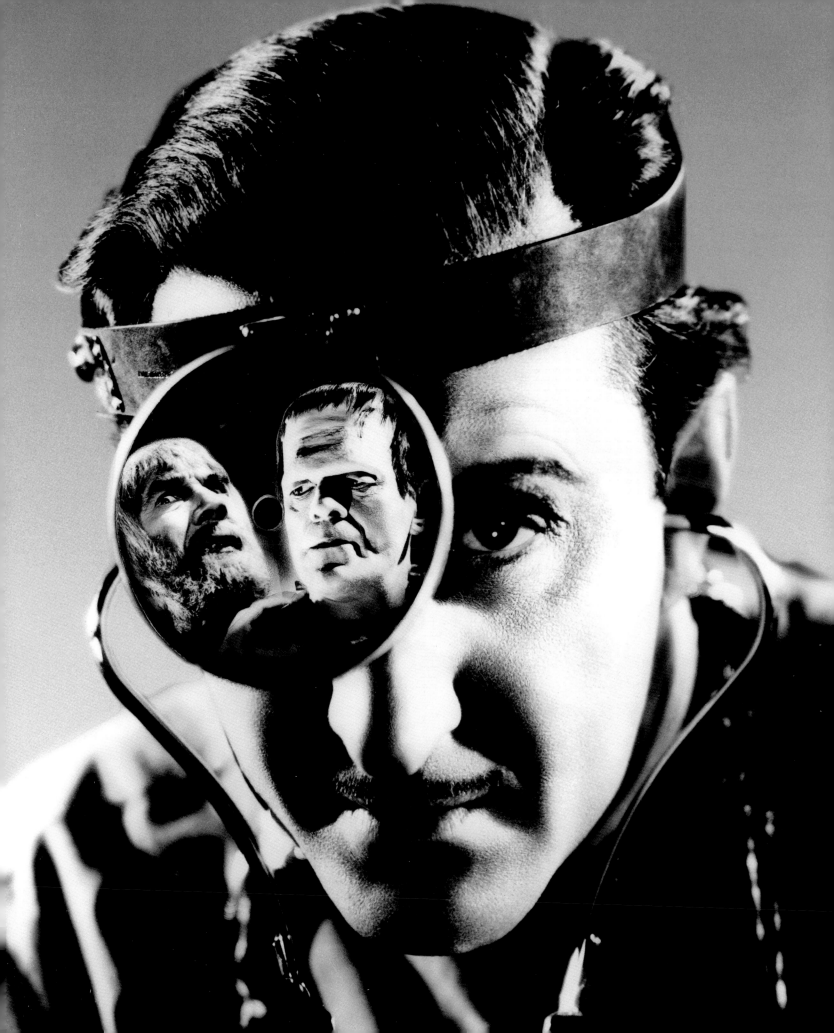

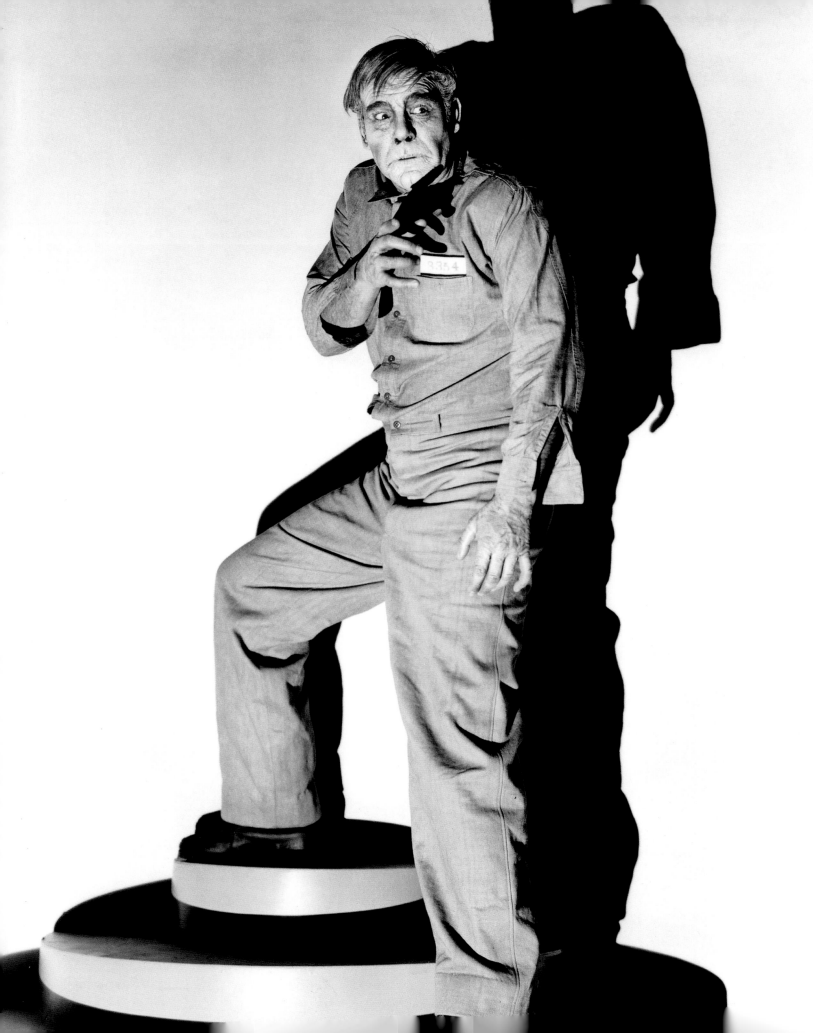

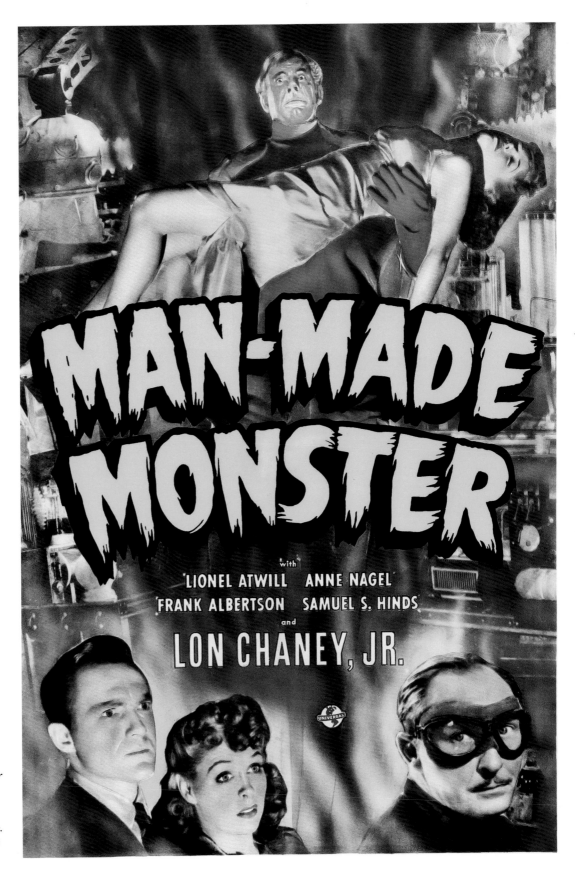

OPPOSITE: Lon Chaney, Jr. as 'Dynamo' Dan McCormick, the Electric Man who kills people just by touching them, in Universal's Man-Made Monster (1941). This film was originally intended to co-star Karloff and Lugosi: instead, it launched Lon Chaney, Jr.'s career in horror films. RIGHT: Original American poster for Man-Made Monster (1941), with Lionel Atwill as the mad scientist Dr. Paul Rigas. The film was re-titled The Electric Man for the UK market.

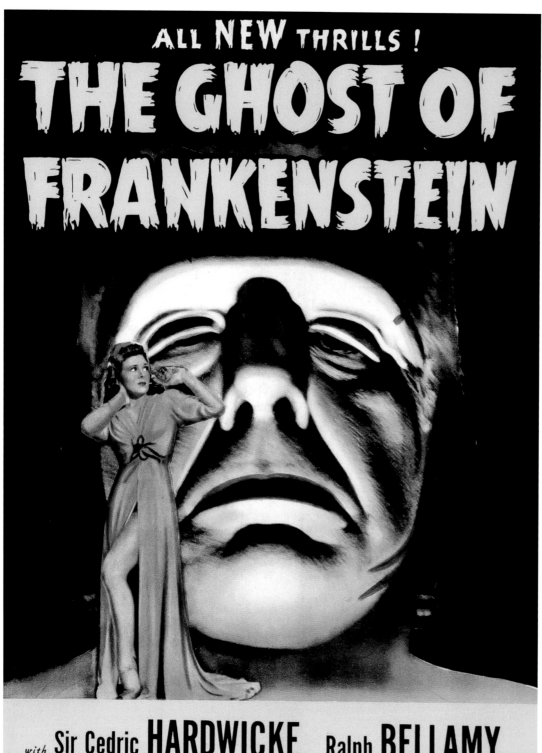

ALL NEW THRILLS !

THE GHOST OF FRANKENSTEIN

with *Sir Cedric* **HARDWICKE** *Ralph* **BELLAMY**

Lionel **ATWILL** *Bela* **LUGOSI** *Evelyn* **ANKERS**

and **LON CHANEY**

LEFT: Original American poster for the fourth in Universal's cycle, The Ghost of Frankenstein *(1942), this time with Cedric Hardwicke as Dr. Ludwig Frankenstein (his second son) and Lon Chaney, Jr. as the Monster. OPPOSITE: The Monster (Lon Chaney, Jr.) is resurrected from a sulphur pit—with help from Ygor—in* The Ghost of Frankenstein *(1942).*

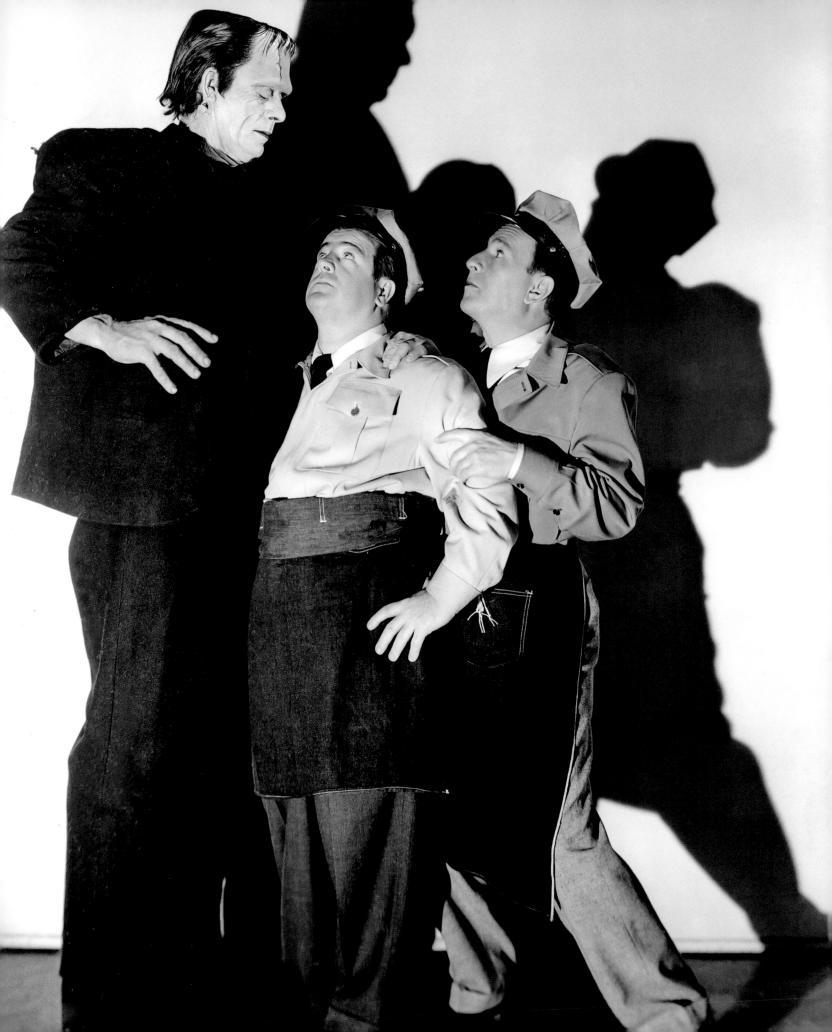

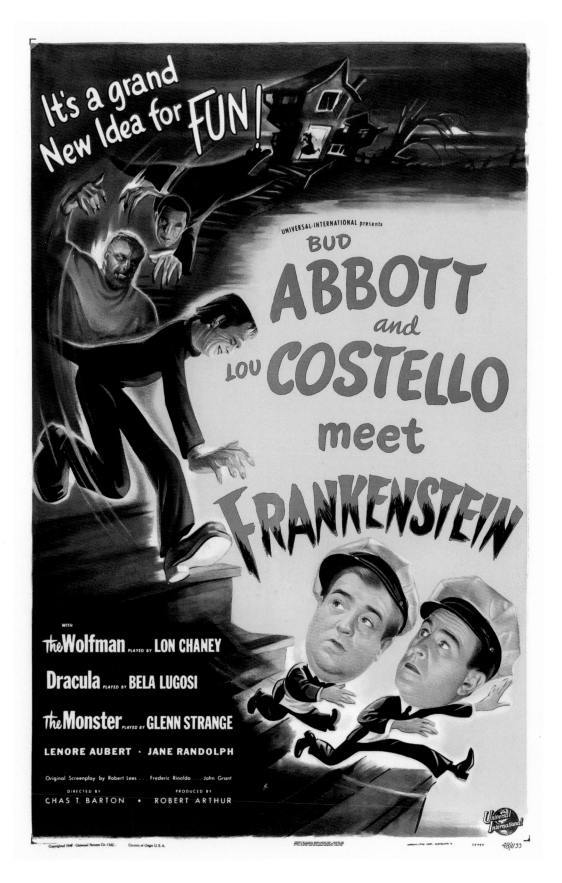

OPPOSITE: The Monster (Glenn Strange) meets Wilbur (Lou Costello) and Chick (Bud Abbott), after being resurrected with help from Dr. Henry Frankenstein's book The Secrets of Life and Death *(with extra research material by his sons Wolf and Ludwig). RIGHT: Original American poster for* Abbot and Costello Meet Frankenstein *(1948), which also had the alternative tagline 'JEEPERS! The Creepers are after Bud and Lou': this film was the most successful in the cycle, at the box-office, since* Frankenstein *(1931).*

ABOVE: Original American poster for I Was a Teenage Frankenstein *(1957), illustrated by Reynold Brown: this followed the surprise hit* I Was a Teenage Werewolf *of the same year. OPPOSITE: A monster (Gary Conway) is constructed out of car-crash victims, in 1950s Los Angeles, for* I Was a Teenage Frankenstein *(1957): at one point Professor Frankenstein (Whit Bissell) snaps at him 'I know you have a civil tongue in your head—I sewed it there myself!'*

It's Started !

THE CURSE OF F

— STA[R

PETER

W[

HAZEL COURT AND

CHRISTOPHER L[

Screenplay by JIMMY SANGSTER

Produced by ANTHONY HINDS

Directed by TERENC[

A HAMMER FILM PRODUC[

RANKENSTEIN

RING —

CUSHING

TH

ROBERT URQUHART

ND

E as the Creature

Based on the Classic by MARY SHELLY

FISHER

TION IN EASTMAN COLOUR

PREVIOUS PAGE: British trade announcement of Hammer's The Curse of Frankenstein *(1957), the film which launched a brand. The 'colour' was a selling-point.* *ABOVE: Early British trade advertisement (1957), with characteristic 'blood' dripping from the word* Frankenstein. *OPPOSITE: French poster (1957) for* The Curse *(re-titled* Frankenstein has Escaped*), designed by the Italian-born Jean Mascii—a prolific film poster designer in France.*

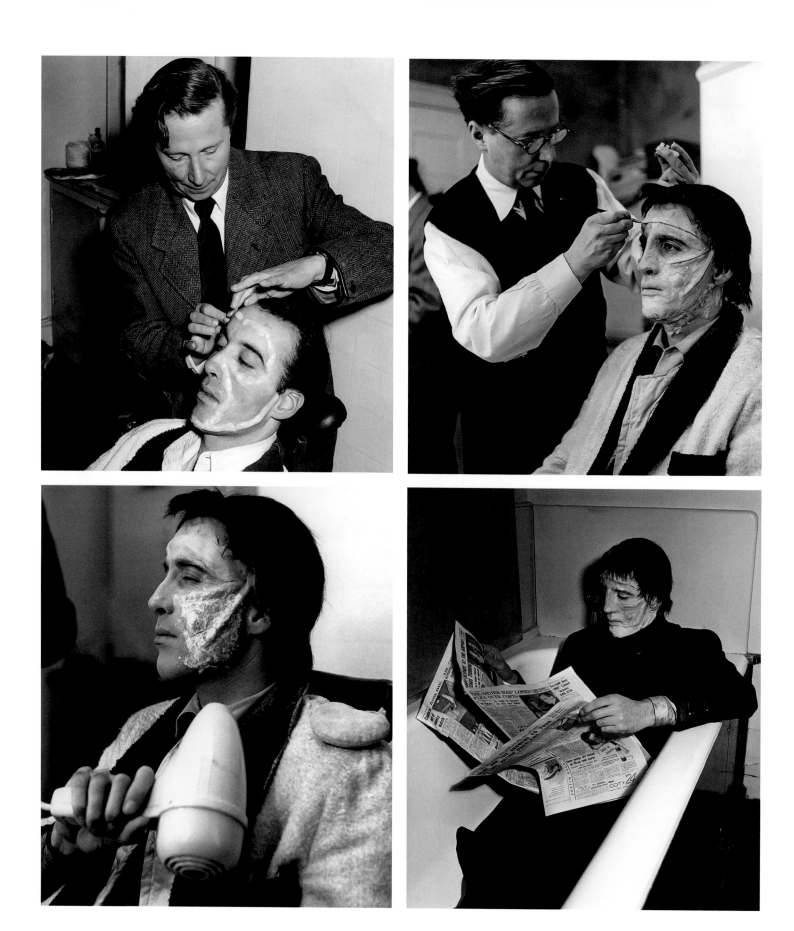

ABOVE: Christopher Lee's makeup—with a stronger emphasis this time on scars and transplanted tissue—applied by makeup artist Philip Leakey, for **The Curse of Frankenstein** *(1957). OPPOSITE: Atmospheric studio portrait of Christopher Lee as the Creature. Universal had copyrighted the Karloff-style makeup.*

ABOVE: Peter Cushing as the haughty Baron Victor Frankenstein, surrounded by glassware, photographed for The Curse of Frankenstein *(directed by Terence Fisher in 1957). The emphasis in Hammer's cycle was on the Baron rather than the creature. OPPOSITE: Christopher Lee as the creature in* The Curse of Frankenstein *(1957): the outstretched hands, both menacing and begging, featured in much of the publicity.*

ABOVE: Illustrations of the Monster by makeup artist Roy Ashton for Evil of Frankenstein *(1964). OPPOSITE: Former wrestler Kiwi Kingston as the Monster in Hammer's* Evil of Frankenstein *(directed by Freddie Francis in 1964): this was a co-production with Universal, so Karloff-style makeup was now allowed.*

ABOVE: *Suitably garish British poster by Tom Chantrell for* Carry On Screaming *(directed by Gerald Thomas, 1966), a send-up of the Hammer craze. The Monster Odbodd (Tom Clegg) carries the hapless Doris (Angela Douglas) to her doom.*
OPPOSITE: **Carry On Screaming** *family portrait, with (front row) Detective Sergeant Bung (Harry H. Corbett), Valeria Watt (Fenella Fielding), Dr Watt (Kenneth Williams) and (back row) Odbodd Senior (Tom Clegg) and Odbodd Jr (Billy Cornelius).*

ABOVE: Fred Gwynne as Herman Munster, in the 1964-66 television comedy-horror series The Munsters. *His face was ideally suited to Karloff-style makeup —and colleagues would say to him, as they saw him on the set, 'working today, Fred?'. RIGHT: Lily (Yvonne De Carlo) and Herman (Fred Gwynne), in a cobwebby studio portrait for* The Munsters.

Frankensex (top, left to right): **House on Bare Mountain** *(1962) with the fake Monster (Warren Ames) at a costume ball;* **Kiss Me Quick** *(1964), featuring Fattie Beltbuckle as a sex-change Monster. Strange Variations (bottom, left to right); ex-professional wrestler 6ft 8in. Mike Lane as the Monster in* Frankenstein 1970 *(1958) which had Karloff as the scientist;* Japanese Frankenstein Conquers the World *(1964), in which a boy who has eaten the Monster's radioactive heart does battle with a pre-historic lizard; OPPOSITE: A puppet version of Frankenstein's Monster, from the children's film* Mad Monster Party? *(1967), which included Boris Karloff voicing a puppet Baron Von Frankenstein and even singing a musical number: it was co-scripted by Harvey Kurtzman of* Mad *magazine fame.*

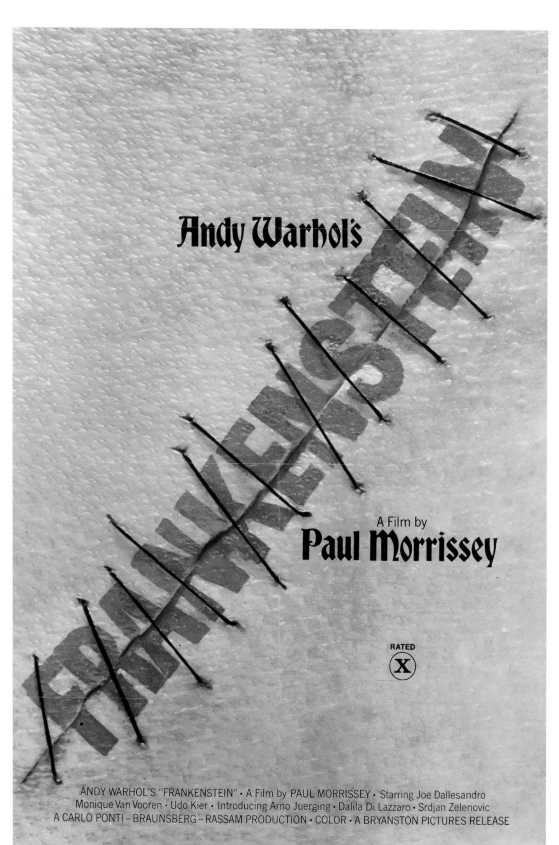

Andy Warhol's

A Film by
Paul Morrissey

RATED
X

ANDY WARHOL'S "FRANKENSTEIN" • A Film by PAUL MORRISSEY • Starring Joe Dallesandro
Monique Van Vooren • Udo Kier • Introducing Arno Juerging • Dalila Di Lazzaro • Srdjan Zelenovic
A CARLO PONTI – BRAUNSBERG – RASSAM PRODUCTION • COLOR • A BRYANSTON PICTURES RELEASE

LEFT: Original poster for **Andy Warhol's Frankenstein** *(1973) known in Europe as* **Flesh for Frankenstein,** *directed by Paul Morrissey. The poster was the most—the only— stylish aspect of this film. OPPOSITE: The foundation of a 'Serbian super-race', as Baron Frankenstein (Udo Kier) prepares his male monster (Srdjan Zelenovic) to mate with his female counterpart in* **Andy Warhol's Frankenstein** *(1973). The makeup effects were by Carlo Rambaldi.*

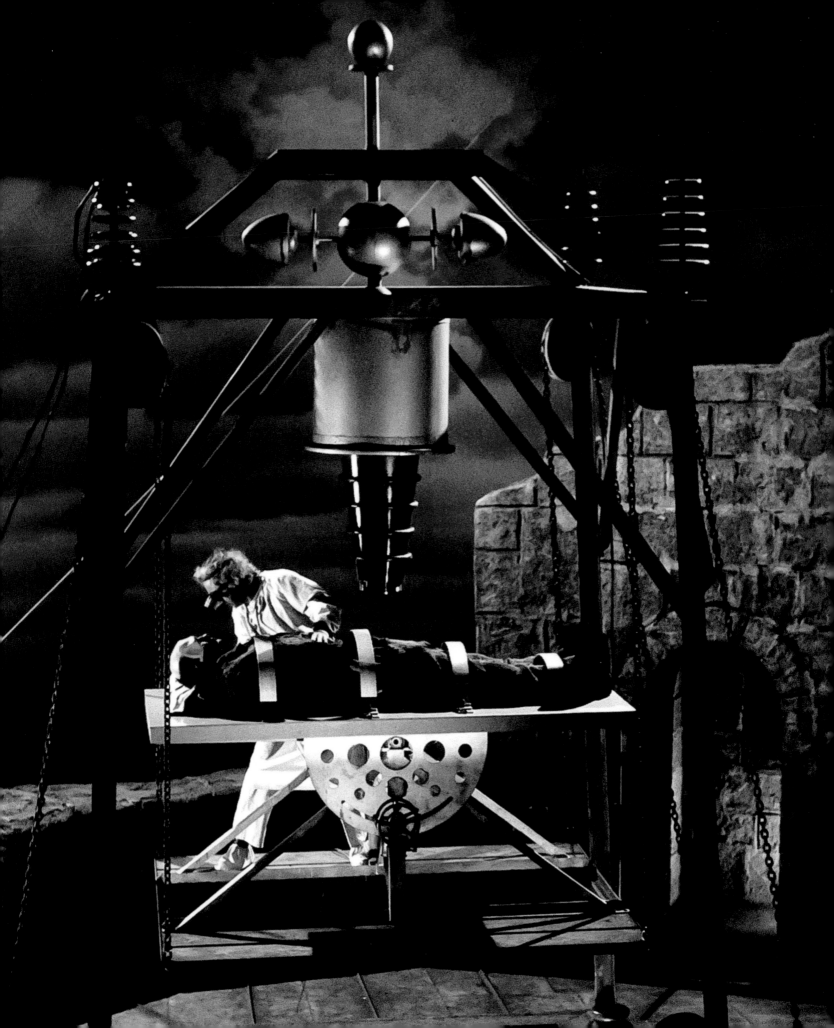

OPPOSITE: Frankenstein's original laboratory equipment from 1931—designed by Kenneth Strickfaden—was re-discovered and re-assembled for Mel Brooks's affectionate parody Young Frankenstein (1974), with co-writer Gene Wilder as Dr. Frederick Frankenstein. Breathing new life into dead tissue . . . RIGHT: Original American poster for Young Frankenstein (1974) with artwork by John Alvin—director Mel Brooks said of the film 'It's about womb-envy, and the mob's ignorance and fear of genius. So it's a very Promethean work . . .'

A MEL BROOKS FILM

YOUNG FRANKENSTEIN

starring

"YOUNG FRANKENSTEIN" GENE WILDER · PETER BOYLE · MARTY FELDMAN
CLORIS LEACHMAN costarring TERI GARR also starring KENNETH MARS and MADELINE KAHN
produced by directed by screen story and screenplay by
MICHAEL GRUSKOFF MEL BROOKS GENE WILDER and MEL BROOKS
based on characters in the MARY W. SHELLEY music JOHN MORRIS PRINTS BY DE LUXE®
novel "Frankenstein" by by

PG PARENTAL GUIDANCE SUGGESTED

20th CENTURY FOX

ABOVE: Moments from Young Frankenstein *(1974), including the Monster (Peter Boyle) meeting the blind hermit (Gene Hackman) the celebrated 'little girl' sequence, and—uniquely—a happy ending with the Monster settling down with Elizabeth (Madeline Kahn). OPPOSITE: Studio Portrait of Peter Boyle as the increasingly debonair Monster in* Young Frankenstein *(1974).*

ABOVE: Hungarian poster for Young Frankenstein *(1974), illustrated by Péter Dékány.* OPPOSITE: *Polish poster for* Young Frankenstein *(1974), illustrated by Jerzy Flizak, emphasising the horror and the comedy as two sides of the same coin.*

The Rocky Horror Picture Show *(directed by Jim Sharman, 1975). ABOVE (clockwise from top left): Richard O'Brien (the writer of the musical) as the seedy butler Riff Raff; Tim Curry as Dr. Frank N. Furter; Peter Hinward as the hunky creature called Rocky; and Patricia Quinn as the alien domestic Magenta. OPPOSITE: Tim Curry as the sweet transvestite from the planet Transylvania Dr. Frank N. Furter, about to launch his new creation. Based on the camp cult musical, this film launched the craze for 'dressing up' or 'cosplay' cinema.*

Two portraits of Robert De Niro as the creature in Mary Shelley's Frankenstein *(directed by Kenneth Branagh, 1994) which aimed to be the 'definitive' version—with an unusually large budget of $45 million. Daniel Parker was co-nominated for an Academy Award, for his 'creature makeup'—a first for a* Frankenstein *film.*

ABOVE: 'Teaser' character posters designed by BLT Communications, for the animated version of Tim Burton's Frankenweenie *(2012), about young Victor's reanimation of his dead dog Sparky. Another homage to the Universal cycle.* *RIGHT: Special poster for the IMAX presentation of* Frankenweenie *(2012).*

A FILM BY TIM BURTON

Disney

FRANKENWEENIE

OCTOBER 5 IMAX® 12:01

Grindhouse Frankensteins. ABOVE: **Frankenstein's Bloody Terror** *(Spain, 1967);* **Dracula vs. Frankenstein** *(Spain/W. Germany/Italy, 1969);* **Lady Frankenstein** *(Italy, 1971),* **Black Frankenstein** *aka* **Blackenstein** *(USA, 1972);* **Frankenhooker** *(USA, 1990); and* **Rock N Roll Frankenstein** *(USA, 1999) in which a new rock star is created out of bits of old dead celebrities—including Elvis's head. OPPOSITE:* **Blackenstein** *(1972), a Blaxploitation movie in which the monster is a Vietnam veteran with extra limbs and an Afro haircut. He is destroyed in the final reel by police dogs.*

FRSCO PRESENTS...

BLACKENSTEIN
(THE BLACK FRANKENSTEIN)

IT WALKS THE NIGHT!

THE KING OF MONSTERS!

NO BULLET CAN KILL HIM!

NO CHAINS CAN HOLD HIM!

WARNING! TO PEOPLE WITH WEAK HEARTS... NO DOCTORS OR NURSES · IN ATTENDANCE ·

POSITIVELY GOREFFIC RATED PG BY MONSTERS MAG

A FRSCO PRODUCTIONS LIMITED FILM

STARRING **JOHN HART, IVORY STONE.** FEATURING **ANDREA KING, LIZ RENAY, ROOSEVELT JACKSON, JOE DE SUE, NICK BOLIN, CARDELLA DI MILO, ANDY C.** AND INTRODUCING **JAMES COUSAR.**

WRITTEN AND PRODUCED BY **FRANK R. SALETRI** EXECUTIVE PRODUCER—**TED TETRICK** DIRECTED BY **WILLIAM A. LEVEY**

COLOR BY DE LUXE RELEASED BY EDDIE C. STEWART AND EXCLUSIVE INTERNATIONAL PIX

OPPOSITE: Cover of Vanity Fair by
Paolo Garetto, August 1935.
RIGHT: The all-too-serious version—
symbolic representation of the
German worker in an exhibition
about the economy organised by the
Third Reich's Labour Front.

The Mad Scientist in Mad Settings. LEFT: An American comic of February 1963. OPPOSITE: Mad magazine cover by Norman Mingo, September 1964, the same month as The Munsters premiered on CBS television.

ABOVE: Frankenstein Comics. Dick Briefer's celebrated **Frankenstein** comic ran from 1945 to November 1954, placing the Monster in small-town America and mixing children's humour with a more grown-up sensibility. OPPOSITE: Between 1952 and 1954, Dick Briefer's **Frankenstein** became more horrific, as this issue of spring 1953 shows. It was soon to be cancelled.

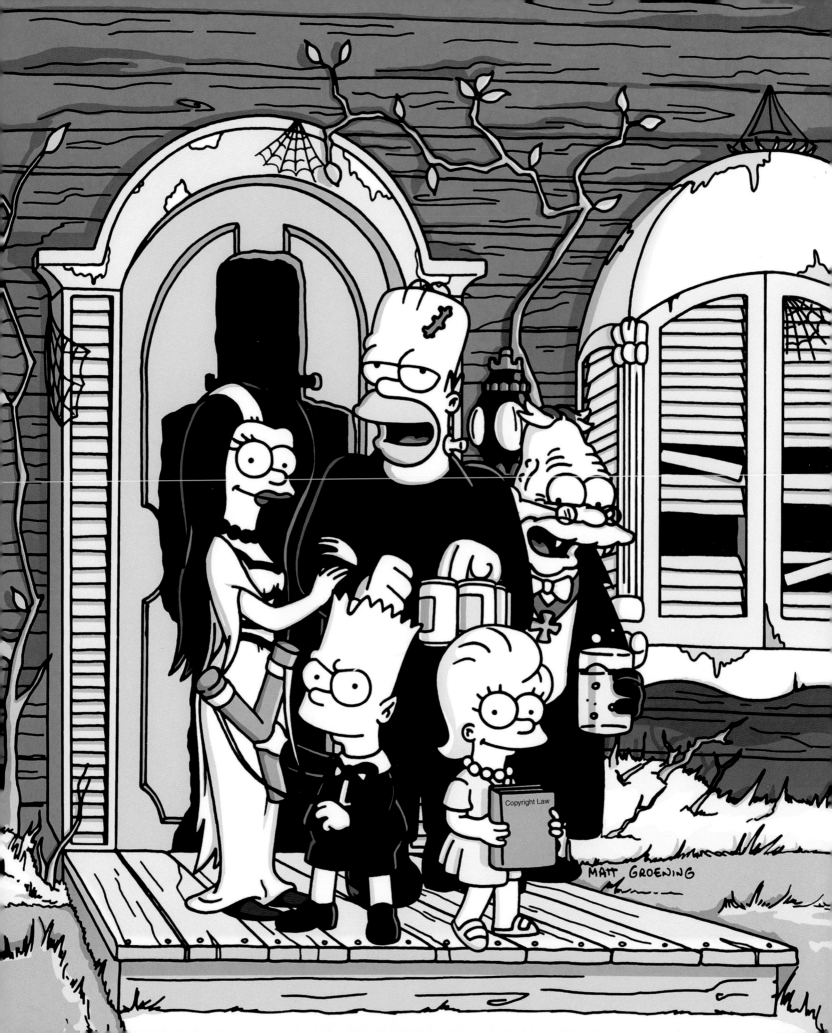

The creature re-animated.
OPPOSITE: Matt Groening's
The Simpsons—*Marge, Homer,*
Abraham, Bart and Lisa—pose as
The Munsters *in 2005. A parody*
of a parody of a parody. RIGHT:
Poster for the Mickey Mouse short
The Mad Doctor *(directed by David*
Hand, 1933).

ABOVE: Concept artwork for 'Frank Frankenstone' in the animated Hallowe'en TV special The Flintstones Meet Rockula and Frankenstone *(1979).*
OPPOSITE: Comic-book version of The Flintstones *in which Fred and Wilma have a suburban monster rally featuring Frankenstein (or rather his Monster) and Dracula, published April 1966.*

"Instead of creating life, I've decided just to establish an online persona."

Two cartoons of Frankenstein in the digital age. ABOVE: Robert Leighton for The New Yorker *magazine.*
OPPOSITE: The Monster with smartphone by Jeff Stahler.

Frankenstein as advertising. ABOVE: the scared-looking creature promotes Smirnoff Vodka (1967).
OPPOSITE: The creature enjoys Winchell's Donuts (1977) with photograph by Sid Avery.

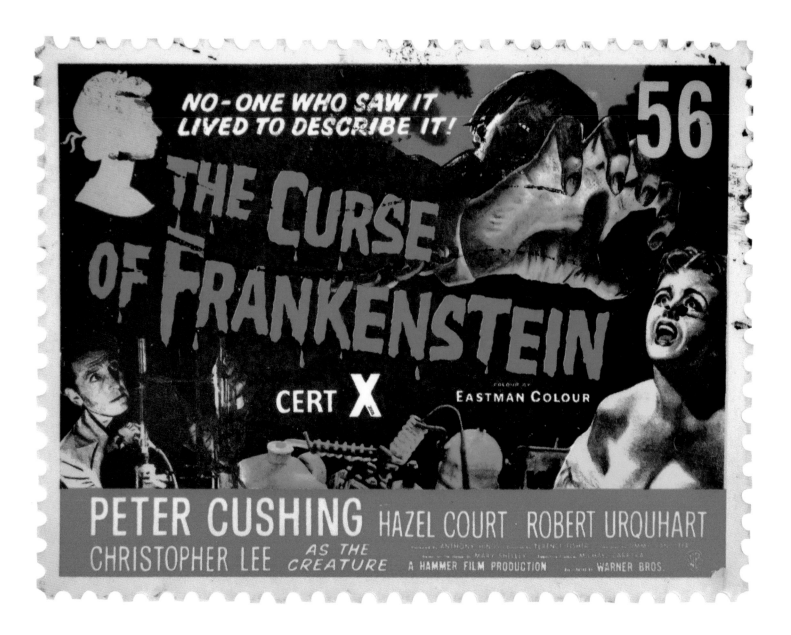

Frankenstein as postage stamps. ABOVE: Stamp, printed in Britain for overseas use in 2008, featuring the original British 1957 poster from Hammer's **The Curse of Frankenstein.** *OPPOSITE: American stamp of 1997 with artwork by Thomas Blackshear II, part of a Universal Monsters series.*

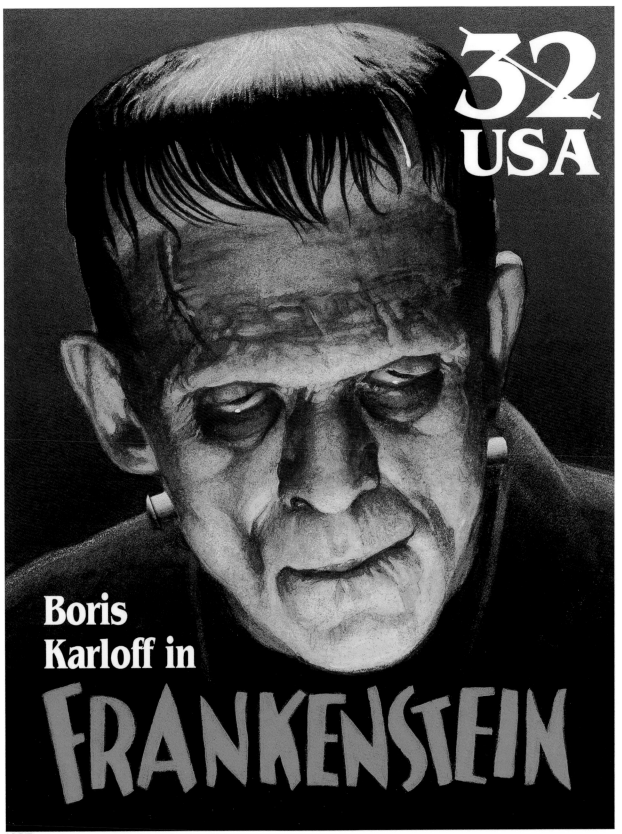

32 USA

Boris Karloff in

FRANKENSTEIN

1997

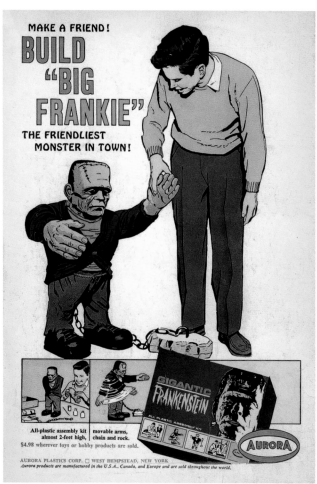

Frankenstein toys, assembly kits and jigsaw puzzles: the creature as surrogate little friend.

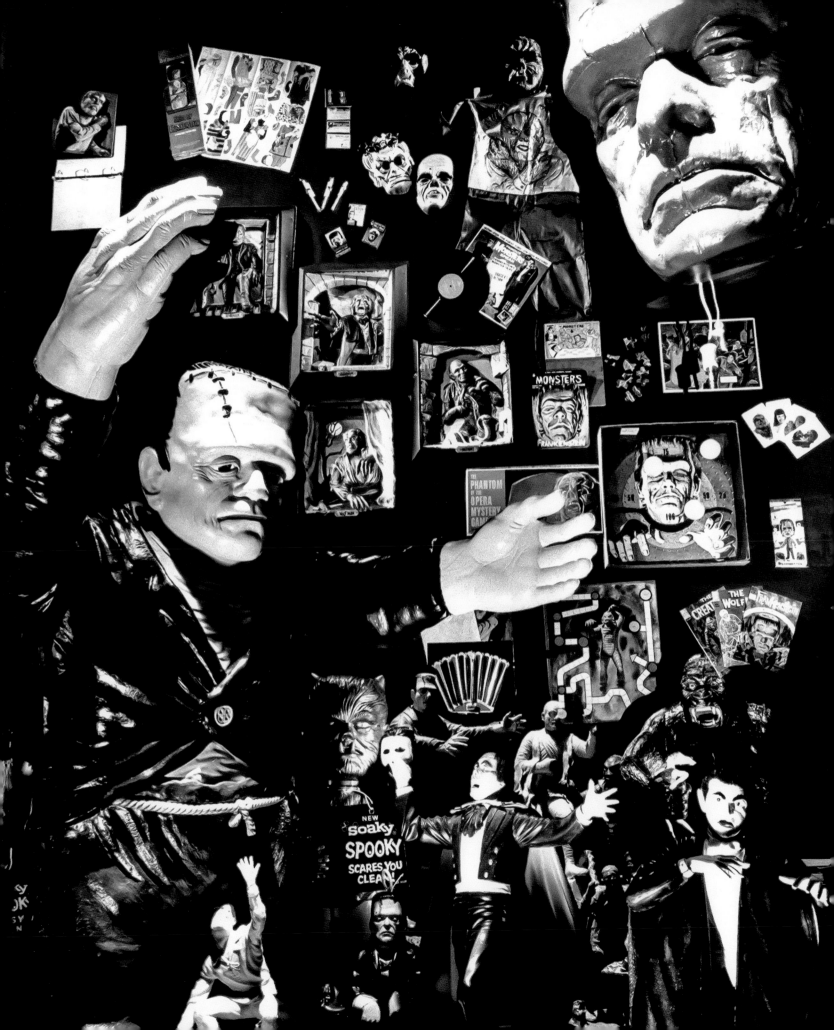

ABOVE: Classics Illustrated comic version—first issued 1945—with cover by Norm Saunders. It ended with encouragement for young readers to visit their local library . . . OPPOSITE: Lion Books edition of 1953, making the novel resemble steamy pulp fiction.

THE GREATEST HORROR STORY OF THEM ALL

FRANKENSTEIN

MARY
SHELLEY

25c

146
A LION BOOK
COMPLETE AND UNABRIDGED

PYRAMID BOOKS

K-1212 **45¢**

Mary Shelley

FRANKENSTEIN

Some classic paperback book covers. LEFT: Pyramid Books 1957 edition, by British painter and printmaker Richard Smith. OPPOSITE: Signet Classics 1965 edition.

Lynd Kendall Ward's classic woodcut illustrations to the 1934 New York edition of Frankenstein, *capturing some of the ambiguities of the original novel.*

Frankenstein *taken seriously again, following the re-appraisal of Mary Shelley and her work. LEFT: Steven McRae as the Creature in artist-in-residence Liam Scarlett's full-length ballet* Frankenstein *premiered by the Royal Ballet at Covent Garden (2016). OPPOSITE: Benedict Cumberbatch as the creature in Nick Dear's adaptation of* Frankenstein *directed by Danny Boyle for London's National Theatre in February–May 2011. Cumberbath alternated the parts of Victor Frankenstein and the Creature with Johnny Lee Miller.*

Acknowledgements

Warm thanks for conversations about *Frankenstein*, over the years, to: Jennie Bisset, Richard Holmes, Roger Highfield (who commissioned the Science Museum lecture, out of which this book grew), Sophie Waring, Andrew Kelly, Mark Kermode, the late Christopher Lee and Jimmy Sangster, Kim Newman, the late Professors Siegbert Prawer and Devendra Varma, Professor Jeffrey Richards, Derek Towers, Professor Marina Warner and Anthony Wornum. Mons. Jolie (on behalf of the Philippe Washer family) let me spend two fascinating days in the Villa Diodati; Catherine Santschi opened the 1816 Geneva police files for me; the staff at the Bodleian Manuscripts Reading Room, British Library, Bfi Library, Cambridge University Library Rare Books Room, Royal College of Art Library, and New York Public Library were unfailingly helpful; and Lucy Edyvean processed my semi-decipherable longhand with her characteristic efficiency and good humour (she needed it, at times). And my belated thanks to the un-named manager of the Plaza cinema, Piccadilly, London, who let me in to the X certificate Hammer *Revenge of Frankenstein* in September 1958—when I was just eleven years old—and unwittingly planted a deep seed. The poster shrieked 'WE DARE YOU TO FORGET IT!' and I never did.

This book is dedicated to Dora Frayling, who was a close friend of Sir Percy.

Bibliography

TEXTS

BYRON, Lord (ed. Jump, John D.): *Childe Harold's Pilgrimage* (London, 1975)
BYRON, Lord (ed. McGann, Jerome J.): *Complete Poetical Works* (7 vols, 1980–93)
BYRON, Lord (ed. Marchand, Leslie A.): *Letters and Journals 1816–1817* (London, 1976)
CLAIRMONT, Claire (ed. Stocking, Marion Kingston): *Journals* (Harvard, 1968)
CLAIRMONT, Claire (ed. Stocking, Marion Kingston): *Correspondence* (2 vols, Baltimore, 1995)
GENEVA POLICE RECORDS (*Archives d'état de Genève*, cote Jur. Pen. Juin et Juillet 1816)
GENEVA PERMITS (Registre de permis de séjour; cote D, Etrangers)
GODWIN, William: *The Lives of Edward and John Philips* (London, 1815)
MEDWIN, Thomas: *Journal of the conversations of Lord Byron at Pisa* (London, 1824)
MEDWIN, Thomas: *The Life of Percy Bysshe Shelley* (London 1847; re-edited Oxford 1913)
MOORE, Thomas: *Letters and Journals of Lord Byron* (vol. I, London, 1830)
POLIDORI, John (eds Macdonald, D.L. and Scherf, Kathleen): *Collected Fiction* (Toronto, 1994)
POLIDORI, John (ed. Rossetti, William Michael): *Diary* (London, 1911)
POLIDORI, John (eds Morrison, Robert and Baldick, Chris): *The Vampyre* (Oxford, 1997)
QUARTERLY REVIEW, London, July 1819
SHELLEY, Mary: *Frankenstein, or the Modern Prometheus* (3 vols, London, 1818)
SHELLEY, Mary: *Frankenstein, or the Modern Prometheus* (2 vols, London, 1823)
SHELLEY, Mary: *Frankenstein, or the Modern Prometheus* (1 vol, London, 1831)
SHELLEY, Mary (ed. Butler, Marilyn): *Frankenstein, or the Modern Prometheus* (1818 text; Oxford, 1994)
SHELLEY, Mary (ed. Crook, Nora): *Frankenstein, or the Modern Prometheus* (1818 text; London, 1996)
SHELLEY, Mary (ed. Hindle, Maurice): *Frankenstein, or the Modern Prometheus* (1831 text; London, 1992)
SHELLEY, Mary (ed. Hunter, J. Paul): *Frankenstein, or the Modern Prometheus* (1818 text; New York, 2012)
SHELLEY, Mary (ed. Joseph, M.K.): *Frankenstein, or the Modern Prometheus* (1831 text; Oxford, 1980)
SHELLEY, Mary (ed. Lyons, Paddy): *Frankenstein, or the Modern Prometheus* (1818 text; London, 1994)
SHELLEY, Mary (eds Macdonald, D.L. and Scherf, Kathleen): *Frankenstein, or the Modern Prometheus* (Ontario, 1994)
SHELLEY, Mary (ed. Robinson, Charles E.): *Facsimile edition of the manuscript novel 1816–1817 in draft and fair copy* (2 vols, New York, 1996)
SHELLEY, Mary (ed. Rieger, James): *Frankenstein, or the Modern Prometheus* (1818 text; Chicago, 1982)
SHELLEY, Mary (ed. Smith, Johanna M.): *Frankenstein* (1831 text; Boston, 1992)
SHELLEY, Mary (ed. Wolf, Leonard): *The Essential Frankenstein* (1818 text; New York, 1993)
SHELLEY, Mary: *History of a Six Weeks' Tour* (London, 1817; facsimile Oxford, 1989)
SHELLEY, Mary (eds Feldman, Paula R. and Scott-Kilvert, Diana): *Journals 1814–1822 and 1822–1844* (2 vols, Oxford, 1987)
SHELLEY, Mary (ed. Bennett, Betty T.): *Letters* (3 vols, Baltimore, 1980–88)
SHELLEY, Mary (ed. Jones, Frederick L.): *Letters* (vols 1 & 2, Oklahoma, 1944)
SHELLEY, Mary (ed. Robinson, Charles E.): *Collected Tales and Stories* (Baltimore, 1990)
SHELLEY, Percy (ed. Rogers, Neville): *The Complete Poetical Works* (Oxford, 1975)
SHELLEY, Percy (ed. Jones, Frederick L.): *Letters* (2 vols, Oxford, 1964)
SHELLEY, Percy (ed. Murray, E.B.): *The Prose Works* (Oxford, 1993)
SHELLEY, Percy (eds Cameron, Kenneth Neill, Reiman, Donald H. and Fischer, Doucet Devin): Shelley and His Circle 1773–1822 I–VIII (Harvard, 1961–)

CONTEXTS - GENESIS

*entries which proved especially useful

BBEER, Gavin de: *Meshes of the Byronic Net in Switzerland* (English Studies, XLIII, 5 October 1962)
BIGLAND, Eileen: *Mary Shelley* (London, 1959)
*BROWNE, Max: *The Romantic Art of Theodor von Holst* (London, 1994)
CLUBBE, John: *The Tempest-toss'd Summer of 1816* (Byron Journal, 19, 1991)
CROUCH, Laura: *Davy's A Discourse – a possible scientific source of Frankenstein* (Keats-Shelley Journal, vol. XXVII, 1978)
ENGEL, C-E.: *Byron et Shelley en Suisse* (Chambéry, 1930)
FATIO, Guillaume: *Milton et Byron à la Villa Diodati* (in Nos Anciens et leurs Oeuvres, Genève, 1912)
FLORESCU, Radu: *In Search of Frankenstein* (Boston, 1975)
*FRAYLING, Christopher: *Nightmare – the birth of horror* (London, 1996)
GITTINGS, Robert and MANTON, Jo: *Claire Clairmont* (Oxford, 1995)
*GORDON, Charlotte: *Romantic Outlaws* (London, 2016)
GRYLLS, R. Glynn: *Mary Shelley* (Oxford, 1938)
HALL, Basil: *Patchwork* (London, 1841)
*HOLMES, Richard: *The Age of Wonder* (London, 2008)

HOLMES, Richard: *Shelley – the Pursuit* (London, 1974)
KETTERER, David: *Frankenstein's Creation* (Victoria, BC, 1979)
KING-HELE, Desmond: *The Essential Erasmus Darwin* (London, 1968)
LYLES, W.H.: *Mary Shelley – an annotated bibliography* (New York, 1975)
*MACCARTHY, Fiona: *Byron – Life and Legend* (London, 2002)
MACDONALD, D.L.: *Poor Polidori* (Toronto, 1991)
MARCHAND, Leslie A.: *Byron – a biography* (3 vols, London, 1957)
*MELLOR, Anne K.: *Mary Shelley – her life, her fiction, her monsters* (London, 1988)
MOERS, Ellen: *Literary Women* (London, 1978)
*MYRONE, Martin (ed.): *Gothic Nightmares* (London, 2006)
NITCHIE, Elizabeth: *Mary Shelley* (New Jersey, 1953)
PALACIO, Jean de: *Mary Shelley dans son oeuvre* (Paris, 1969)
*RIEGER, James: *Polidori and the Genesis of Frankenstein* (Studies in English Literature, 3, 1963)
REIMAN, Donald H. (ed.): *Romantics Reviewed* (New York, 1972)
*ROBINSON, Charles E.: *Introduction to the Facsimile edition of Frankenstein* (vol I, New York, 1996)
*ST CLAIR, William: *The Godwins and the Shelleys* (London, 1991)
ST CLAIR, William: *The Reading Nation in the Romantic Period* (New York, 2004)
SCHOR, Esther: *The Cambridge Companion to Mary Shelley* (Cambridge, 2003)
*SEYMOUR, Miranda: *Mary Shelley* (London, 2001)
SPARK, Muriel: *Mary Shelley* (London, 1987)
SUNSTEIN, Emily W.: *Mary Shelley* (Baltimore, 1991)
*TENNANT, J.S.: *Up at a Villa* (Times Literary Supplement, June 10th 2016)
TOMORY, Peter: *The Life and art of Henry Fusili* (London, 1972)
TROPP, Martin: Mary Shelley's Monster (Boston, 1976)
VASBINDER, S.H.: Scientific Attitudes in Frankenstein (UMI Research Press, 1976)
VEEDER, William: Mary Shelley and Frankenstein (Chicago, 1986)
VIETS, Henry R.: The London Edition of the Vampyre (Papers of the Bibliographical Society of America, 63, 1969)

CONTEXTS - AFTERLIFE

*BALDICK, J.S.: *In Frankenstein's Shadow* (Oxford, 1987)
BALL, Phil: *Unnatural - the heretical idea of making people* (London, 2011)
*BELL, James: *Gothic - the dark heart of film* (London, 2013)
BORST, Ronald V.: *Graven Images* (New York, 1992)
BRANAGH, Kenneth: *Mary Shelley's Frankenstein* (London, 1994)
CLARENS, Carlos: *Horror Movies* (London, 1968)
*FORRY, Stephen Earl: *Hideous Progenies* (Philadelphia, 1990)
*FRAYLING, Christopher: *Mad, Bad and Dangerous?* (London, 2005)
FRIEDMAN, Lester and KAVEY, Allison: *Monstrous Progeny* (New Jersey, 2016)
*GLUT, Donald: *The Frankenstein Catalog* (N. Carolina, 1984)
GLUT, Donald: *The Frankenstein Legend* (New Jersey, 1973)
HAINING, Peter (ed.): *The Frankenstein File* (London, 1977)
HITCHCOCK, Susan Tyler: *Frankenstein – a cultural history* (New York, 2007)
JENSEN, Paul M.: *The Men Who Made the Movies* (New York, 1996)
JONES, Darryl: *Horror – a thematic history* (London, 2002)
*JONES, Stephen: *The Illustrated Frankenstein Movie Guide* (London, 1994)
KING, Stephen: *Danse Macabre* (New York, 1982)
*LEVINE, George and KNOEPFLMACHER, U.C. (eds): *The Endurance of Frankenstein* (California, 1979)
MANK, Gregory William: *It's Alive* (London, 1981)
MANK, Gregory William: *Hollywood's Maddest Doctors* (Baltimore, 1998)
*NEWMAN, Kim: *The Bfi Companion to Horror* (London, 1996)
NEWMAN, Kim: *Nightmare Movies* (London, 1988 and 2011)
NOURMAND, Tony and MARSH, Graham: *Horror Poster Art* (London, 2004)
PIRIE, David: *A Heritage of Horror* (London, 1973)
*PRAWER, S.S.: *Caligari's Children* (Oxford, 1980)
*SKAL, David J.: *The Monster Show - a cultural history of horror* (London, 1993)
SKAL, David J.: *Screams of Reason* (New York, 1998)
SMALL, Christopher: *Ariel Like a Harpy* (London, 1972)
TUDOR, Andrew: *Monsters and Mad Scientists* (Oxford, 1989)
TURNEY, Jon: *Frankenstein's Footsteps* (New Haven, 1995)
TWITCHELL, James B.: *Dreadful Pleasures* (Oxford, 1985)
UNIVERSAL FILM SCRIPTS: *Frankenstein* (vol 1) and *The Bride of Frankenstein* (vol 2) (New Jersey, 1989)
WISCHHUSEN, Stephen (ed.): *The Hour of One* (London, 1975)

ADDITIONAL CAPTIONS

p.2: Colin Clive as Dr. Henry Frankenstein, in a publicity still for James Whale's *Frankenstein* (1931) . . . p.5 . . . and Boris Karloff—billed as '?' in the opening credits—as The Monster. p.6: Playbill from Palace Theatre's production of *Frankenstein*, January 1981. p.8-9: A woodcut illustration by Lynd Ward for his well-known illustrated edition of *Frankenstein* in 1934. p.114: Italian poster for *The Curse of Frankenstein* (1957) with artwork by renowned poster artist Luigi Martinati. p.205: *The Revenge of Frankenstein* (starring Peter Cushing) advertised in sensational form outside a cinema.

IMAGE CREDITS

p.2, 5, 100, 103, 105, 109, 118 (top left, middle middle, middle right, bottom left), 120, 123, 128, 131, 133, 135, 137, 143, 150 (top right, bottom left), 152, 153, 155 (all), 166 (top left), 167: TCD; p.6, 18, 29, 35, 36, 38, 63, 68, 73, 80, 81, 95 (right): Private Collection; p.8-9, 200 (all), 201: The Lynd Ward Collection; p.10, 101, 106, 114, 121, 122, 125, 129, 134, 144, 149, 156, 162, 168, 174, 175, 180, 181, 182 (all), 183, 186, 187, 193, 194 (top right, bottom left, bottom right), 196, 197, 198, 199: R|A|P Archive; p.12, 17, 112-3, 118 (top right, middle left), 124, 126, 138, 139, 140, 141, 142, 145, 146-7, 160 (top left), 161, 172, 179, 205: Mary Evans Picture Library; p.14 (both), p.19 (both), p.26 (right), 31, 32, 88, 90, 91 (both), 102, 107, 130, 151, 176 (bottom left), 178, 194 (top left), 195: Getty Images; p.15, 21, 25, 26 (left), 62, 79 (left), 83, 94, 95 (left), 97, 98, 118 (top middle), 119, 148, 150 (top left), 154, 157, 160 (top right, bottom left, bottom right), 164, 166 (bottom left), 173, 176 (top left), 202, 203: Rex Features; p.41: The British Museum; p.44, 99, 116, 117, 118 (bottom middle and bottom right), 158 (all), 159, 163, 166 (top right, bottom right): mptvimages.com; p.170 (all), 171: © John Jay/mptvimages.com; p.191: © Sid Avery/mptvimages.com; p.49-58: The Bodleian Libraries, The University of Oxford, MS. Abinger c.56, fols. 21r.-25v; p.69, 150 (bottom right), 184, 185, 192: Alamy; p.77, 84, 85 © Collection Jennie Bisset; p.79 (right) Victoria & Albert Museum, London; p.82: BnF Bibliothèque nationale de France; p.127, 132, 136, 165, 169, 176 (top middle, top right, bottom middle, bottom right): Hershenson/Allen Archive; p.174, 175, 185: © Disney Corporation; p.176 (bottom left), 177: The Separate Cinema Archive; p.188 © Robert Leighton; p.189 © Jeff Stahler/Cartoon Stock; p.190: Ad Archives

Special thank you to Jennie Bisset

Editor: Tony Nourmand

Art Direction and Design: Joakim Olsson

Text Editor: Alison Elangasinghe

Assistant Editor: Rory Bruton

Photography: Andy Johnson, A.J. Photographics

Pre-Press: HR Digital Solutions

First published 2017 by Reel Art Press, an imprint of Rare Art Press Ltd, London, UK

www.reelartpress.com

First Edition 10 9 8 7 6 5 4 3 2 1

ISBN: 978-1-909526-46-4

Printed by Graphius, Gent